ENTERTAINING IDEAS FROM WILLIAMSBURG

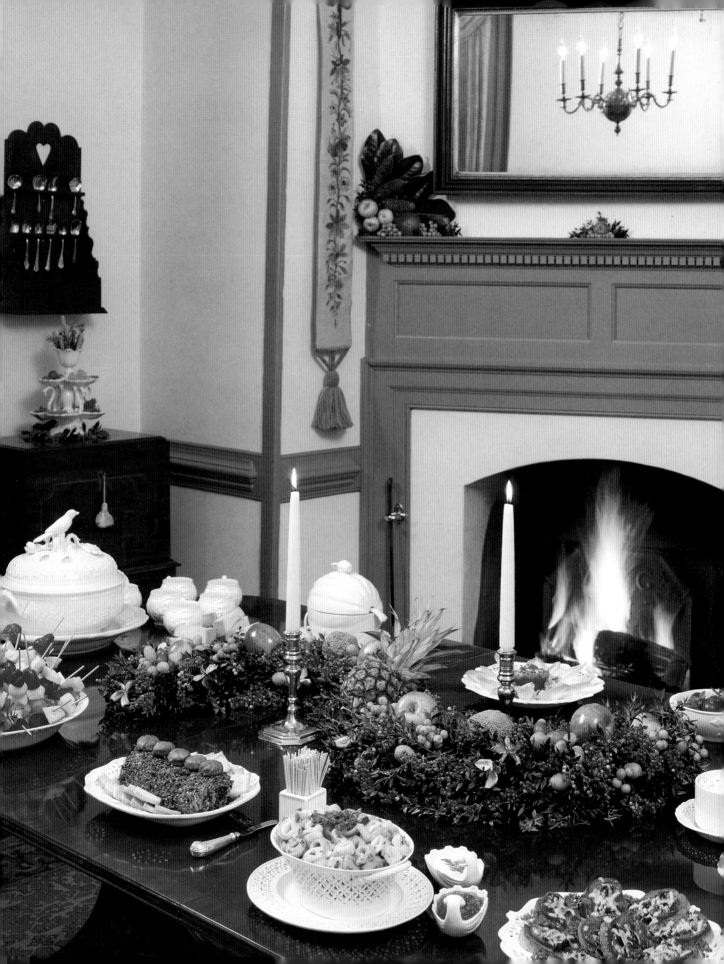

ENTERTAINING IDEAS FROM WILLIAMSBURG

By
Susan Hight Rountree

Illustrations by Elizabeth Hundley Babb

Photography by Tom Green

Line drawings by Louis Luedtke

Additional photography by
David M. Doody and the staff of the
Colonial Williamsburg Foundation,
Bill Boxer, Susan Hight Rountree, and
John Hurt Whitehead

The Colonial Williamsburg Foundation
Williamsburg, Virginia

Fifth printing, 1998

Library of Congress Cataloging in Publication Data

Rountree, Susan Hight.
Entertaining ideas from Williamsburg / by Susan Hight Rountree;
drawings by Elizabeth Hundley Babb; photography by Tom Green.
 p. cm.
 Includes index.
 ISBN 0-87935-095-4
 1. Entertaining—Virginia—Williamsburg. 2. Cookery—
Virginia—Williamsburg. 3. Nature craft—Virginia—Williamsburg.
I. Title.
TX731.R68 1993
642'.4'097554252—dc20 93-23178
 CIP

This book was designed by Helen Mageras.

Printed and bound in Singapore.

Contents

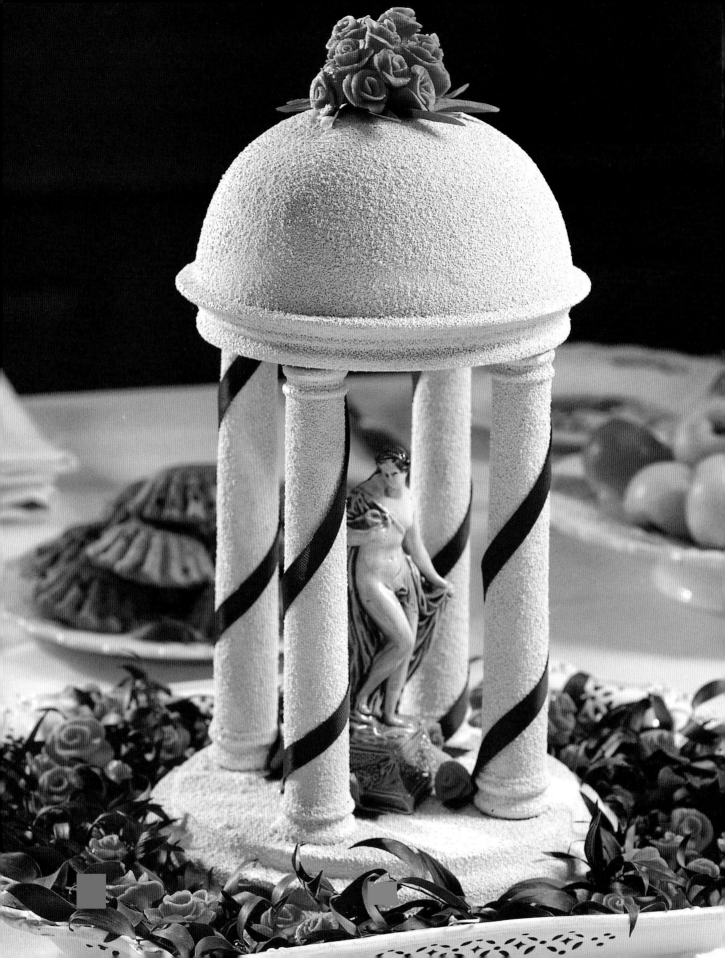

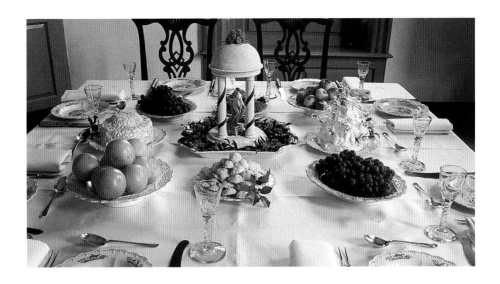

ENTERTAINING IN WILLIAMSBURG

For over three hundred years Virginians have been known for their hospitality. New Jersey native Philip Vickers Fithian, who came to Virginia in 1773 to tutor the children of Robert Carter, observed that "the People are extremely hospitable, and very polite both of which are most certainly universal Characteristics of the Gentlemen in Virginia."

The preparation and serving of food and the setting of the table have always been important components of entertaining. Hannah Glasse, the author of a popular eighteenth-century English cookbook read by many fashionable Virginia hostesses, described the success of a table "on which . . . gravel walks, hedges, and [a] variety of different things, as a little Chinese temple for the middle" were placed symmetrically. Above, a table at the George Wythe House is set as it might have been in colonial times. The balanced arrangement of the dishes and the small flower-bedecked temple with its wreath of Alexandrian laurel leaves and marzipan roses *(opposite)* would have delighted Mr. Wythe's guests.

Modern visitors to Williamsburg are still treated to the best of seasonal foods and imaginative table settings. We hope that the ideas presented in the following pages will encourage you to use some of these plant materials, forms, accessories, and recipes when you entertain in your own home. We also hope that you and your guests will agree with the motto gilded over the mantel of the Apollo Room at the Raleigh Tavern: *Hilaritas Sapientiae et Bonae Vitae Proles*—"Jollity, the off-spring of wisdom and good living."

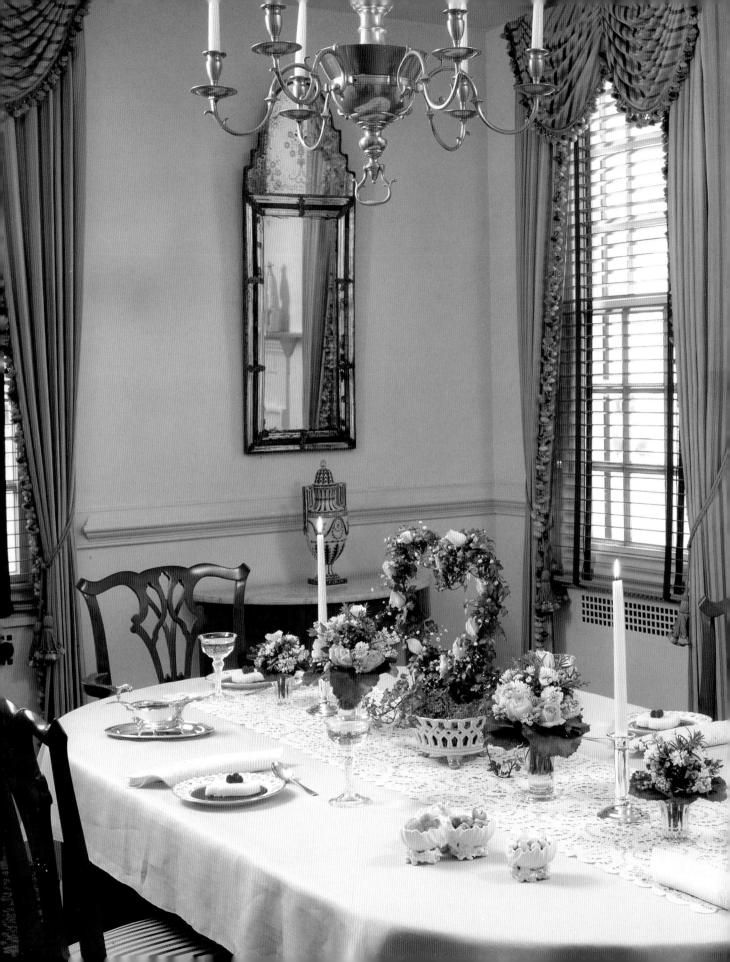

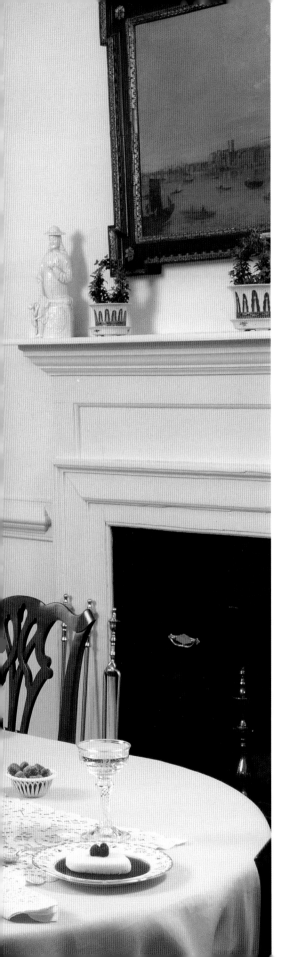

WINTER

After the celebrations of the holiday season, winter provides time for smaller but no less festive gatherings. Decorations featuring roses, lilacs, plum foliage, and other harbingers of spring are a nice contrast to the rich golds, reds, and greens of Christmas. Winter is also the perfect time to indulge in a favorite hobby or craft, and perhaps to learn a new one. Visitors discover the charm of winter in Williamsburg, where a brisk stroll through the old town is followed by a hearty meal at a colonial tavern.

An ivy topiary decorated with flowers, pairs of nosegays, and silver candlesticks form the centerpiece for an anniversary dinner. Three small topiary circles of tiny ivy placed on the mantel carry out the theme.

3

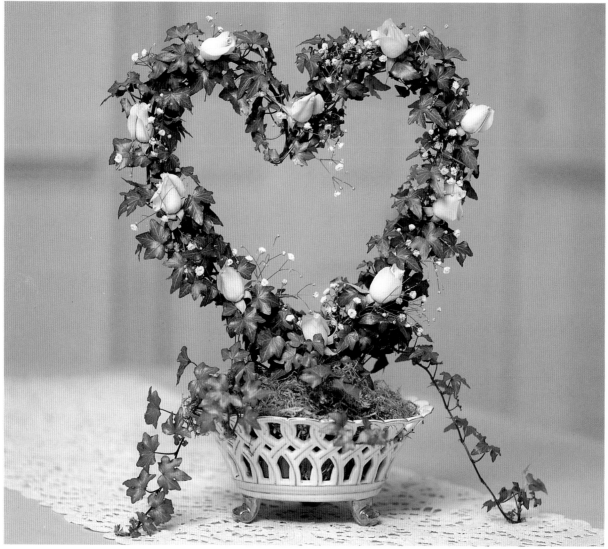

Ivy is trained over a wire topiary heart form. Pale pink roses and baby's breath are tucked in for the party. Graceful ivy tendrils extend over the edge of the container.

ANNIVERSARY DINNER

The ambience of a handsome formal dining room in an eighteenth-century home at Colonial Williamsburg helps to create an especially elegant setting for a dinner party in the winter *(overleaf)*. A heart-shaped ivy topiary, little nosegays of flowers, and pastel candied nuts in small shell dishes are placed on an heirloom lace runner over a pale pink linen cloth. White chocolate ice cream hearts on a raspberry puree and champagne toasts to honor the couple are the climax of this romantic and lovely anniversary dinner.

How to Plant and Train a Topiary on a Wire Form

Supplies and materials needed: wire heart-shaped topiary form, clean plastic or clay pot and saucer, gravel, potting soil mixed with peat moss and perlite, outer ornamental pot (optional), soft yarn or other plant ties, ivy with long, self-branching tendrils in a 3- to 4-inch pot, and Spanish moss.

Portable topiaries are marvelous to use throughout the year. They may be embellished with fresh flowers for a special occasion as shown here. Select a pot in proportion to the finished topiary and one in which the base of the topiary form will fit. Ivy planted in a plastic pot will hold moisture longer and will usually fit more easily into the correct size ornamental pot. A clay pot is more attractive, however, and also provides weight to help

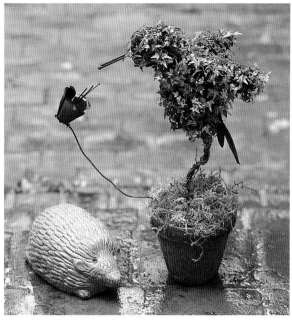

Miniature ivy has been trained to grow over a tiny moss-stuffed hummingbird topiary form. The hummingbird appears almost real as it sips nectar from a brass flower while a little hedgehog sits nearby.

keep the topiary from tipping over.

Put a thin layer of gravel in the pot. Fill half of the pot with the potting soil mixture.

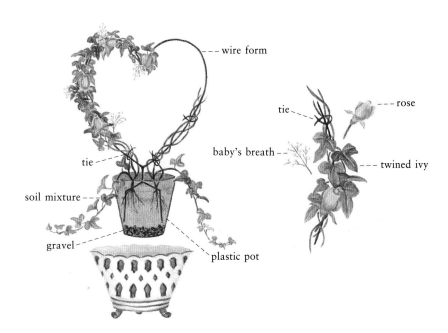

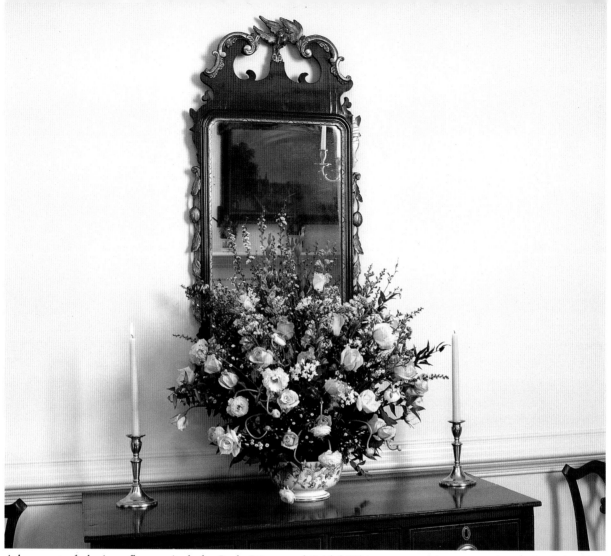

A bouquet of glorious flowers includes Lady Diana and Bridal White roses, white ranunculus, pale pink bouvardia, Alexandrian laurel, white lilacs, pale pink larkspur, spirea, variegated pittosporum, pink heather, and ornamental plum.

Plant the ivy in the center of the pot and add more potting soil as necessary. Be sure the soil is packed firmly around the roots. Use 1 or more plants with 3 tendrils 6 to 8 inches long for each side of the wire topiary form. For the 12-inch frame shown, 2 plants with long tendrils and average size leaves were used. Any remaining short tendrils are attractive and look graceful when allowed to extend out to the sides of the pot as shown.

Insert the prongs of the topiary form into the pot so that the form is at the proper height and the base of the heart is visible above the rim of the pot. Starting close to the point of the heart, carefully wind the ivy tendrils, 1 at a time, around the wire and tie them gently with soft yarn or other plant ties near the bottom, middle, and elsewhere as needed. Continue in this way on both sides of the heart. Do not tie the ivy close to the tender ends. When the ivy grows beyond the middle or top of the heart, cut it back to the top. This will encourage the plant to become thicker and therefore give better coverage.

Place the topiary in the ornamental pot. Cover the top of both containers with Spanish moss. Conditioned roses and baby's breath, which will stay fresh out of water for a few hours, have been inserted into the ivy for this party.

WHITE CHOCOLATE ICE CREAM HEARTS

½ cup sugar
⅓ cup water
8 ounces white chocolate, chopped
2 cups whipping cream
fresh raspberries

Put a deep stainless steel mixing bowl and beaters in the freezer. Combine the sugar and water in a saucepan and rotate the pan over medium high heat until the sugar has dissolved. Remove from the heat, add the chocolate, and cover. Place the mixture in its pan into a shallow pan of very hot water to melt the chocolate. Set the stainless steel bowl into a large bowl of ice just covered with water. Add the whipping cream and beat until it doubles in volume. Beat the white chocolate and syrup mixture until it is very smooth. Put the pan containing the chocolate mixture into the bowl of ice and continue beating until it is cool. Beat in ½ cup of the whipped cream. Fold the white chocolate mixture into the whipped cream and blend well. To make the individual ice cream hearts shown here, place heart cookie cutters on squares of plastic wrap. Pull the plastic wrap tightly across the open bottom and up the sides of each cutter so that it adheres and forms a base for the cutter. Put the cutters in a flat bottomed dish or pan. Spoon the mixture into the cutters, cover with plastic wrap, and freeze. To speed up the serving process, carefully unmold the cutters, wrap the ice cream hearts in plastic wrap, smooth any rough edges through the wrap, and return them to the freezer. Serve the hearts on a bed of raspberry sauce. Garnish with fresh raspberries.

NOTE: The white chocolate ice cream may also be frozen in a mold or shallow dish.

RASPBERRY SAUCE

2 packages (10 ounces each) frozen whole raspberries, unsweetened if possible
1 to 2 tablespoons crème de cassis or Chambord liqueur
sugar to taste

Thaw the raspberries. Puree the berries in a food processor. Rub the puree through a sieve and add the liqueur and sugar to taste.

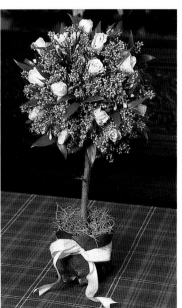

A graceful "faux" topiary (see page 48) of pink roses, heather, and bouvardia is an elegant choice for a winter table. The container is covered with galax leaves and is tied with a cream satin ribbon edged with gold.

A FAMILY
VALENTINE PARTY

The wish for indoor activities during the long winter season inspired this traditional Valentine's Party for family and friends of all ages. An assortment of supplies is assembled so guests may choose to make colorful woven paper hearts, delicate hearts of vines, wire, or paper, or to paint a variety of designs on sugar cookies. Cookies, which the children help bake the night before, and a red cranberry-raspberry punch are welcomed by all.

A branch from an old blueberry bush set in plaster of paris (see page 48) and then placed in a ceramic container is decorated with woven paper hearts. Miniatures of toys and furniture from the Abby Aldrich Rockefeller Folk Art Center surround the field moss and partridgeberries at the base of the little tree.

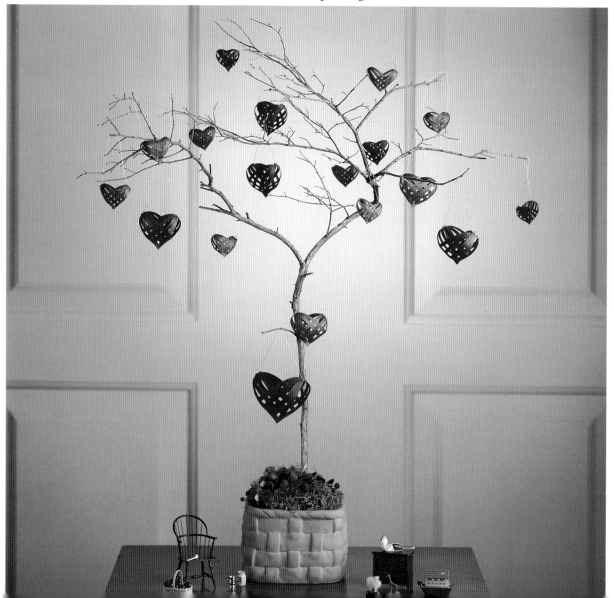

How to Make Woven Paper Hearts

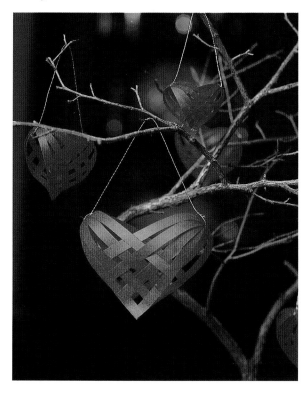

Supplies and materials needed: medium weight red paper, ruler, scissors, white hobby glue, and fine gold thread.

Measure and cut 8 8½-inch x ⅜-inch strips of paper for a large heart, 8 6-inch x ¼-inch strips of paper for a medium heart, or 8 3¼-inch x ⅛-inch strips for a tiny heart. With the horizontal strip on top, glue the ends of 2 strips together to form a right angle (1). Glue 3 more horizontal strips to the vertical strip as shown (2). Alternate the placement of the ends where they are attached—over, under, over, under. The space between 2 strips should be equal to the width of a strip. Weave the remaining 3 strips vertically through the horizontal strip from left to right, leaving a space equal to the width of a strip between the vertical strips. Glue the vertical strips to the horizontal strip alternating over, under, over as shown (3).

Refer to the diagram. Glue the end of strip 4 over the end of strip 4A to form a right angle. Cross strip 5 over strip 4 and glue it under strip 4A leaving the width of a strip between the 2. Cross strip 6 over strips 4 and 5 and glue it on top of strip 4A. Repeat with strip 7. Weave strip 5A under strip 7, over strip 6, under strip 5, and glue it on top of strip 4. Weave strip 6A over strip 7, under strip 6, over strip 5, and glue it under strip 4. Weave strip 7A under strip 7, over strip 6, under strip 5, and glue it on top of strip 4. The strips will automatically form the curved top of the heart.

Bring the tips of the heart together and secure the insides of the two points with a dot of glue. Gently gather the 4 strips together at the top on each side and tie with fine gold thread.

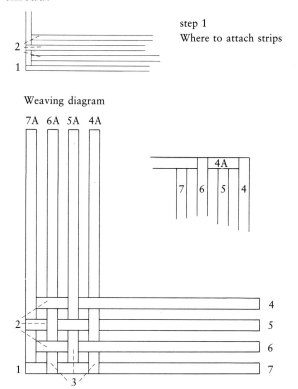

step 1
Where to attach strips

Weaving diagram

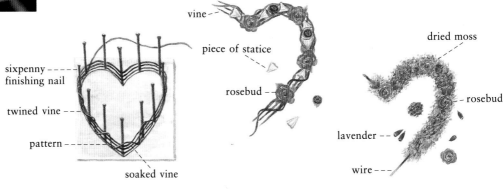

Hearts made from delicate vines or fine wires and decorated with moss and flowers, and hearts of heavy paper to which pieces of dried flowers have been glued hang from a white twig tree. The tree is set in plaster of paris (see page 48). It can be put away after Valentine's Day and used again at Easter.

A tiny vine wreath is accented with dried fairy rosebuds, white statice, and bits of ageratum.

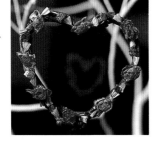

Rosebuds, pieces of lavender, and dried orange mint blooms decorate a moss-covered wire heart.

How to Make Hearts Using Natural Materials

Supplies and materials needed: heart cookie cutters, pencil, small board, 2-inch sixpenny finishing nails, hammer, dark brown or gray thread, #22 gauge green floral wire, wire cutters, white hobby glue, moss, heavy paper, scissors, thin, well-soaked vines, long sprigs of fresh thyme, and dried materials.

Using a cookie cutter for the pattern, draw a heart outline on the board. Drive in finishing nails about ½ inch apart around the pattern as shown. Several heart shapes can be made on a larger board.

TO MAKE A VINE HEART WREATH, use a piece of vine long enough to go around the heart pattern about 4½ times. Starting at the top of the heart, wrap the vine around the outside of all of the nails 3 times, except the top center nail where the vine goes inside, 1 layer above the other. After the third wrap, slide the vine up on the nails. Weave the tail of the vine under and over the 3 layers to hold them together. A separate piece of thyme can be used to weave the layers together. Be careful to tuck in each end. The diameter of the vine will determine the thickness of the wreath.

sixpenny ----
finishing nail

twined vine ---

pattern ---

soaked vine

vine --

piece of statice

rosebud -

dried moss

-- rosebud

lavender --

wire ---

Allow the vine to dry completely before slipping it up and off the nails. Attach a dark thread for a hanger. Bits of dried moss, dried rosebuds, statice, lavender, celosia, or other tiny pieces of plant materials can be glued to the dried vine heart.

TO MAKE A WIRE HEART WREATH, bend a piece of wire into the shape of a heart. Overlap the 2 ends on 1 side of the form. Glue moss on the wire. When dry, glue other bits of plant materials to the moss. Attach a dark thread for a hanger.

How to Make Painted Cookies

SUGAR COOKIES *36 cookies*

½ cup butter, softened
1 cup sugar
1 egg, beaten
1 teaspoon vanilla
1 tablespoon whipping cream
2 cups sifted all-purpose flour
1½ teaspoons baking powder
½ teaspoon salt

Cream the butter and sugar. Add the egg, vanilla, whipping cream, and sifted dry ingredients. Mix well. Wrap the dough in plastic wrap and chill in the refrigerator for several hours. Preheat the oven to 375°F. Grease baking sheets. Roll out the dough and cut it in heart shapes. Place the hearts at least 3 inches apart on the prepared cookie sheets (they spread quite a bit). Bake at 375°F. for 15 minutes or until lightly browned. Cool.

ICING

2 pounds confectioners' sugar, sifted
½ cup butter, softened
2 to 3 tablespoons vanilla
milk
food coloring

Add the confectioners' sugar to the butter in a bowl. Stir well. Add the vanilla and enough milk to make a smooth consistency. Tint with food coloring if desired. Add 2 to 3 drops of hot water and stir until the icing is very smooth and will coat the cookies smoothly. Ice the cookies and allow the icing to dry.

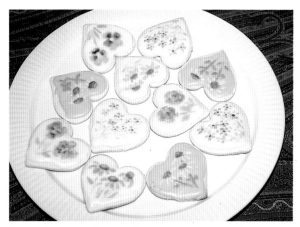

The whole family will find it fun to paint designs on heart-shaped sugar cookies.

COOKIE PAINT

½ cup confectioners' sugar
food coloring
#1 watercolor brush

Add water to the confectioners' sugar a few drops at a time and stir until the mixture is the consistency of honey. Divide the mixture into small bowls. Using toothpicks, tint very lightly with food coloring. Paint the designs with a fine-tipped brush. Allow the cookies to dry.

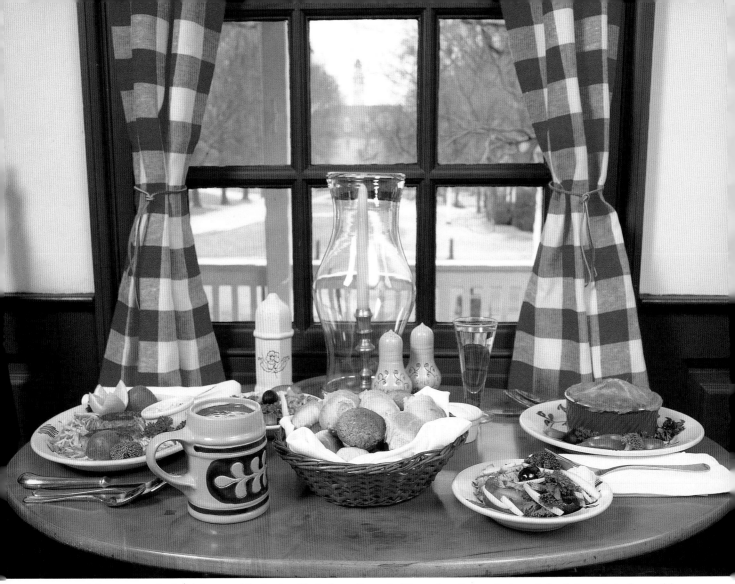

A hearty meal of chicken and leek pie, Christiana Campbell's crab cakes, salad, and fresh breads is framed by a view of the Capitol, where, as a young man, George Washington gained prominence when he reported on a trip he took to the northwestern frontier of the colony just prior to the French and Indian War.

WASHINGTON'S BIRTHDAY LUNCH AT CHRISTIANA CAMPBELL'S TAVERN

George Washington was a frequent guest at Christiana Campbell's "Tavern in the House, behind the Capitol" where she promised "genteel Accommodations, and the very best Entertainment." During sessions of the House of Burgesses, a distinguished clientele patronized this tavern for refreshments and to discuss everything from politics to horse races. Today tasty fare such as Captain Rasmussen's clam chowder, chicken and leek pie, spoon bread, and sweet potato muffins accompanied by a mug of ale help ward off winter's chill. A special dessert of sour cherry flan celebrates the first president's birthday.

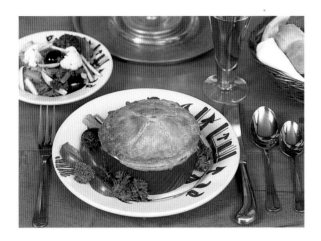

CHRISTIANA CAMPBELL'S TAVERN CHICKEN AND LEEK PIE *8 servings*

2 broiler-fryers (2½ to 3 pounds each)
2 ribs of celery, chopped
1 medium onion, sliced
2 carrots, sliced
1 bay leaf
1 teaspoon salt
½ teaspoon white pepper
½ cup butter
½ cup all-purpose flour
chicken stock
1 pound fresh mushrooms, sliced
6 leeks (white part only), diced
½ cup white wine
1 egg
2 tablespoons milk
pastry dough

Cut up and place the chickens in a large pot with enough water to cover. Add the celery, onion, carrots, bay leaf, salt, and pepper. Bring the water to a boil, reduce the heat, and cook until the chickens are tender. Remove the fat, strain the stock, and reserve it. Discard the skin and bones and cut up the chicken. Melt the butter, stir in the flour, and cook 5 minutes over low heat, stirring frequently. Add enough hot chicken stock, stirring constantly, to achieve the consistency of the sauce desired. Simmer 5 minutes. Season to taste. Cook the mushrooms and leeks in ½ cup of chicken stock and the wine. Preheat the oven to 375°F. Grease 8 individual casseroles. Divide the chicken and cooked vegetables equally into the casseroles. Add the sauce. Mix the egg and milk together to make an egg wash. Cover each casserole with pastry, brush with the egg wash, and prick with a fork. Bake at 375°F. until the pastry is golden brown.

SOUR CHERRY FLAN

pastry dough for a 10-inch flan pan
1⅔ cups sour red cherries, drained
¾ cup milk
¼ cup light cream
1 egg
¼ cup sugar
¼ teaspoon vanilla
nutmeg
toasted sliced almonds

Preheat the oven to 375°F. Grease a 10-inch flan pan that is 1 inch deep. Roll out the pastry, press it firmly into the prepared pan, and prick it with a fork. Spread the cherries over the dough. Bake at 375°F. for 20 to 25 minutes until the sides and top of the shell are lightly browned. Whisk the milk, cream, egg, sugar, and vanilla together and pour over the cherries. Sprinkle lightly with nutmeg. Turn the oven down to 325°F. and bake the flan for another 20 minutes or until the custard is set. Cool completely. Garnish with almonds.

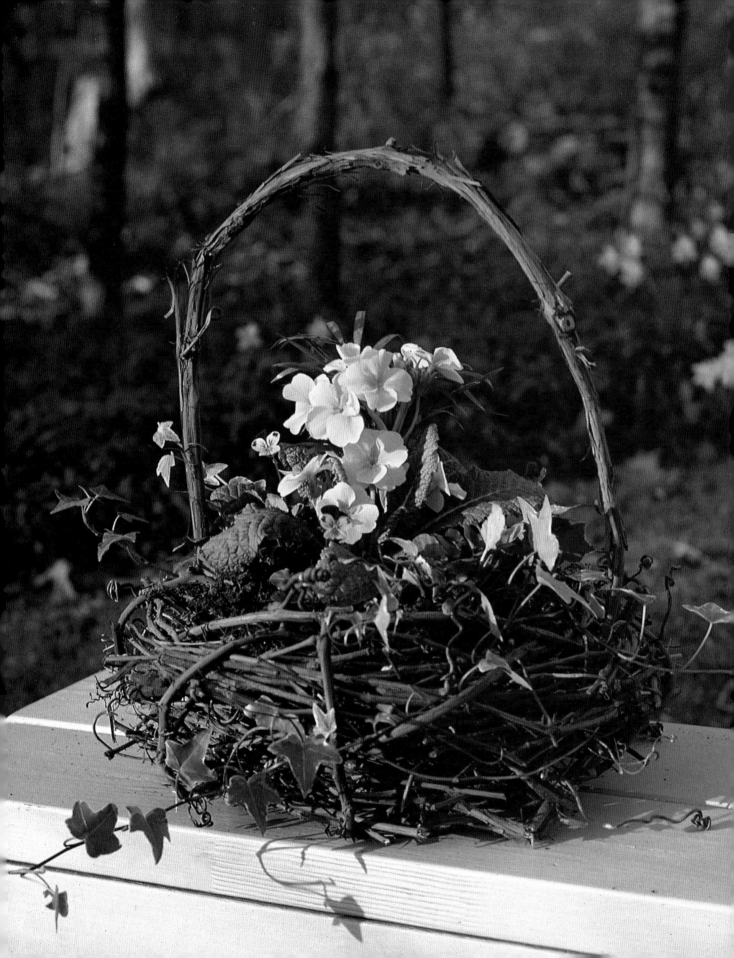

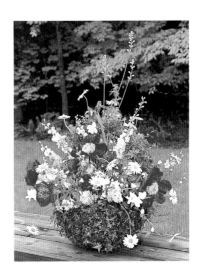

SPRING

Spring comes early to Williamsburg. Gardens bursting into life encourage us to look for new colors, plant materials, and forms of decoration. Redbud, shadbush, flowering quince, and crocus bloom first. Long-established gardens outlined by new growth boxwood display daffodils, species tulips, anemones, Virginia bluebells, columbine, grape hyacinths, and English daisies. Lavender chive blossoms, deep purple and gold Johnny-jump-ups, and bright yellow primulas contrast with the subtle colors of rosemary, thyme, and mints in the brick-bordered herb and kitchen gardens. Later in the long season, the lilacs, iris, larkspur, and peonies favored by colonial Virginians and still beloved today make their appearance.

Opposite: Ivy trails from a grapevine basket planted with cheery yellow cowslip primroses and Johnny-jump-ups.
Above: An ivy topiary basket contains an arrangement of brilliantly colored flowers.

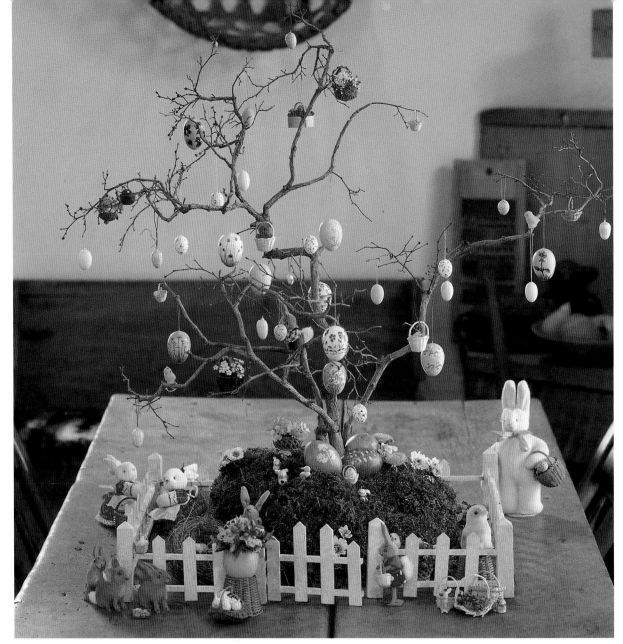

An Easter tree (see page 48) is decorated with hand-painted eggs, eggs dyed with onion skins, and little baskets of primroses. A collection of long-eared admirers observe their springlike surroundings with pleasure.

EASTER

The delightful fresh colors of early spring are brought inside for this Easter scene. Diminutive cowslip primroses, violets, Johnny-jump-ups, and forget-me-nots are planted in a mossy bank. Bunnies, small wooden eggs with hand-painted herb designs, and tiny baskets of flowers kept fresh by concealed bottle caps of water add to the charm of the miniature garden. For those who enjoy decorating Easter eggs, sgraffito designs from folk pottery and freshly picked herbs provide ideas and patterns for scratched or herb-imprinted eggs.

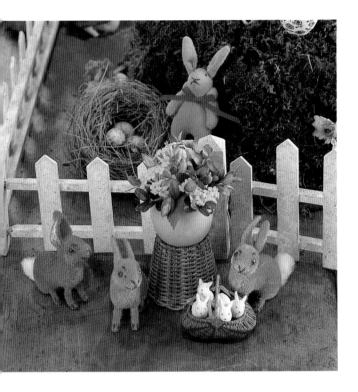

Bunnies gather around a tiny basket filled with baby bunnies and a carefully cut eggshell that holds colorful spring blossoms.

A tiny basket of forget-me-nots and white violets and a water-filled egg containing yellow cowslip primroses stand between two lady bunnies, one holding a bouquet of bright yellow flowers.

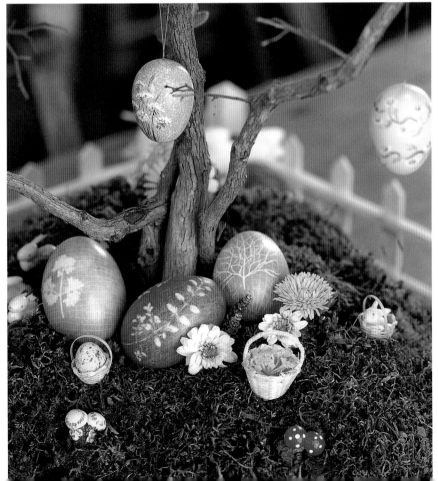

Eggs imprinted with herb designs nestle among blossoms and baskets with flowers and a tiny bunny.

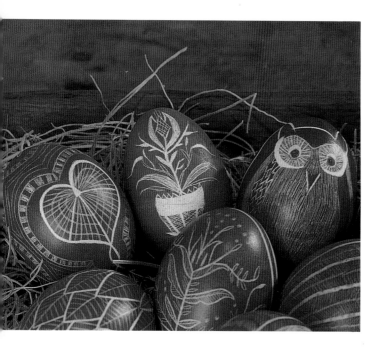

you go to the grocery store until you have 6 cups.

Allow the eggs to come to room temperature. Put the onion skins in a clean stainless steel or enamel saucepan. Any oil in the pan may cause the eggs to take the dye unevenly. Add the eggs and enough water to cover them by 1 inch. Bring the water to a boil slowly so that the eggs do not crack. Simmer for 4 to 5 hours, adding warm water as needed. Turn the eggs occasionally with a wooden spoon. The lengthy cooking will form an air sac around the yolk, which will help prevent the eggs from exploding later, and also will produce a deep mahogany color. Drain the eggs and allow them to cool.

Draw a design on each egg, or scratch it on freehand. To make a scratched design, hold an egg gently and use the point of an X-acto

How to Make Scratched Easter Eggs

Supplies and materials needed: 6 cups yellow onion skins, brown or white eggs with very smooth surfaces, 3-quart stainless steel or enamel saucepan, wooden spoon, white pencil or chalk, X-acto knife or other small sharp object, hone and honing oil, vegetable oil or spray varnish, and waxed paper.

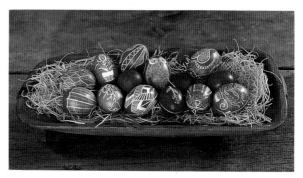

This centuries-old folk tradition is German in origin and has been passed from generation to generation. Pennsylvanians of German descent continue to scratch eggs to give as gifts to friends and family on Easter Sunday. Many of the designs are similar to the sgraffito-decorated pottery from that region.

Before you plan to make these eggs, collect onion skins from the onion bin each time

knife, pin, or other small sharp object to scratch away the dyed area. The deeper the design is scratched, the whiter the design will be. Use the hone to get a burr on the tool. Be careful not to put too much pressure on the egg or it will break. If a large area is to be removed, use a razor blade. Traditionally, after the designs were finished, the eggs were wiped with vegetable oil. To give the eggs a more durable finish, place them on waxed paper and spray with 6 to 8 light coats of varnish, turning them frequently. Periodic rubbing with vegetable oil will revive the deep color.

How to Make Herb-Imprinted Eggs

Supplies and materials needed: 4 to 6 cups yellow onion skins, white eggs, 3-quart stainless steel or enamel saucepan, herbs, flowers, or foliage, cheesecloth, scissors, wooden clothespins, waxed paper, and spray varnish.

Collect 4 to 6 cups of onion skins from the onion bin at the market.

Allow the eggs to come to room temperature and cover them with water. Bring the water to a boil slowly so that the eggs do not crack. Simmer for 4 to 5 hours, adding warm water as needed. The lengthy cooking will form an air sac around the yolk, which will help prevent the eggs from exploding. Drain the eggs and allow them to cool.

Simmer the onion skins in water for 40 minutes to produce a strong dye bath. Remove a few of the skins. Those remaining will cushion the eggs. Keep the dye bath hot.

Assemble a variety of small fresh herbs, flowers, and foliage and keep them in water. Cut the cheesecloth into 8-inch squares and rinse it well. Select an herb, flower, or a piece of foliage. Arrange it on the surface of an egg. Center the cheesecloth over the egg, carefully gather the ends at the back, and secure them

with a clothespin. Gently submerge the egg in the hot dye bath. Simmer slowly until each egg reaches the color desired. Remove the eggs from the pan, remove the cheesecloth and plant materials, and cool on a cake rack.

A number of eggs can be dyed at the same time. They will range in color from light tan to dark mahogany depending on how long they remain in the dye. When the eggs are cool, place them on waxed paper and spray with 6 to 8 light coats of varnish, turning them to cover all sides.

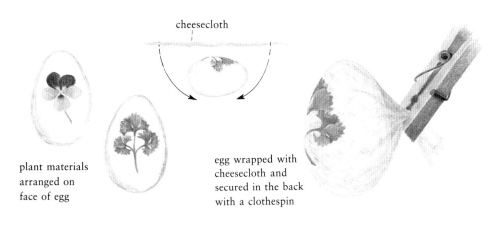

cheesecloth

plant materials arranged on face of egg

egg wrapped with cheesecloth and secured in the back with a clothespin

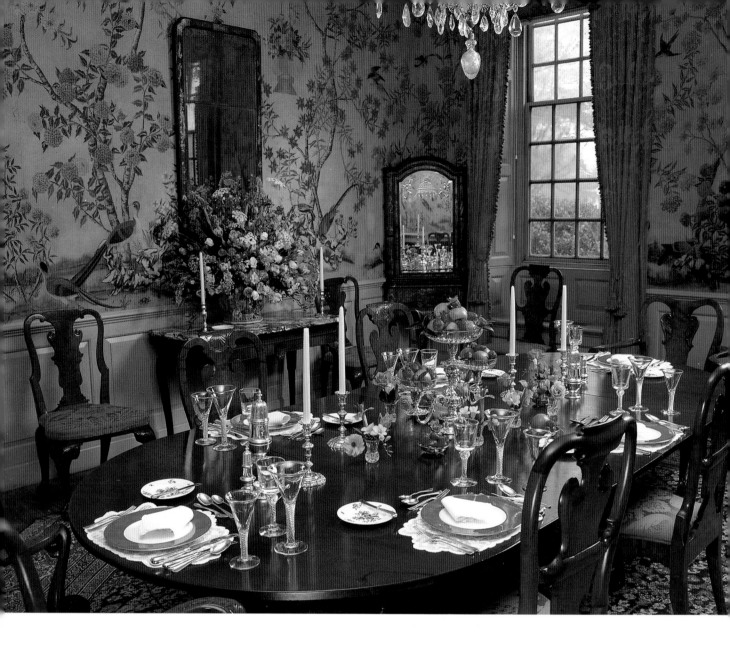

GARDEN WEEK DINNER AT THE LIGHTFOOT HOUSE

The handsome eighteenth-century brick Lightfoot House was opened to visitors to honor Colonial Williamsburg's commitment to historic preservation and to celebrate Garden Week in Virginia. This statewide effort of the Garden Club of Virginia enables the restoration of many of Virginia's historic gardens.

The dining room, furnished with eighteenth- and nineteenth-century antiques and reproductions, is a magnificent setting for these splendid spring flowers. The striking colors of the centerpiece of fruits and flowers and the other table appointments are echoed in the dramatic arrangement on the serving table.

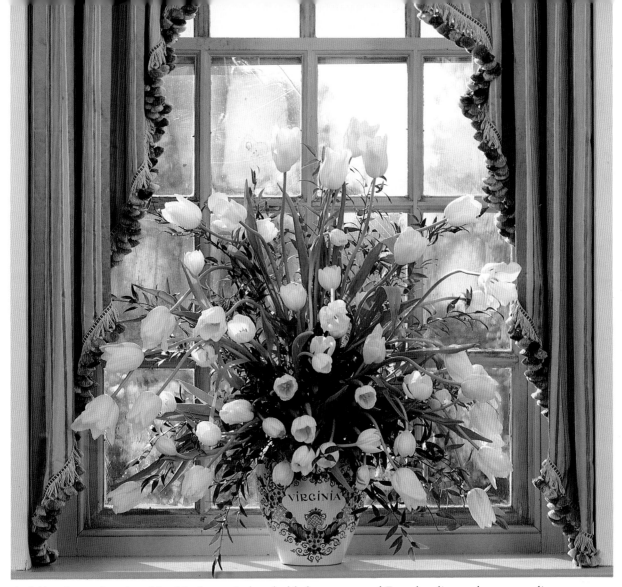

A delft tobacco jar placed in this deep window holds long-stemmed French tulips and cottage tulips.

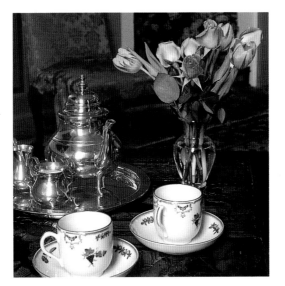

In the living room, tulips and roses repeat the colors in the Duke of Gloucester china coffee cups.

In the dining room epergne, a dish of oranges and strawberries is accented with Alexandrian laurel leaves.

A crystal vase on the dining room table contains an iris, a ranunculus, a freesia, and a Betina rose.

MAY WINE PARTY AT THE NELSON-GALT GAZEBO

The "Mai Bowle," or May Bowl, is an ancient tradition in Europe that marks Beltane—the first day of May—the month for rejoicing when the lovely, soft greens of spring appear on the trees. What a wonderful reason to invite friends to enjoy subtly flavored wine and foods featuring fresh herbs, fruits, and edible flowers. This gazebo with its moss-covered roof and Chippendale railing is decorated for a party to greet the arrival of spring. A double hoop covered with fresh flowers and boxwood hangs above a bowl of May wine that is garlanded with a sweet woodruff and strawberry wreath. An assortment of foods celebrates the tastes, fragrances, and beauty of spring herbs.

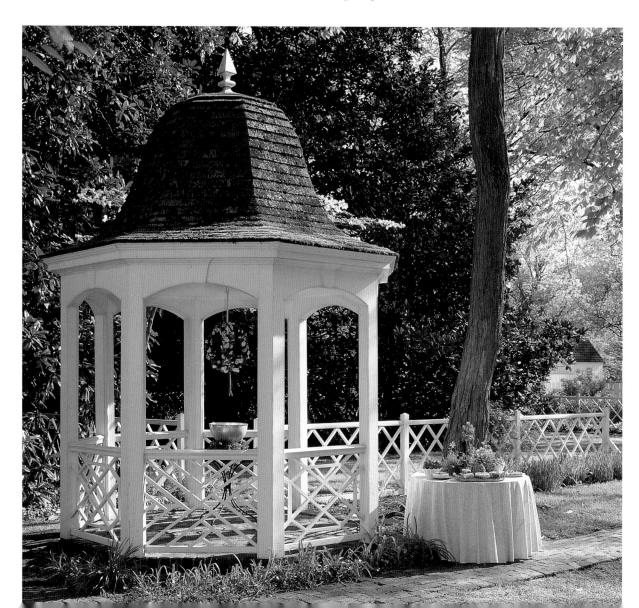

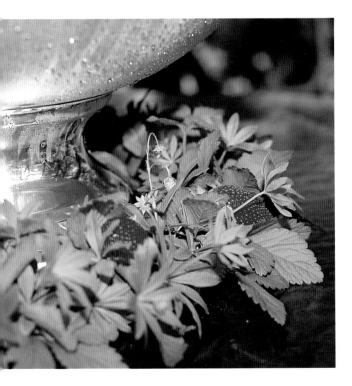

How to Make a Wreath of Fresh Plant Materials

Supplies and materials needed: floral foam wreath ring, floral preservative, toothpicks, scissors, strawberries, plate or tray, plant mister, and conditioned plant materials (see page 152).

Soak the ring in water to which floral preservative has been added. Insert 3-inch pieces of sweet woodruff and strawberry foliage to cover the ring completely. If the stems are tender, make holes in the foam with a toothpick and insert the stems into the holes. Impale strawberries on toothpicks and insert them into the floral foam. Place the strawberries around the ring to distribute their red color. Insert delicate little 4-inch wild strawberry sprigs and white strawberry blossoms to add a light and airy quality to the wreath. After the wreath is completed, place it on a plate or tray to protect the table. Mist frequently, and add water to the floral foam to keep the plant materials fresh.

NOTE: A wire box wreath form may also be used. You will need floral foam, a knife, green floral adhesive tape, and a plate or tray.

Soak the floral foam as described above and cut it into small blocks that will fit into the frame. Tape the blocks of floral foam as shown in the detail. Proceed as described above.

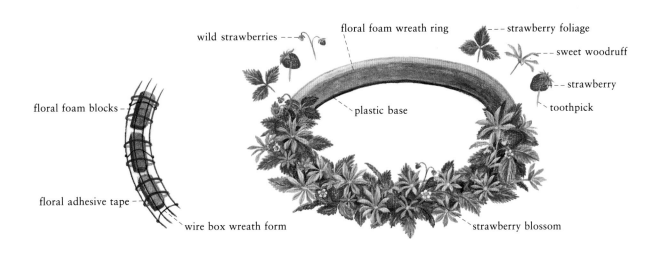

wild strawberries

floral foam wreath ring

strawberry foliage

sweet woodruff

strawberry

toothpick

floral foam blocks

plastic base

floral adhesive tape

wire box wreath form

strawberry blossom

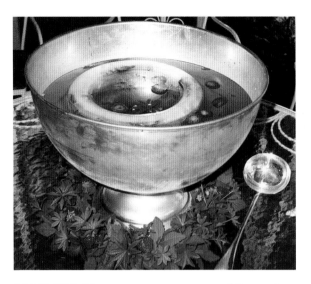

MAY WINE *32 servings*

8 pieces of woodruff, young growth
1 gallon Rhine wine or other medium dry
 German white wine
1 cup strawberries, sliced
½ cup sugar
½ cup brandy (optional)
ice ring or block
strawberries, woodruff leaves, and violets

Heat the woodruff pieces in a 350°F. oven until they are almost dry. Crush the pieces slightly and place them in the bottle of wine. Recork the wine and allow it to steep for several days. Place the sliced strawberries, sugar, and brandy in a punch bowl. Allow the sugar to dissolve. Stir gently. Strain the wine over the berries. Mix well. Place the ice ring or block in the bowl. Garnish with whole strawberries, woodruff leaves, and violets. Serve with a strawberry in each glass.

A round of Brie decorated with Johnny-jump-ups, chervil, and dill and then glazed with gelatin is encircled by a thyme wreath and violets. Other cheeses are placed on scented geranium leaves or are ringed with herbs and other edible flowers.

ICE RING OR BLOCK

mold
strawberries with their leaves
mint sprigs
woodruff sprigs

Boil a kettle of water and allow the water to cool. Fill the bottom of a mold with the boiled water and freeze. Add strawberries with their leaves, mint sprigs, woodruff sprigs, and only enough water to come partway up the berries and sprigs. Freeze. Add a little more water, freeze, and repeat until the mold is filled.

GELATIN GLAZE FOR HERB- AND FLOWER-DECORATED CHEESES

cheeses in a variety of shapes and colors such
 as Brie, Camembert, L'Explorateur, Pont
 l'Evêque, gourmandise, and goat cheese
edible flowers and herbs such as violets, Johnny-
 jump-ups, dill, mint, and thyme
1 teaspoon unflavored gelatin
1 cup dry white wine

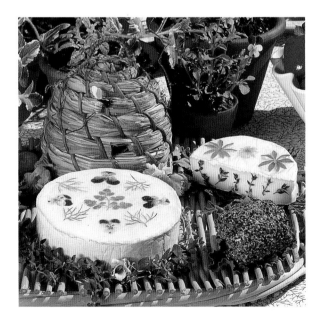

Pots of fragrant herbs are surrounded by decorated cheeses, a whipped cheese spread garnished under a wine glaze with sliced strawberries, minted melon balls, an herbed cheese ring, snow peas and sweet red pepper squares with herb cheese, and glistening glazed strawberries.

Place the cheeses on a cake rack over a tray. Rinse the flowers and herbs and very gently pat them dry. Dissolve the gelatin in the wine over low heat. Remove from the heat. Place the pan in a bowl of ice and water. Stir very slowly until the mixture thickens. Spoon the glaze over the cheeses. Refrigerate for 3 to 4 minutes. Carefully arrange the plant materials on the cheeses in different designs and color combinations. Refrigerate for 15 minutes. Remove and spoon more of the glaze over the plant materials. Return the cheeses to the refrigerator. Continue glazing and refrigerating the cheeses until the plant materials are well covered. Excess glaze that accumulates on the tray may be reused. When the glaze becomes too thick to use, reheat and repeat the above process.

WHIPPED CHEESE SPREAD

2 packages (8 ounces each) cream cheese, cubed
⅓ cup whipping cream
4 tablespoons confectioners' sugar

Process the cream cheese, whipping cream, and confectioners' sugar in a food processor. Add more cream if needed to make an easily spreadable mixture. Serve with fruit bread or sweet crackers.

HERBED CHEESE RING *10 servings*

1 cup milk
8 tablespoons butter, cubed
1 cup flour
4 eggs, at room temperature
1 cup Gruyère cheese, coarsely grated
3 ounces pepperoni or smoked sausage, minced
1 tablespoon fresh parsley, minced
1 tablespoon fresh thyme, minced
1 tablespoon fresh chives, minced
⅛ teaspoon cayenne or to taste
1 egg white, beaten

Preheat the oven to 400°F. Grease and flour a baking sheet. Combine the milk and butter in a heavy saucepan and bring to a boil. Add all the flour, reduce the heat to simmer, and stir quickly until the mixture is smooth and pulls away from the sides of the pan. Remove from the heat and cool for 5 minutes. Beat in the eggs, 1 at a time, with a wooden spoon until incorporated. Stir in the cheese, sausage, herbs, and cayenne. Spoon the mixture onto the baking sheet in a 10-inch circle. Brush the top of the ring with the egg white. Bake for 10 minutes at 400°F., reduce the heat to 350°F. and bake an additional 30 minutes. Turn off the oven and leave the ring in the oven for 10 minutes. Serve hot or at room temperature.

A Spring Wedding
in Williamsburg

The abundance of springtime flowers and foliage in Williamsburg inspires the decorations called for by that most special of occasions—a wedding. Many brides dream of a wedding in a historic setting like eighteenth-century Bruton Parish Church and a reception in a garden filled with the nostalgic fragrances of boxwood and old roses. Following are suggestions for using spring's bounty of beautiful flowers, fresh herbs, and verdant foliage to celebrate the joyous events associated with the ritual of marriage.

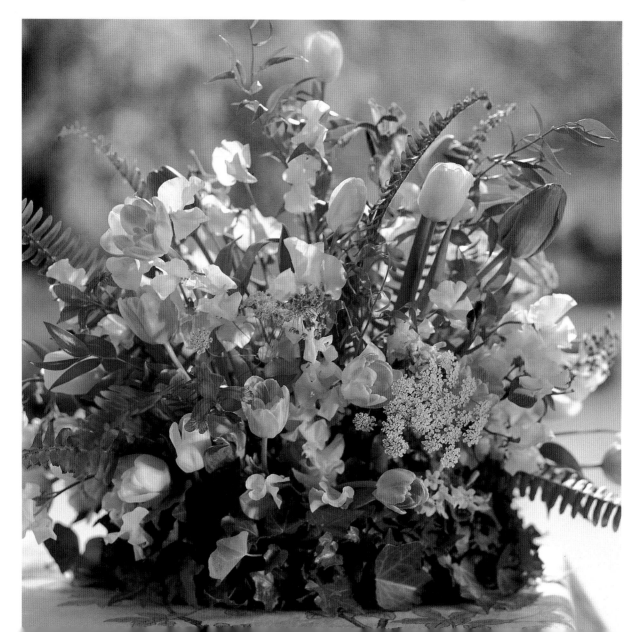

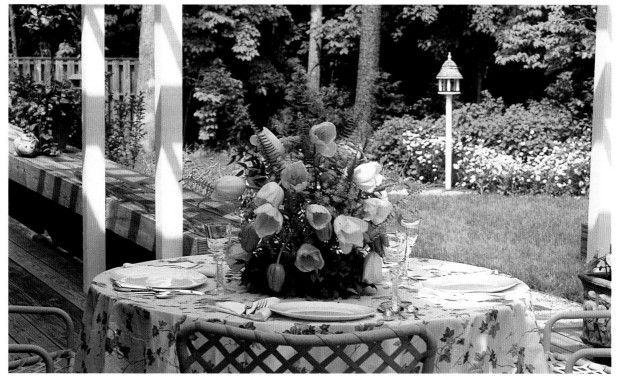

Luncheon is served on a spacious deck overlooking a garden filled with iris and daisies.

A Bridal Luncheon

A luncheon for the bride and her attendants that features a profusion of flowers and topiaries and a delicious light meal sets the scene for the wedding festivities to follow. The menu includes shrimp, tiny spears of marinated asparagus, a salad of smoked chicken, mushrooms, and mixed greens, and lemon cloud garnished with fresh strawberries and mint leaves.

Opposite: Ivy tendrils inserted into a wet floral foam wreath surround a glorious collection of spring flowers—tulips, iris, Queen Anne's lace, sweet peas, ferns, and Alexandrian laurel. The flowers are arranged in a separate container.

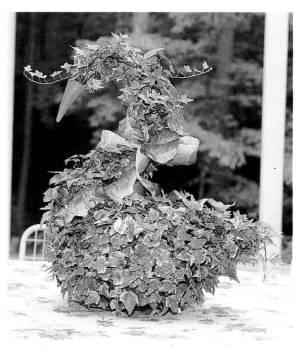

A beribboned topiary swan of variegated ivy (see page 5) rests on an imaginary nest.

How to Make a Lavender Basket

Supplies and materials needed: approximately 15 (or more, use an uneven number) freshly cut lavender stems, each about 12 inches long, medium gray-green thread, ⅙-inch or ⅛-inch ribbon or raffia 1½ to 2 yards long, and scissors.

A small woven lavender basket awaits each guest.

This little basket should be made soon after the lavender is picked to ensure that the stems will be pliable and less apt to break. Place the lavender stems in water until they are used. Choose spikes with long stems with only the lower flowers opened. Remove any leaves or flowers below the main blooms.

Group the stems so that the center bloom is a little higher, as might be done in a flower

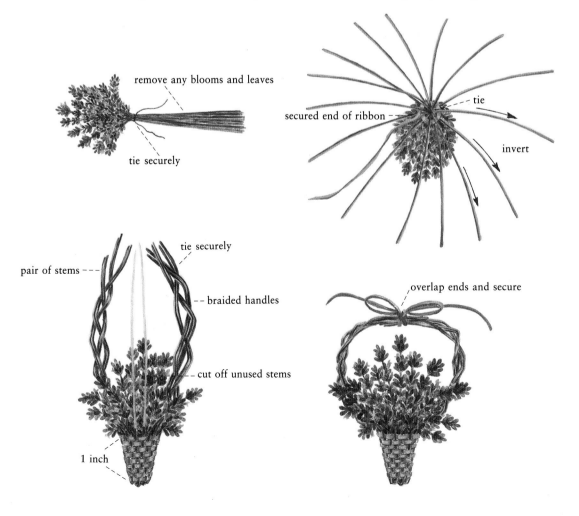

arrangement. Tie the stems securely with a doubled thread just below the flowers.

Turn the bundle upside down and very carefully bend the stems over the blooms. The bent stems should be evenly spaced around the flowers. If a stem breaks, save it and include it when you start weaving.

Wedge 1 end of the ribbon or raffia into the lower flowers close to the tied base. Working carefully, weave the ribbon or raffia under and over the stems. If a stem breaks, gently reinsert it so there will be the necessary uneven number of stems. During weaving, pull the ribbon taut to keep the weaving compact and even. After weaving about 1 inch, cut the ribbon, leaving enough of an end to push down into the blooms so it will not pull out.

To make the handle, use 6 adjacent stems in pairs on each side and braid them to the end. Tie securely with the thread. There will be some unused stems in the front and back that may be cut off about ¼ to ⅓ inch above the last row of weaving. Bend the 2 braided pieces into a pleasing arc, overlap the ends, and tie the ends securely with the thread as shown. Trim the ends at an angle.

The remaining ribbon or raffia may be used to make a bow. A few more lavender blossoms, feverfew, or other small flowers that dry well may be tucked in.

Hang the basket by its handle or by a thread hanger. It can be saved and used as a charming tree ornament at Christmas.

LEMON CLOUD *8 servings*

1 envelope unflavored gelatin
¾ cup sugar
¼ teaspoon salt
½ cup lemon juice
rind of 2 lemons, grated
4 egg yolks
6 egg whites
¼ teaspoon cream of tartar
3 tablespoons confectioners' sugar
strawberries
mint leaves

Soften the gelatin in ¼ cup of cold water for 5 minutes and set aside. Combine the sugar, salt, lemon juice, lemon rind, and egg yolks in the top of a double boiler. Cook over hot water, stirring constantly, until the mixture has thickened and is the consistency of a thin custard sauce. Remove from the heat and mix in the softened gelatin, stirring until the gelatin is dissolved. Cool to room temperature. Beat the egg whites until foamy, add the cream of tartar, and continue beating until stiff peaks are formed. Sprinkle in the confectioners' sugar and beat until thick peaks are formed. Fold into the lemon mixture. Spoon into individual serving dishes. Chill well before serving. Garnish with strawberries and mint leaves.

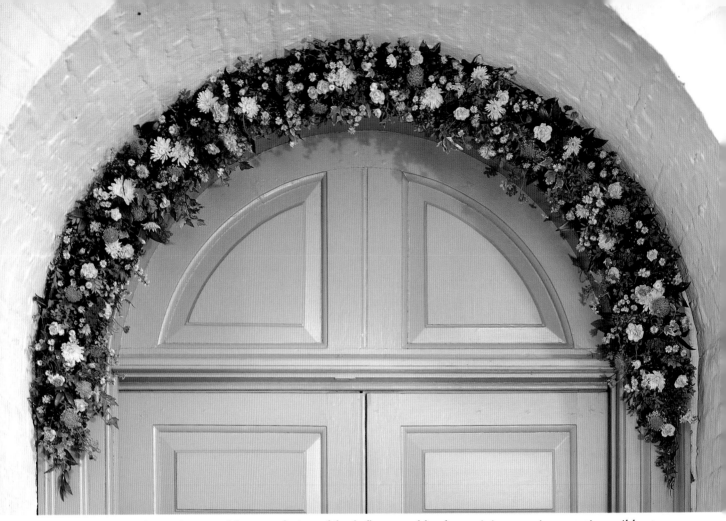

A joyous welcome is created by a profusion of fresh flowers—blue lace, pixie carnations, statice, wild asters, fairy roses, and chrysanthemums—on a bed of Alexandrian laurel and boxwood.

AT THE CHURCH

The bridal party enters the sanctuary of historic Bruton Parish Church under an archway outlined with fresh flowers. This floral arch can be adapted for use over the entrances of most traditional churches or may be used informally in any other arched location. Fresh flowers have also been used to create lovely pew-end plaques for the sanctuary.

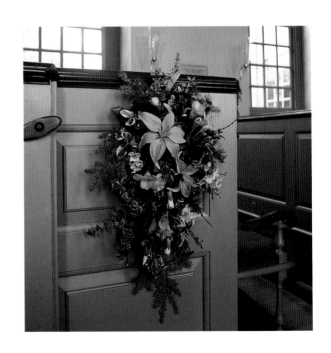

How to Make an Arch of Fresh Flowers and Greens

Supplies and materials needed: tape measure, green florist wire mesh netting (12 inches wide sold in rolls with bound edges) or chicken wire, wire cutters, 2 blocks of floral foam, floral preservative, knife, thin plastic such as a dry cleaner's plastic clothes bag, scissors, #16 and #24 gauge green floral wire, 9 eye hooks, and conditioned plant materials (see page 152).

To make the wire form, measure the archway and determine the total length of the arch you wish to make. The finished arch shown is 115 inches long and 9 inches wide. Deduct 10 inches (5 inches for each side) from the total length since the plant materials will extend beyond the ends of the form to create a pleasing taper. Therefore, cut a piece of wire mesh netting or chicken wire 105 inches long to make this form. It is advisable to use 12-inch-wide florist wire mesh netting and overlap the wire a little more because its finished edges make the wire netting easier to handle. Cut chicken wire is very sharp.

Soak the blocks of floral foam in water to which floral preservative has been added. Cut each whole block into 8 4½-inch x 2-inch x 1½-inch pieces as shown. You will need 15 small blocks to make the form shown.

If possible, work on a large flat surface that will hold the whole form. Place the wire on the surface. Cut long 10-inch-wide pieces of very thin plastic. Do not use plastic food wrap because it cannot be punctured easily. Lay the strips of plastic along the wire and overlap them until the form is covered. Center the 15 blocks of wet floral foam along the length of the form. Leave 2½ inches between each block. Fold the plastic over the blocks of floral foam and secure it in the center of each block with a 3-inch-long piece of #24 gauge green floral wire bent into a hairpin shape. Small hairpins can be used, but fern pins are too long. Gather the plastic ends and secure with floral wire. The plastic will help keep the floral foam moist and thus the flowers fresh longer.

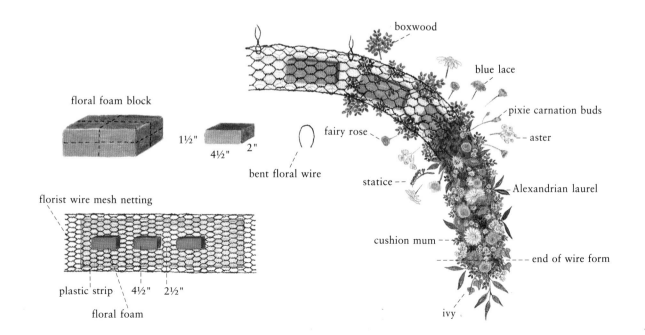

floral foam block

1½"

4½" 2"

bent floral wire

florist wire mesh netting

plastic strip 4½" 2½"

floral foam

boxwood

blue lace

pixie carnation buds

fairy rose

aster

statice

Alexandrian laurel

cushion mum

end of wire form

ivy

Bend the wire mesh over the floral foam and secure it every 6 inches with a 3-inch piece of #24 gauge wire threaded through the 2 layers of wire mesh. Twist the ends of the wires together tightly and bend them down into the floral foam. Carefully shape the form into the desired curve.

To hang the form, screw 9 eye hooks, evenly spaced, into the outer edge of the molding of the archway. Thread 9 8-inch pieces of #16 gauge floral wire through the back of the form to correspond with the position of the eye hooks and fasten securely.

Insert 4-inch pieces of boxwood and Alexandrian laurel to cover the form. Add flowers, distributing the types and colors evenly throughout the design. Vary the length of the stems from 4 to 6 inches. Finally, add longer pieces of Alexandrian laurel, ivy, or other delicate plant materials to give depth and airiness to the design and to create a graceful effect. Add long pieces at the ends for an attractive taper.

NOTE: Any suitable green plant materials that grow in abundance in your area can be conditioned and used as a background.

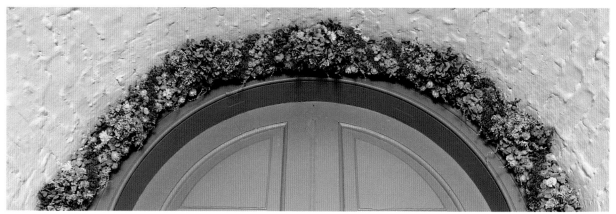

A dried arch of hydrangeas, eucalyptus, artemisia, strawflowers, celosia, larkspur, blue salvia, and globe amaranth with pink yarrow arranged to give the illusion of a twisted ribbon is elegant and understated.

How to Make an Arch of Dried Materials

Determine the length of the form required. Cut the wire mesh netting as described and place dry blocks of floral foam, cut in the same manner, on a bed of Spanish moss or long-fiber sphagnum moss. Place additional moss on top of the blocks, wrap the wire mesh around the moss and blocks of floral foam, and secure it with short pieces of #24 gauge wire. It is important to pre-fit the form to the space you have selected. Screw eye hooks, evenly spaced, into the outer edge of the molding of the archway. Bend the form to fit the archway. Thread 8-inch pieces of #16 gauge floral wire through the form to correspond to the position of the eye hooks. Remove the form to your work area. Insert the dried floral materials, distributing the colors, forms, and textures evenly or to form patterns as shown. Add longer pieces to give depth and airiness to the design. Carefully attach the finished dried arrangement to the archway. Bring additional dried materials to fill in as needed.

How to Make a Plaque of Fresh Materials

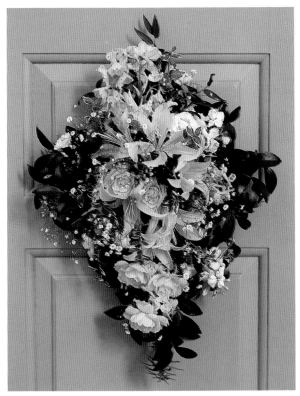

A pew-end plaque features yellow lilies, soft yellow roses, white stock, delphinium, baby's breath, and pixie carnations interspersed with Alexandrian laurel and variegated ivy.

Supplies and materials needed: plastic floral foam cage (available at floral supply or craft outlets), floral preservative, clippers, #16 gauge green floral wire, wire cutters, eye hook, and conditioned plant materials (see page 152).

Most hanging arrangements using fresh plant materials need to be kept moist. Plastic floral foam cages are convenient containers to use because they will extend the life of the plant materials. They are available in a variety of shapes and sizes. Soak them in water to which floral preservative has been added before you make the plaque.

Determine the outside silhouette by inserting the background foliage first. Add the most prominent flowers, then fill in with the other flowers and foliage, being careful to place the plant materials at different heights and facing in different directions to achieve a graceful effect.

Attach the #16 gauge floral wire securely to the holder. Secure the wire to the surface with an eye hook.

NOTE: It is advisable to make the finished arrangement and then hang it temporarily where the excess water can drip and not cause damage before it is installed in the church.

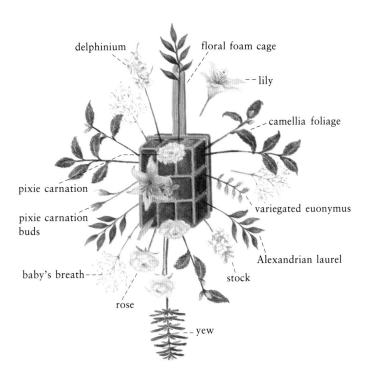

FLOWERS FOR THE BRIDAL PARTY

S pring flowers for the bridal party are available in a wide variety of colors and textures and may be arranged in many ways. Lush and tender spring greens can be blended with tulips, blue lace, iris, freesias, pansies, forget-me-nots, and sweet peas. Bridesmaids might wear fresh flowers in their hair or select flattering straw hats, inspired by eighteenth-century prototypes in Colonial Williamsburg's collection, and encircle the crowns with fresh flowers. Angelic flower girls, their heads wreathed with dainty blooms, might carry tiny tussie-mussies or flower baskets.

Bouquets for the bride and her attendants usually take one of three forms: a cascade, a sheaf of flowers or presentation bouquet, or a round nosegay or tussie-mussie.

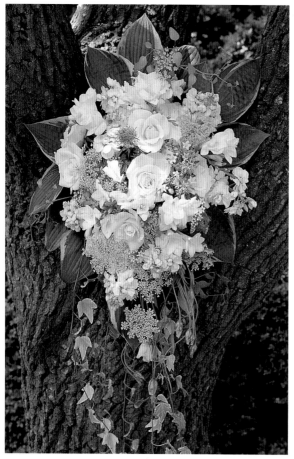

An elegant cascade is always appropriate for a formal wedding. Here the softly blending colors of cream roses, soft white freesias, pale yellow and white stock, abelia, gooseneck loosestrife, cream double lisianthus, and Queen Anne's lace are framed with variegated "Francee" hosta leaves. Trails of variegated ivy and wild clematis tendrils extend the graceful line of the bouquet.

How to Make a Bridal Cascade

Supplies and materials needed: large plastic floral bouquet holder with handle (approximately 3½ inches across with a 4-inch-long handle) fitted with floral foam, floral preservative, clippers, ribbon (optional), and conditioned plant materials (see page 152).

A time-honored and always lovely type of wedding bouquet is shown here. It combines traditional bridal flowers—roses, freesias, and stock—with other, more unusual, blooms and plant materials such as abelia, gooseneck loosestrife, double lisianthus, Queen Anne's lace, variegated "Francee" hosta leaves, ivy, and wild clematis foliage. Always select flowers and greens that offer an interesting variety of textures, shapes, sizes, and colors.

Soak the holder containing floral foam in water to which floral preservative has been added until the foam is well saturated.

Starting with a row of hosta leaves with the largest leaf at the center bottom, insert the ends into the outer area on the sides of the holder as shown. The leaves should protrude

approximately 6 inches to serve as the background for the bouquet. Add the roses, placing them at various angles and being careful to arrange them randomly. Add pale yellow and white stock next, distributing the colors and angles in a pleasing fashion. Fill in any spaces with the smaller flowers. Long-stemmed double lisianthus flowers are used as accents. Lisianthus buds at the base extend the vertical line of the arrangement. Place these flowers and the Queen Anne's lace at different heights and facing in different directions to give a graceful effect. Protruding freesia and wild clematis vines provide added dimension. Ivy tendrils added to the lower third of the bouquet lend an elegant line to the cascade when it is held by the bride. Attach ribbon streamers or loops to wires and insert the wires into the floral foam. The ribbons will follow the lines of the ivy and other trailing materials.

NOTE: Dried or silk materials can be used in a bridal cascade. Special holders are made for dried materials.

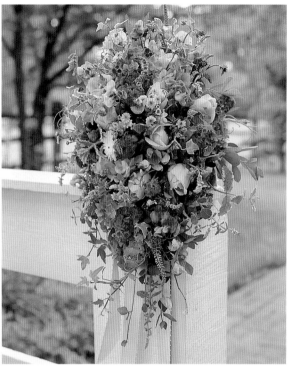

This cascade in shades of pink and purple with accents of white feverfew and variegated pineapple mint and ivy could be carried by a bridesmaid or a bride as an alternative to a traditional bouquet.

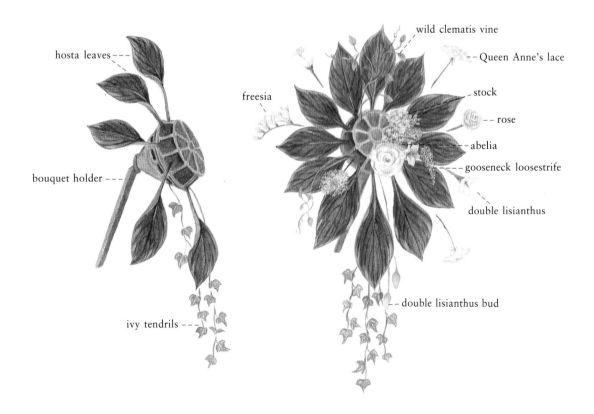

Yellow lilies, white delphinium, pixie carnations, and baby's breath are gathered together in a simple sheaf secured with a bow of satin picot ribbon. Note the placement of the lilies. They are the largest and most dramatic flowers and show to best advantage in the center of the bouquet.

How to Make a Presentation Bouquet

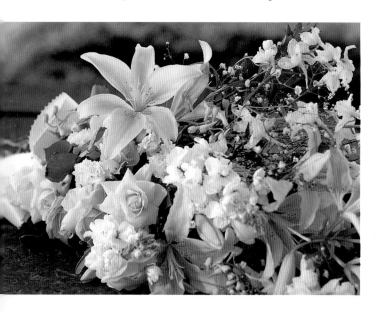

Supplies and materials needed: chenille wire, clippers, ribbon, and conditioned plant materials (see page 152).

An interesting combination of flowers tied together with a beautiful ribbon makes a simple yet elegant bouquet for the bride or bridesmaid.

Group the flowers so that the most dramatic blooms are dominant. Group the other flowers (usually the smaller ones) to the sides and above, add foliage, and secure the stems with a chenille wire. Cover the chenille wire with the ribbon.

How to Make a Tussie-Mussie

Supplies and materials needed: lace-edged tussie-mussie holder, plastic twist ties or chenille wire, lace or paper doily (optional), clippers, green floral tape, ribbons, and conditioned plant materials (see page 152).

The nosegay, or tussie-mussie, is popular in Williamsburg for weddings and for many other occasions. In colonial days ladies carried tussie-mussies to repel offensive odors or placed them on tables to help freshen a room. A tussie-mussie makes a charming remembrance for a friend, and many can be saved and dried. Tussie-mussies can also serve in place of a more traditional table arrangement. This delightful form can be made with fresh or dried materials, may be large or small, and may be formal or informal.

Select a small flower for the center. Surround the center flower with a row of flowers or foliage. Continue to add flowers and foliage around the center, keeping the shape sym-

Sweetly scented mints, rosemary, feverfew, silver artemisia, pale pink celosia, tiny white wild asters, rue, phlox, lavender, and other wildflowers and herbs are ringed with a border of soft lamb's-ears.

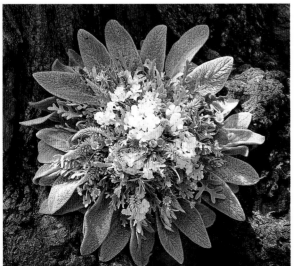

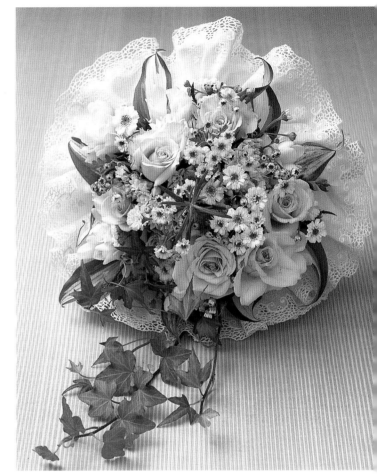

A beautiful tussie-mussie for the bride is bordered with old family lace. Pale pink Lady Diana and creamy Bridal White roses, white freesias, bouvardia, feverfew, and rosemary are outlined with variegated hosta leaves and trails of ivy.

metrical and the colors evenly distributed. Keep the larger blooms low and allow the more delicate flowers to extend out to give depth and airiness. Continue to add flowers and foliage until the tussie-mussie is the desired size. Use the largest leaves as a frame around the outside and add the ivy to trail down when held. Secure the whole bouquet

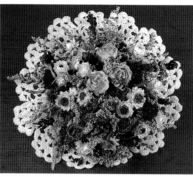
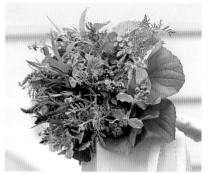

Left: A fragrant tussie-mussie in a paper Biedermeier includes feverfew, roses, hydrangeas, blue salvia, pineapple mint, ageratum, ivy, veronica, lavender, and rosemary surrounded with violet leaves. *Center:* A dried version of a tussie-mussie is a pleasant reminder of the special occasion for which it was created. *Right:* A delicate little nosegay of fresh spring herbs is outlined with violet leaves and tied with pink ribbons. Pansy blooms, Roman wormwood, rosemary, lemon verbena, lavender, wild bergamot, and pineapple mint accent the nosegay.

just below the flowers with a plastic twist tie or chenille wire.

If a tussie-mussie holder or paper doily is used, or if you are using a collar of lace gathered into a small circle, insert the stems down through the center and position the holder over the tie. A commercial plastic nosegay holder with lace will support a collar of fabric or special lace. Recut the stems with a taper at the ends. If the bouquet will be carried, wrap the stems with green floral tape and then with ribbon. If not, leave the stems unwrapped and place the arrangement in water. Attach ribbon streamers or loops to a wire and insert the wire into the bouquet at the base of the doily. Allow the streamers to hang down.

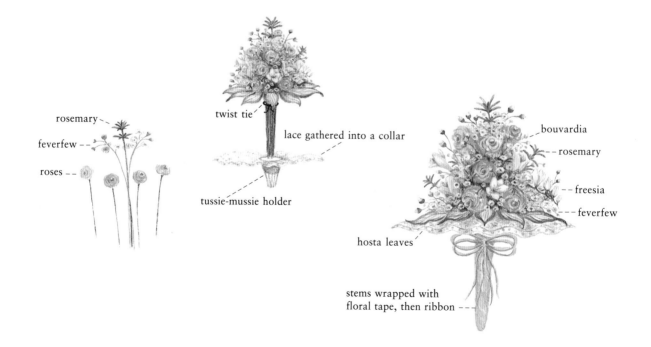

rosemary

feverfew

roses

twist tie

lace gathered into a collar

tussie-mussie holder

bouvardia

rosemary

freesia

feverfew

hosta leaves

stems wrapped with floral tape, then ribbon

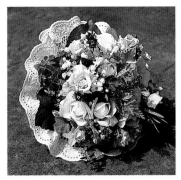 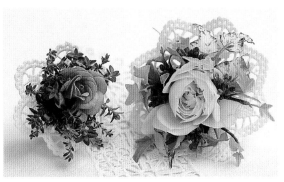 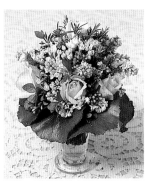

Left: Encircled by a pretty cotton lace collar, pale pink and cream roses, lavender and phlox blooms, a variety of herbs, variegated ivy, boxwood, and violet leaves form a delicate nosegay. *Center:* Two tiny paper Biedermeiers suitable for very young flower girls hold petite bunches of flowers and herbs. On the left, a single rose is encircled with thyme. On the right, a rose is ringed with lavender and ivy. *Right:* Used as a small bouquet to flank an arrangement on a dining room table, a Bridal White rose is surrounded with rosemary, bouvardia, white lilac, plum foliage, a ring of Lady Diana roses, and galax leaves.

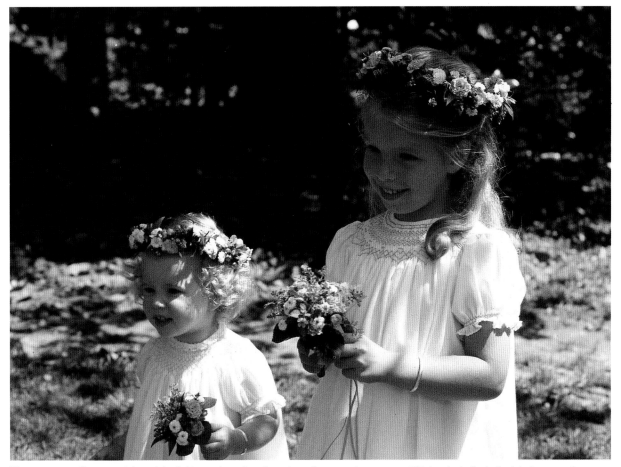

Two young flower girls with delicate bands of spring flowers (see page 40) in their hair hold tiny tussie-mussies as they excitedly await the bride's arrival.

How to Make Floral Bands for Hats and Hair

Supplies and materials needed: coat hanger wire or similar heavy wire, wire cutters, needle nose pliers, green floral tape, #28 gauge spool wire, clippers, ribbon (optional), and conditioned plant materials (see page 152).

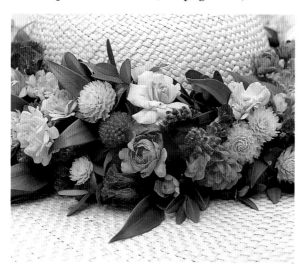

Petite fairy roses, globe amaranth, blue salvia, and Alexandrian laurel encircle this eighteenth-century-style oatmeal straw hat. The floral band may also be worn in the hair. It can even be enjoyed later placed around a small punch bowl to decorate a table.

A garden wedding is the perfect occasion for flower-garlanded straw hats or wreaths of flowers for the bride and her attendants.

Bend a piece of heavy wire into a circle or oval so that it will fit loosely around the brim of the hat or the head of the wearer. Cut the wire, allowing extra wire for a loop at each end, and interlock the 2 loops as shown. Wrap the wire with green floral tape. Select flowers that will stay fresh out of water for several hours.

There are 2 ways to prepare the bunches before they are wired onto the frame.

(1) Wrap the stems of tiny bunches of fresh flowers and foliage about 2½ inches long with green floral tape. The floral tape will help the stems stay moist longer. Using a process similar to making a full-size wreath, attach the end of the spool wire to the wire frame. Leave the wire attached to the spool. Hold a bunch of flowers on the frame and wrap the spool wire around the ends and the frame several times. Hold another bunch of flowers to cover the wired ends of the previous bunch and attach this bunch by wrapping the spool wire around the ends and frame several times. Con-

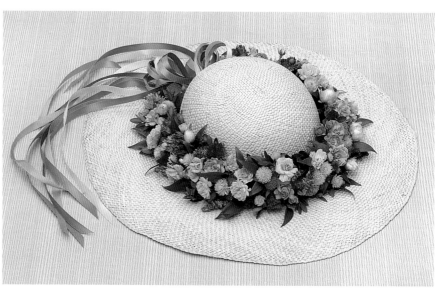

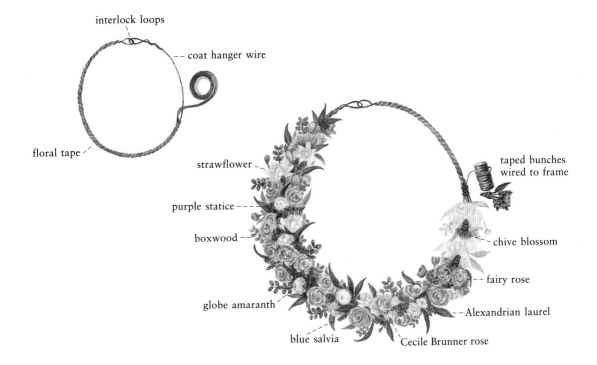

interlock loops

coat hanger wire

floral tape

strawflower

purple statice

boxwood

globe amaranth

blue salvia

Cecile Brunner rose

taped bunches wired to frame

chive blossom

fairy rose

Alexandrian laurel

tinue to wire the bunches to the frame until it is completely covered. The last bunch should be wired underneath the blooms of the first bunch. Cut the spool wire and wrap the end securely around the frame. Be sure to keep the size of the bunches and the distance between them uniform. Mist the band, put it in a plastic bag, and keep it in the refrigerator until needed. The band may be made the day before the wedding.

(2) For very fragile flowers, the floral bunches can be made the day before the wedding. Wire the small bunches of flowers and foliage. Place the bunches in a shallow container of water, mist, and keep them covered with plastic in the refrigerator. When you are ready to attach the bunches to the wire frame, blot the stems and secure to the frame with green floral tape.

Place the flower band over the crown of the hat and attach it to the front and back with a small piece of spool wire. Attach ribbon streamers to the wire loops if desired.

A small nosegay of fresh flowers and foliage—goldenrod, chrysanthemums, miniature roses, and Alexandrian laurel—is secured to the back of a fine Milan straw hat.

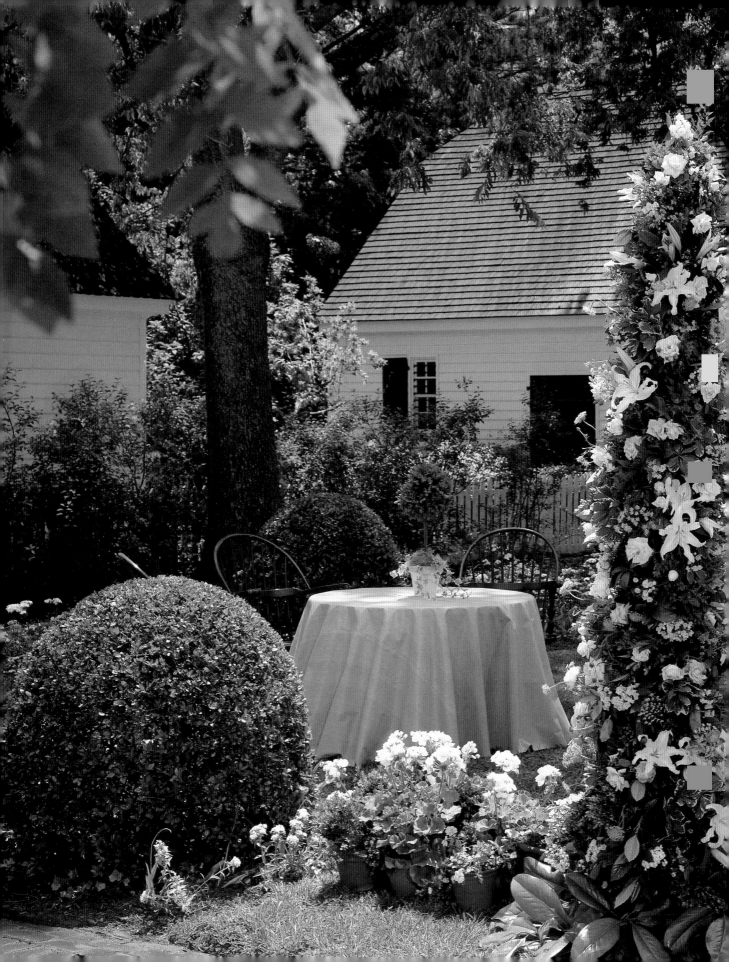

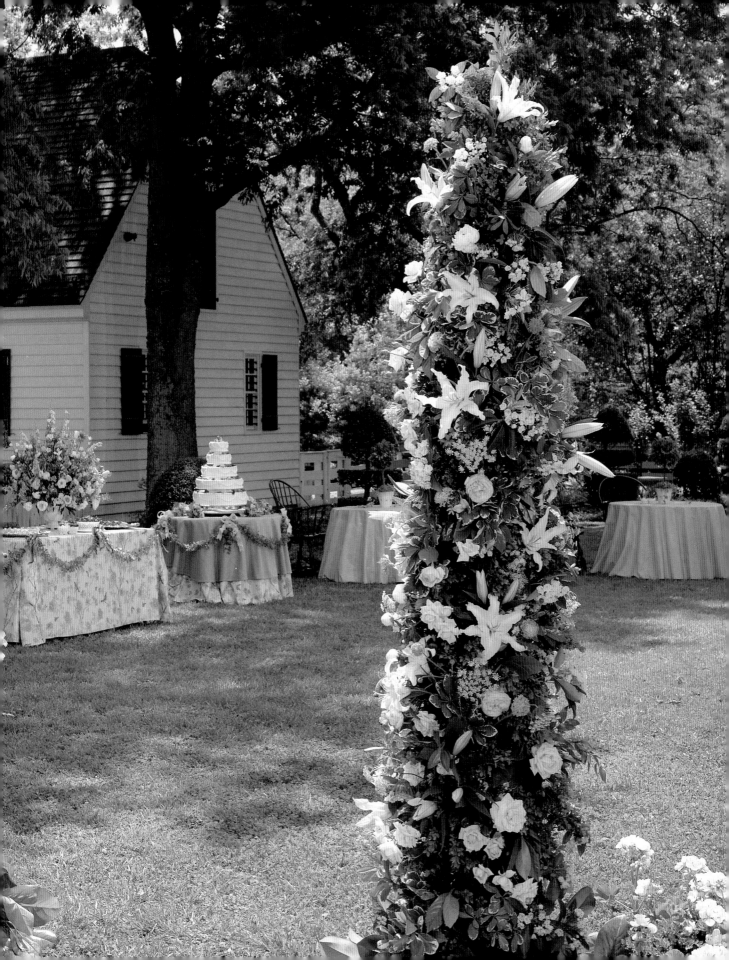

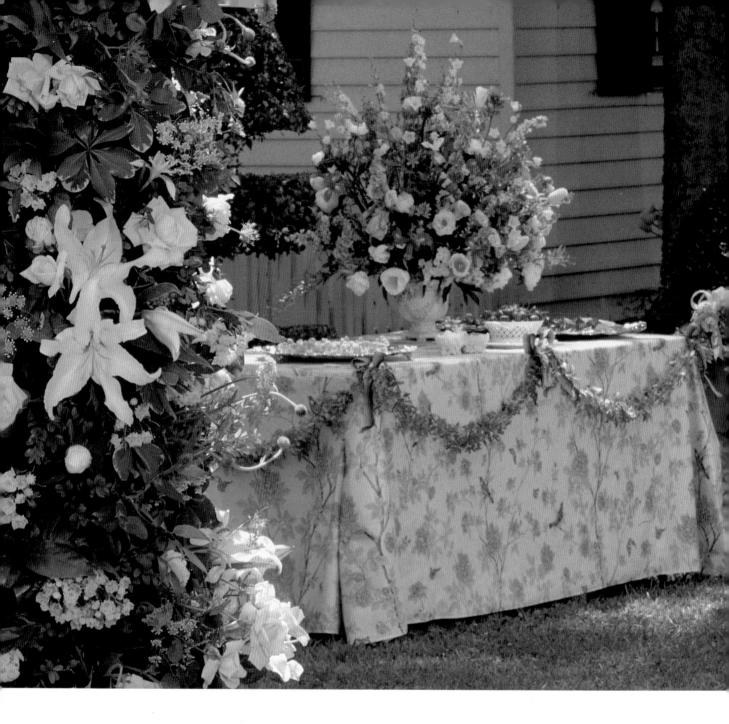

A Garden Reception

At the reception following the ceremony, the wedding party and their guests enjoy the glorious spring setting in the Chiswell-Bucktrout House garden. Spectacular floral trees form a welcoming entrance into this lovely garden area and set the stage for a magnificent wedding cake, sumptuous foods, and a profusion of beautiful flowers. Strolling musicians playing eighteenth-century airs complete this idyllic scene.

44

This garland echoes the design painted on the clay garden pots on the guest tables.

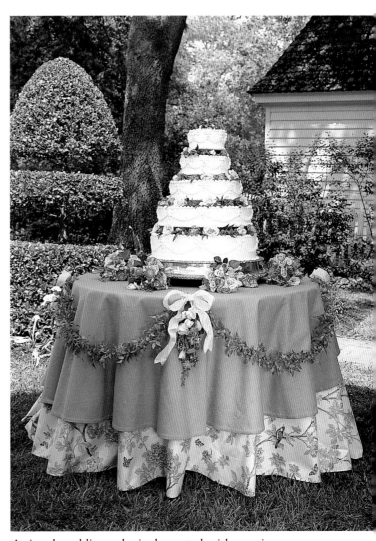

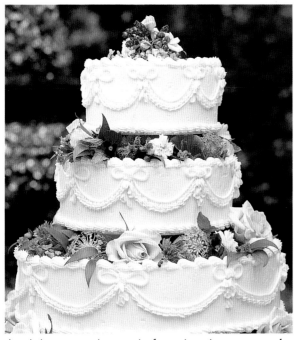

A miniature tussie-mussie featuring tiny roses and rosebuds is inserted into the top of the cake.

A tiered wedding cake is decorated with pansies, forget-me-nots, roses, blue lace, chive blossoms, Johnny-jump-ups, feverfew, and other flowering herbs. Alexandrian laurel and other bits of greenery are placed on the icing, stems between the layers. The tussie-mussies (see page 37) carried by the bridesmaids now surround the cake. The table, covered with Chinese peony fabric and overlaid with leaf-green dobby weave, is garlanded with long strands of smilax caught up with bows of wired ribbons holding small bouquets similar to the flowers on the cake.

How to Make a Floral Tree

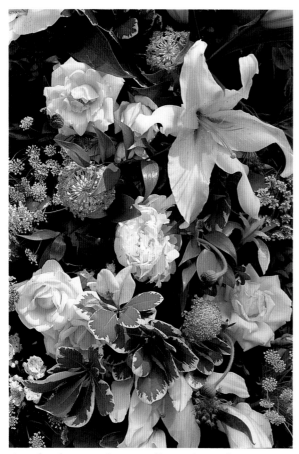

Aucuba, boxwood, magnolia, variegated pittosporum, and Alexandrian laurel form an interesting and varied background for the dramatic lilies, peonies, roses, iris, and delicate blue lace, mountain laurel, and Queen Anne's lace.

Supplies and materials needed (based on the 10-foot tree shown): piece of wood 2 inches wide x 2 inches thick x 8 feet long (preferably clear fir), plywood board ½ inch thick x 18 inches square, with the corners removed, 4 4-inch angle irons with screws, screwdriver, 9-foot piece of green florist wire mesh netting (12 inches wide sold in rolls with bound edges) or chicken wire 9 feet long x 12 inches wide, wire cutters, staple gun and staples, dark green spray paint, heavy wire, eye hooks, 12 tent pegs with side tabs, hammer, 4 cinder blocks, 8 blocks of floral foam, floral preservative, knife, 16 lightweight 1-gallon plastic bags, green floral adhesive tape, clippers, and conditioned plant materials (see page 152).

Floral trees can be made in any height, in pairs, rows, or singly, and with fresh or dried materials. They can contain a wide variety of flowers, foliage, berries, pods, and cones. Some can be formal if made mostly with florists' flowers. Less formal ones can be made using garden flowers, wildflowers, and local greenery. Floral trees made of a variety of greens, berries, and cones are lovely at Christmas. Magnolia, variegated hollies, pines, and hemlock accented with holly and nandina berries would make a festive tree.

To construct the form, attach the 2 x 2 x 8 piece of wood to the plywood base with the angle irons as shown. Wrap the piece of wood loosely with the wire mesh netting or chicken wire, crumpling the excess wire at the top as shown. Staple the wire to the form in 4 or 5 places. It is important to wrap the wire loosely so that greens which do not need to be in water can be inserted into the spaces between the wire and the wooden form. Spray the form and base with dark green paint.

If the floral tree will be used indoors, wire it securely toward the top and bottom to the wall behind the form. If the floral tree is used outdoors, drive 12 tent pegs with side tabs into the ground to secure the edges of the base as shown before adding the plant materials. The finished floral tree will be heavy and could easily be blown down. It is advisable to use all possible means to secure it. Weight the base

down with the 4 cinder blocks. Because of its height and weight, this floral tree must be constructed in place.

Soak the blocks of floral foam in water to which floral preservative has been added. Cut the blocks of floral foam in half lengthwise to form 16 half-blocks 9 inches x 3 inches x 2 inches. Wrap each block of floral foam in a lightweight 1-gallon plastic bag. Secure each wrapped block of floral foam, with the 9 x 3-inch side facing outward, to the form with 3 strips of green floral adhesive tape per block as shown. Stagger the blocks on the form.

Insert pieces of plant materials such as magnolia and boxwood that can remain out of water into the wire mesh areas. Insert the pittosporum and Alexandrian laurel into the foam, then add the flowers. Remember to observe the tree from all sides, distributing similar plant materials evenly throughout, keeping the base wider than the upper part of the tree, and forming a pleasing taper at the top. Add large branches of magnolia and other foliage at the bottom to conceal the cinder blocks and to give sufficient width and visual weight to the tree.

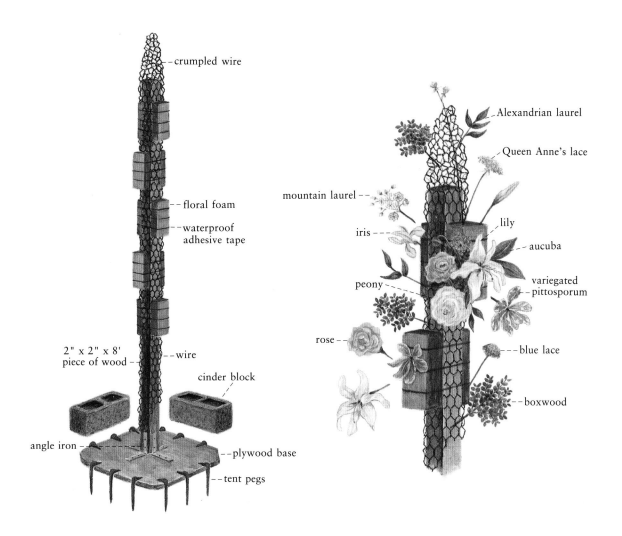

How to Make a "Faux" Topiary

Supplies and materials needed: plastic pot, masking tape, stick or branch approximately 15 inches long, knife, plaster of paris, implement to stir the plaster of paris mixture, ⅓ block of floral foam, floral preservative, clippers, #20 gauge green floral wire, wire cutters, ornamental pot, gravel, Spanish moss, and conditioned plant materials (see page 152).

"Faux" topiaries can be made in any size and in a variety of shapes and plant materials. Dowels, straight pieces of branches, twisted branches, heavily twisted vines, and smooth, rough, dark, or light barks are all possibilities for the trunk. The example is approximately 20 inches tall.

Select a plastic pot that will fit inside the ornamental outside pot. Tape over the drainage holes with masking tape. Pour enough plaster of paris into the plastic pot to come at least ¾ of the way up the container. Add some water and mix quickly with a strong stirring implement. If necessary, add more plaster of paris or water to make a thick but even mixture that fills most of the container. After the plaster of paris is well mixed, make a slight point on the top of the stick, insert it, push it to the bottom of the pot, and position it carefully. Check it from all sides to make sure it is vertical. In a few moments the mixture will be firm enough to hold the branch in place. Let the plaster of paris dry overnight.

Soak the floral foam in water to which floral preservative has been added. Impale the floral foam on the slightly pointed end of the stick and push it downward about 2½ inches. Insert the conditioned plant materials (3-inch

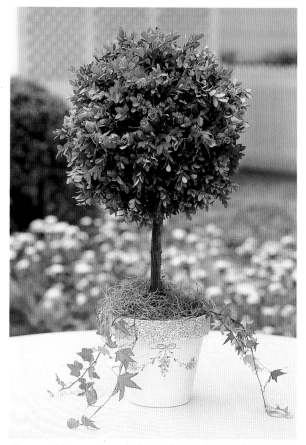

Guest tables scattered throughout the garden feature centerpieces of boxwood "faux" topiaries with garlands of tiny pink rosebuds in charmingly hand-painted clay garden pots.

sprigs of boxwood are shown in this example) to create a well-rounded shape on all sides. Be sure the floral foam is well covered with plant materials.

Make a small loop in 1 end of each piece of wire. Thread tiny rosebuds onto the wire. Shape the wire into an arc that is equal to ¼ of the circumference of the topiary. Cut off any excess wire, leaving enough wire to make a loop at the other end. Repeat for the other 3 wires. Cut 4 10-inch lengths of floral wire and make large U-shaped pins. Insert a pin through 2 adjacent loops of 2 swags and anchor the

pins in the center of the floral foam as shown. Be sure the swags are identical.

Carefully place the topiary in the ornamental pot and add gravel almost to the top. Cover with Spanish moss. Ivy tendrils may be inserted into the gravel to give a delicate look. Mist the plant materials to keep them fresh. Because the topiary form is in a smaller pot, the ornamental pot may be used for other functions after the wedding.

NOTE: Other types of trees may be created by inserting a small branch or a group of branches into a plaster of paris base. When making large, free-standing forms, cement is recommended instead of plaster of paris to give stability.

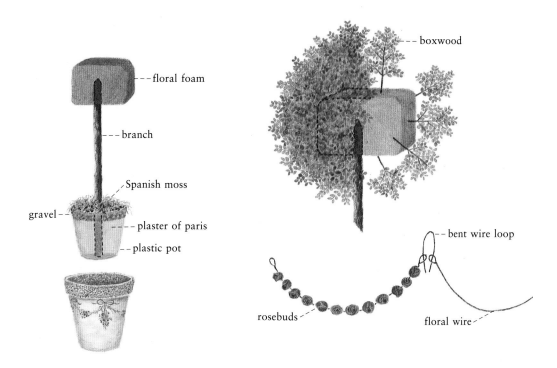

How to Decorate a Flower Pot

Supplies and materials needed: primer/sealer, brushes, clay flower pot, latex paint, acrylic paints, pencil, sponge, newspaper, satin finish polyurethane varnish, and brush cleaner.

Apply a coat of primer/sealer to the pot and allow it to dry. Apply 2 coats of latex paint, allowing the first to dry before the second is applied. Paint the design on the pot using acrylic paints. You may wish to trace the design in pencil before painting it. Lightly dip a natural sponge into 1 or more of the paints and gently blot it on newspaper to remove any excess paint. Gently tap the sponge on the rim of the pot to give a spackled effect. If you do not wish to paint a design on the pot by hand, a stencil can be used. When the pot is dry, add a coat of satin varnish.

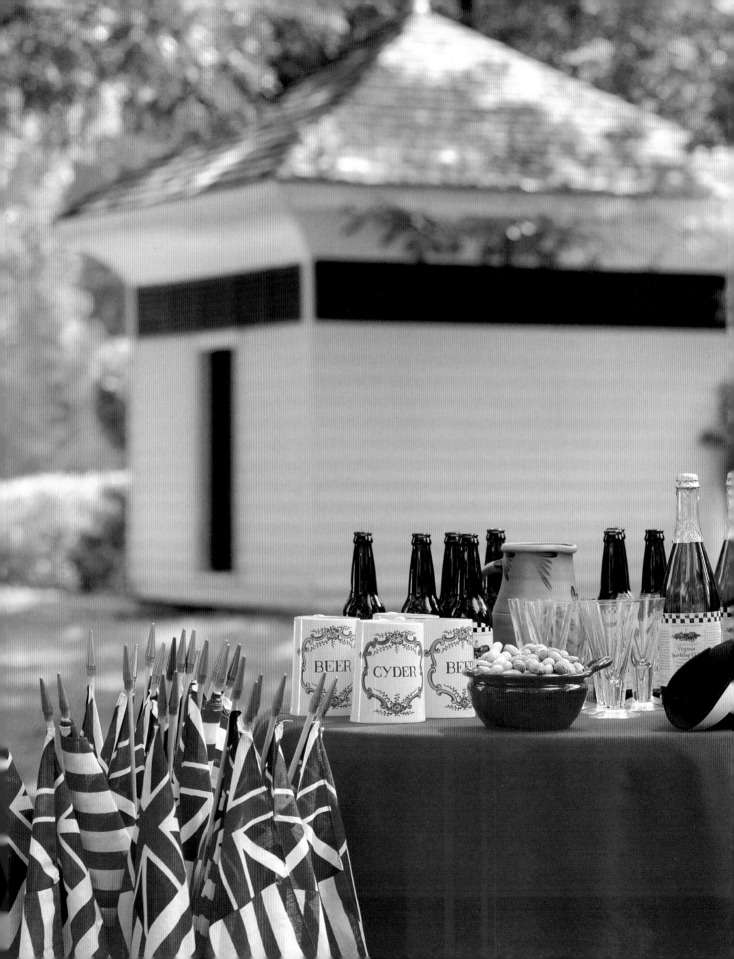

SUMMER

Summer is a busy time in Williamsburg. Militia musters, tradespeople plying their crafts, and actors presenting scenes from popular eighteenth-century plays are all part of the lively scene that comes to life each day. American independence began when, on May 15, 1776, the Virginia Convention meeting in Williamsburg instructed their delegates in Philadelphia to propose independence for the colonies. On the Fourth of July, the city celebrates the Declaration of Independence with a march down Duke of Gloucester Street by the Fife and Drum Corps and a spectacular fireworks display in the evening. Informal functions in the cool of a summer day—a picnic or perhaps a party featuring succulent fruit desserts—are a refreshing change of pace from the excitement of the Fourth of July.

Opposite: Icy cold root beer, cider, and iced tea are set out under tall shade trees for a Fourth of July picnic. *Above:* Sure to intrigue young guests, a miniature well house similar to ones throughout Colonial Williamsburg is decorated for the Fourth.

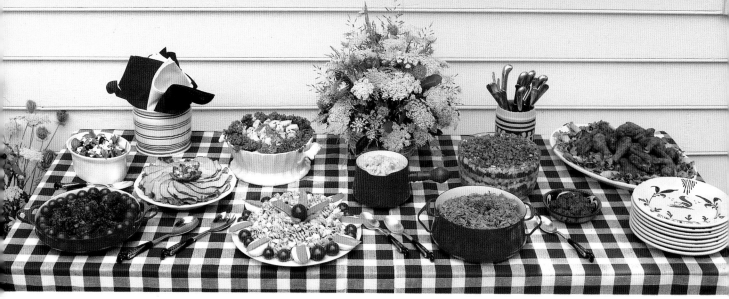

Salads of tomatoes and feta cheese, herbed potatoes, pasta and shrimp, and layered vegetables are among the dishes welcoming Fourth of July picnickers.

FOURTH OF JULY PICNIC AT BASSETT HALL

The pleasant gardens and grounds of Bassett Hall, for many years the Williamsburg home of Mr. and Mrs. John D. Rockefeller, Jr., are the setting for an Independence Day picnic *(overleaf)*. Red, white, and blue napkins, tablecloth, plates, and serving pieces sound a patriotic note. A handwoven split oak basket holds an arrangement of freshly picked Queen Anne's lace and wild grasses. Salads, barbecue from Chowning's Tavern, and fried chicken are perfect for an informal summer gathering. Garnishes enhance the food. Ham slices are accented with a half-tomato cut in a decorative pattern, filled with a mixture of diced red and yellow peppers, celery, and purple onion, and placed on a bed of parsley. Fresh dill heads and thyme flowers garnish alternating slices of mozzarella cheese and ripe tomatoes dressed with a wreath of olive oil and finely minced sun-dried tomatoes.

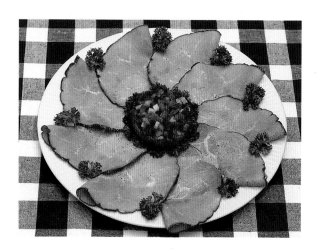

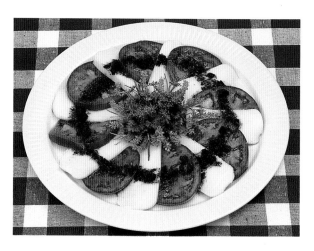

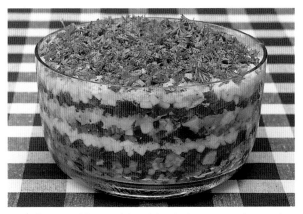

Diced vegetables and hard-boiled eggs are layered in a straight-sided glass bowl. A vinaigrette dressing and an occasional thin layer of fresh bread crumbs and herbs give a nice flavor. The salad is topped with bread crumbs, vinaigrette dressing, and minced parsley.

HERBED POTATO SALAD
10 to 12 servings

3 pounds small red potatoes
4 large sprigs of fresh rosemary
1 teaspoon salt
2 tablespoons shallots
1 clove garlic
2½ tablespoons herb or rice vinegar
1 tablespoon lemon juice
1 teaspoon Dijon mustard
8 tablespoons olive oil or walnut oil
¼ cup dry white wine
2 ribs of celery with leaves, minced
4 tablespoons fresh chives, minced
4 tablespoons fresh parsley, minced
1 tablespoon fresh thyme leaves, minced
salt and pepper

Cover the potatoes with cold salted water, add the rosemary, and bring to a boil. Boil the potatoes slowly for 10 to 15 minutes or until just tender. Drain. Discard the rosemary. Combine the salt, shallots, garlic, vinegar, lemon juice, and mustard in a food processor. Slowly add the olive oil and process until well combined. As soon as the potatoes are cool enough to handle, cut them into ¼-inch slices, leaving the skins on, and place the slices in a mixing bowl. Pour the wine over the warm potatoes. Add the celery, herbs, and dressing. Toss gently. Season to taste.

Strawberries and crab apples brighten a cheerful wreath of parsley (see page 23) made in a floral foam form. A large red delicious apple decorated with a circle of miniature flags holds a candle.

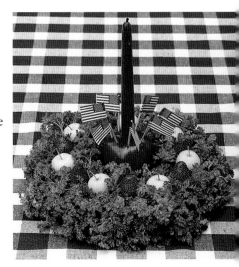

TOMATO AND FETA CHEESE SALAD
12 servings

1 clove garlic, halved
4 pounds Italian plum tomatoes
1 can (6 ounces) pitted ripe olives, halved
8 ounces feta cheese, crumbled
1 cup olive oil
5 tablespoons red wine vinegar
2 teaspoons oregano
2 teaspoons thyme
1 teaspoon freshly ground pepper
mint sprigs

Rub a shallow dish with the cut garlic. Cut the tomatoes into bite-size pieces and combine with the olives and feta cheese. Sprinkle with the olive oil, vinegar, and seasonings. Toss gently. Garnish with mint. Refrigerate overnight. Serve at room temperature.

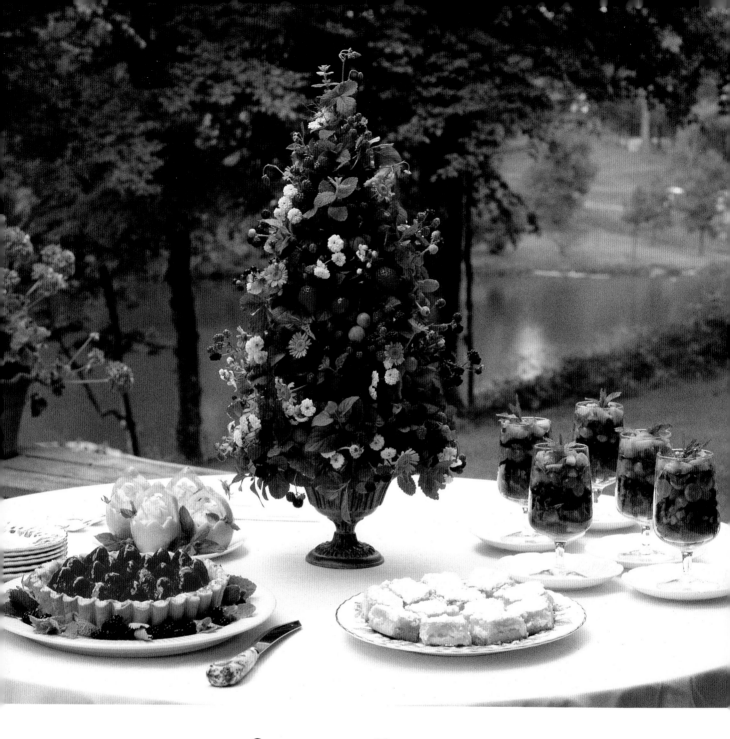

SUMMER DESSERTS

On a deck overlooking a peaceful small pond, the summer sunlight filters through the branches onto a table laden with dessert treats—a delectable strawberry tart, sugared lemon verbena squares, tall glasses of layered berries, grapes, and sprigs of mint, and refreshing lemon ice served in little individual lemon baskets. A cone of seasonal fruits and berries provides the finishing touch for this special occasion.

How to Make and Decorate a Wire Mesh Cone

Supplies and materials needed: paper for pattern, tape measure, marking pen, scissors, tape, green florist wire mesh netting (12 inches wide sold in rolls with bound edges) or chicken wire, wire cutters, #20 gauge green floral wire, floral foam or long-fiber sphagnum moss, floral preservative, knife, chenille wires, plate or tray, toothpicks, clippers, fern pins, assorted fruits and berries, plant mister, and conditioned plant materials (see page 152).

Several ways to use wire cones are shown in this book. The form may be placed on a plate or elevated on an urn or stand as illustrated here. It may be impaled on a stick to give the appearance of a little tree, the technique for which is explained on page 48.

To make this cone of fruits and berries, which is 16 inches tall, refer to the diagram. Make the paper pattern first. Adjustments are quickly made, and the paper pattern will be the pattern for the wire form. If you want to make a larger or smaller cone, determine the overall size you will need. Subtract 4 inches from the height and 4 inches from the diameter of the base. Refer to the diagram and adjust it as necessary. Cut out and form the cone shape. Use tape to secure it temporarily while you verify the base measurement. Check the size and make any necessary adjustments. Trace the pattern onto the wire mesh with the marking pen and cut it out. Bend the wire into a cone shape and tape it temporarily. Secure the overlap with short pieces of #20 gauge wire.

Soak the floral foam or moss in water to which floral preservative has been added. Cut the blocks as necessary to fill the wire form or

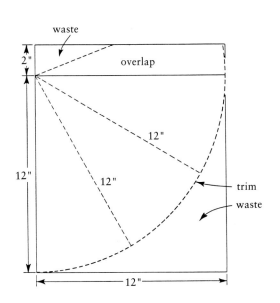

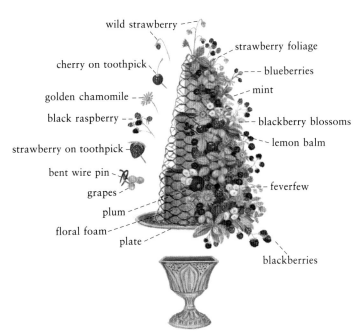

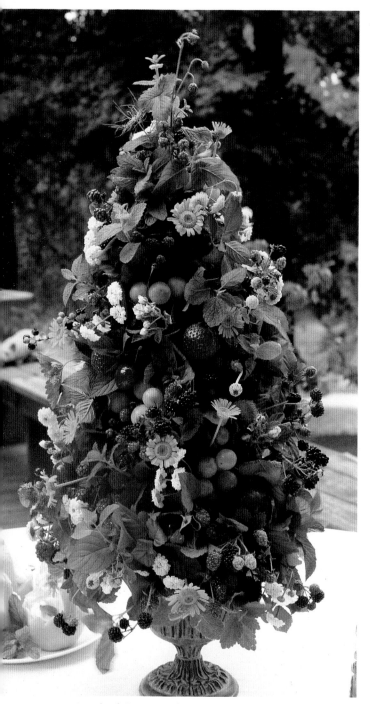

A colorful, unusual cone of glistening fresh summer fruits and berries, bright flowers, and shiny foliage invites close inspection.

stuff it with moss. Crisscross 2 pieces of chenille wire across the bottom of the form and secure the ends to the base to hold the floral foam or stuffing in place. Place the form on a plate that is a little larger than the base of the cone to catch any excess water, to hold the base of the form if it will be on a pedestal, and to protect the table if used without a base.

Cover the form with 3- to 5-inch sprigs of greenery with the bottom 1½ inches of foliage and all thorns removed. Impale the plums on toothpicks and insert them into the foam. Insert small bunches of grapes into the foam and use pieces of bent wire or fern pins to secure them. Impale the cherries on toothpicks and insert them. Cut feverfew, golden chamomile blooms, blackberries and their blooms, and blueberry and wild strawberry sprigs slightly longer than the preceding plant materials to add depth and airiness. Because of their fragile nature, impale the strawberries on toothpicks and add them last. Distribute the forms and colors to give a pleasing effect. Mist frequently and carefully add water to the floral foam.

NOTE: This cone may be made in any size and of fresh or dried materials. When made of evergreen materials that are kept in wet floral foam, it will last a long time. Different flowers may be added for a variety of seasonal colors and textures.

This detail of a wildflower "faux" topiary includes native columbine, coral honeysuckle, sweet shrub, viburnum, new growth photinia foliage, and variegated euonymus.

Summer "faux" topiaries (see page 48) are closely related to the wire cone described. Although the appearance of the form is different, the surface of both floral foam forms is covered with greenery, and floral or other accents have been added.

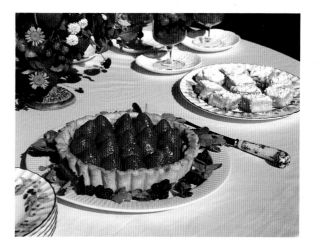

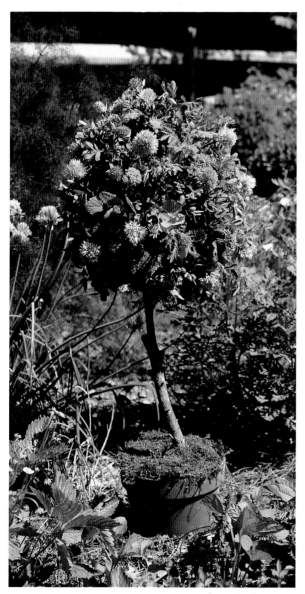

A "faux" topiary of chive, tansy, and golden chamomile blooms, tansy leaves, globe amaranth, pansies, yarrow, boxwood, pineapple mint, rue, and southernwood appears to be growing in this herb garden.

GLAZED STRAWBERRY TART

½ cup sugar
2 tablespoons cornstarch
5 egg yolks
2 cups milk
1 teaspoon vanilla
10-inch baked tart shell
2 pints fresh strawberries, washed
 and hulled
½ cup apricot jam, forced through
 a sieve
½ teaspoon sugar
1 teaspoon Grand Marnier

Combine the sugar and cornstarch. Add the egg yolks. Beat well. Scald the milk. Gradually pour it over the egg mixture, beating constantly. Bring almost to a boil and cook, stirring constantly, for 2 minutes. Remove from the heat. Cool slightly before adding the vanilla. Chill thoroughly. Spoon the custard into the baked tart shell. Place the strawberries, hulled ends down, on the custard in rows or circles. Combine the jam and sugar in a small saucepan. Bring to a boil, stirring constantly. Remove from the heat. Cool slightly before adding the Grand Marnier. Spoon the glaze over the strawberries.

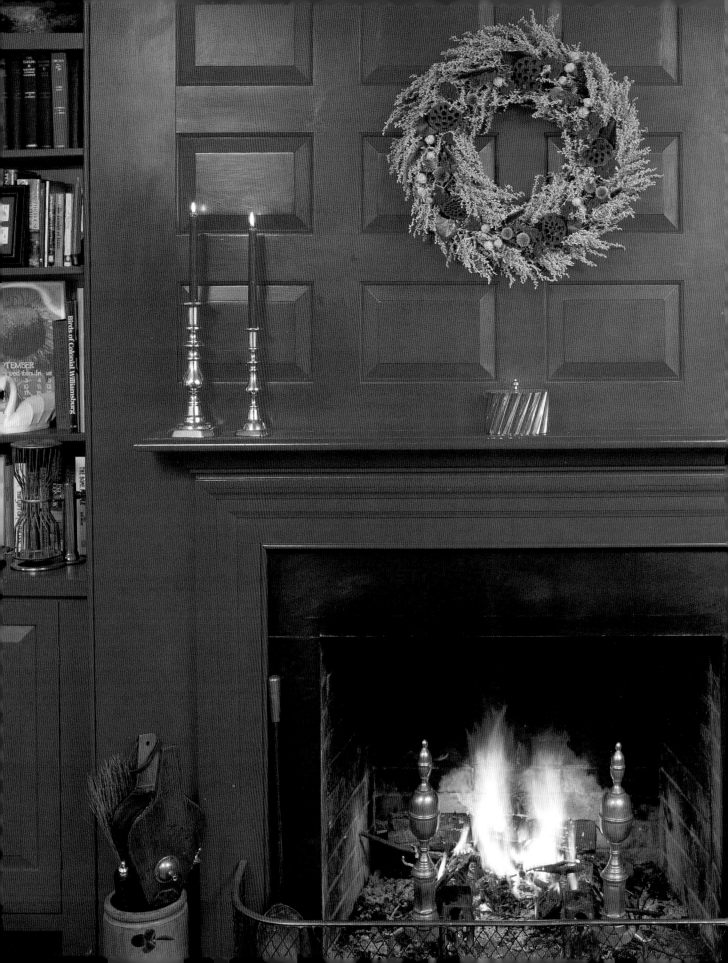

FALL

A fall chill in the air, smoke from wood-burning fires, and rust, gold, and brown leaves carpeting the brick walks signal the arrival of autumn in Williamsburg and the time to make decorations from the season's harvest. Colorful wreaths, swags, or garlands for your front door or fireplace mantel, a vine topiary, a cone of fruits or vegetables, or a soup tureen carved from a pumpkin are all possibilities.

Opposite: Fires are welcome as the evenings turn colder. Several types of celosia in a wreath over the mantel reflect the colors of the room, while other plant materials add a variety of fall colors and textures.
Above: A small wreath of mountain mint and soft red celosia rings a candle on the worn surface of an old table.

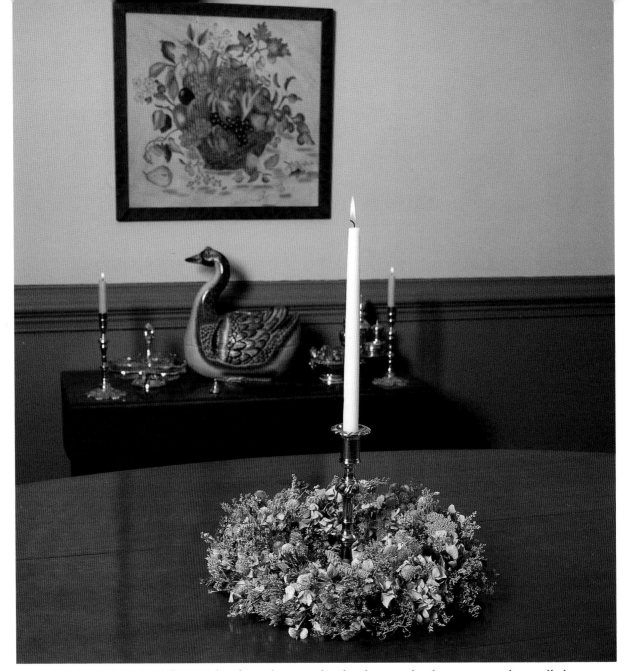

The soft colors of the dried flowers that form this wreath echo those in the theorem over the small chest.

DRIED WREATH AND GARLAND WORKSHOP

When the peak gardening season is over for the year, there is time to invite a group of friends to a workshop to pool their materials, ideas, talents, and enthusiasm and make a variety of decorations from plants harvested and dried earlier. Once made, these creations recall the pleasant memories of summer and brighten winter's iciest days. Garlands and wreaths such as the one shown here take many forms and can feature an enormous variety of herbs, flowers, and foliage. A savory luncheon awaits the workshop participants.

How to Make a Wreath of Dried Materials

Supplies and materials needed: floral foam, knife, 12-inch wire box wreath form, green floral adhesive tape, Spanish moss, chenille wire, #22 gauge green floral wire, #28 gauge spool wire, wire cutters, brown floral tape, toothpicks, and dried plant materials.

A dried wreath adds color to even the darkest days of late fall and winter, and its soft scent is a reminder of summer gardens.

Cut a block of dry floral foam into 4½-inch x 1-inch x 1½-inch pieces. Taper the edges toward the center of the wreath form so the blocks will fit closely. Fit the blocks into the form and secure each block with 2 narrow strips of floral adhesive tape. Wrap Spanish moss around the form to conceal the frame. Attach a chenille wire loop to the back. This hanger also marks the top of the wreath.

Remove the lower foliage on 4-inch pieces of artemisia. Working in one direction, insert

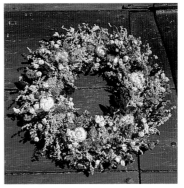

the artemisia at the same angle until the form is covered completely. This will give a pleasing line to the design. Using an uneven number, position the dominant plant materials around the wreath to establish the overall design and to distribute the textures and colors, then insert the stems into the floral foam. Vary the height and angle of the materials to give more interest to the wreath.

To divide large heads of yarrow or celosia, cut or break them into the size desired, put a wire through each piece, bend the wire, and twist it around itself. Wrap the wire with floral tape. To add a single leaf, tape or wire a toothpick to the stem and insert it into the foam. NOTE: Sea lavender, German statice, ambrosia, and mountain mint are also good background materials. Details of two other wreath forms are shown below: (1) a vine wreath and (2) a single wire wreath.

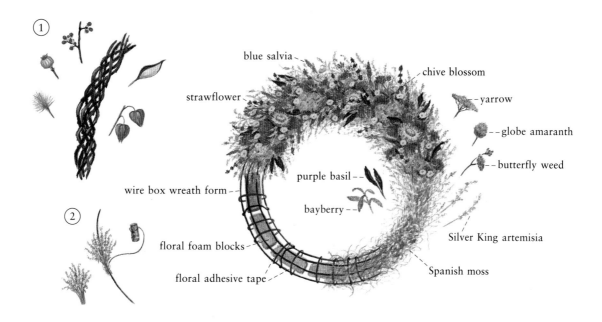

blue salvia
chive blossom
strawflower
yarrow
globe amaranth
butterfly weed
purple basil
bayberry
wire box wreath form
Silver King artemisia
floral foam blocks
Spanish moss
floral adhesive tape

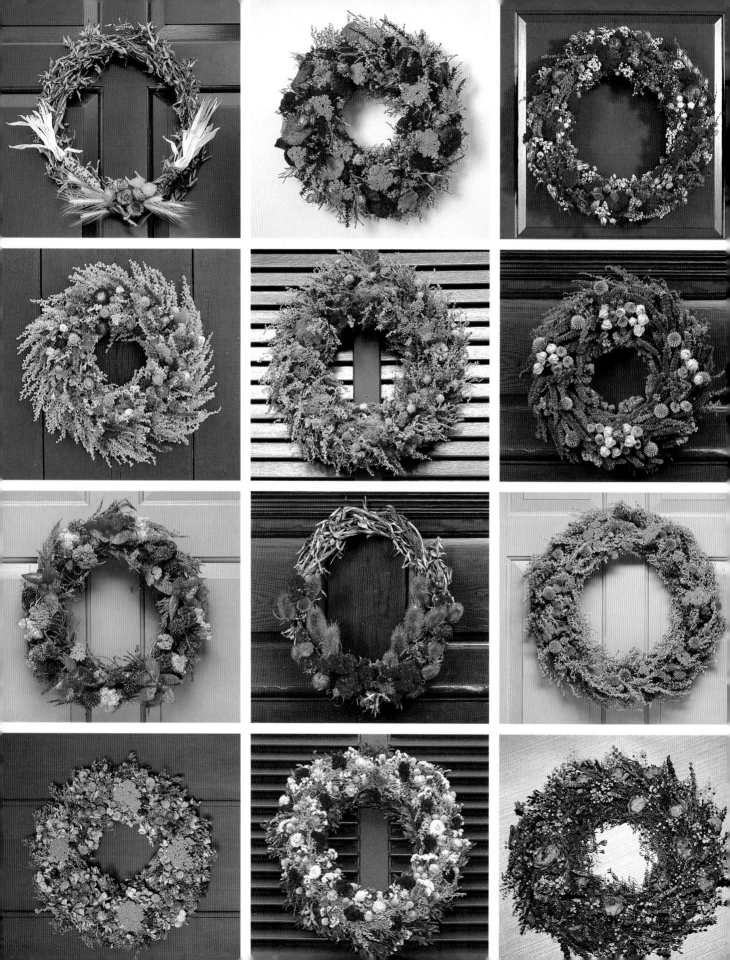

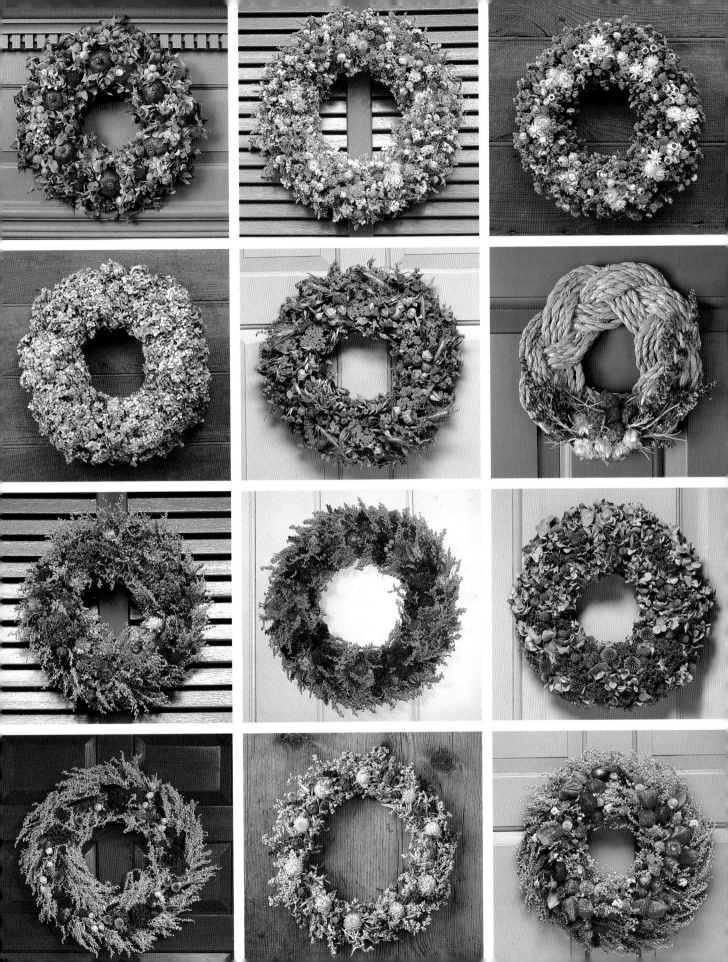

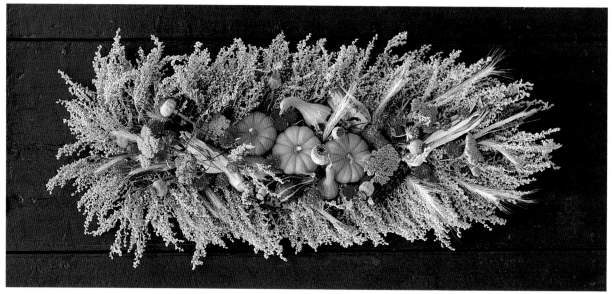

A colorful garland of mini-pumpkins, gourds, and Indian corn also features wheat, poppy seed heads, yarrow, butterfly weed, and globe amaranth.

How to Make a Garland of Autumn Materials

Supplies and materials needed: tape measure, florist wire mesh netting (12 inches wide sold in rolls with bound edges) or chicken wire, wire cutters, Spanish or long-fiber sphagnum moss, #18 gauge green floral wire, chenille wires, brown floral tape, gourds, mini-pumpkins, ears of corn, and dried plant materials.

Garlands are delightfully versatile and may be made of dried or fresh materials, long or short, curved or straight, constructed on a wire form as shown here or of materials gathered together loosely and bound in the center with raffia and a few pods. Kitchen swags using culinary herbs are less formal than the colorful one pictured over the mantel at Carter's Grove. Best of all, garlands can be hung almost anywhere, vertically or horizontally, to give extra color to a setting.

Determine the length of the finished gar-

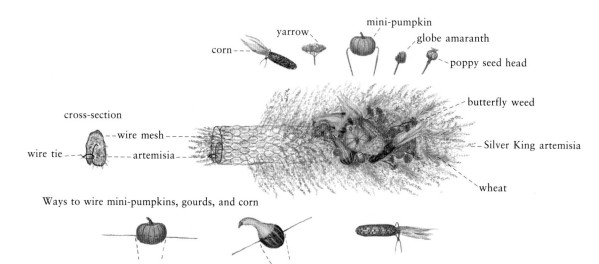

Ways to wire mini-pumpkins, gourds, and corn

land and subtract 5 inches from each end since the plant materials will extend beyond the ends of the form. The garland pictured is 30 inches long and 12 inches wide. To make the form for this garland, cut a strip of wire mesh netting or chicken wire 20 inches long and 8 inches wide. Pack the center of the strip tightly with Spanish moss, artemisia, or long-fiber sphagnum moss. Roll the wire into a tube and flatten it slightly so that it is 3 inches across. Secure the form in several places with pieces of #18 gauge floral wire as shown.

Insert 6-inch pieces of artemisia into the form along 1 side at a slight angle. Insert artemisia into the other side of the form at the same angle as shown. Use longer pieces to give a pleasing taper to the ends. The moss or artemisia rolled into the center of the form will hold the edging pieces in place. Insert a few pieces of artemisia on top of the form to hide the wire mesh. Attach chenille wire loops on the back of the wire form as necessary to hang the garland.

Position gourds, mini-pumpkins, and ears of corn on the center of the form. When you are satisfied with the arrangement, pierce the gourds and mini-pumpkins with pieces of #18 gauge floral wire and bend the ends down as

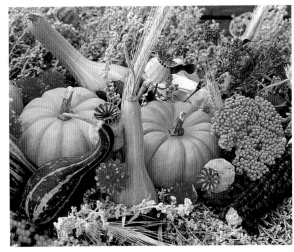

A detail of the garland opposite shows the interesting and colorful variety of materials used on the artemisia base.

shown. Twist a piece of wire around the base of each ear of corn as shown. Push the wires through the wire form and twist the wires securely in the back.

Add yarrow, globe amaranth, poppy seed heads, wheat, and butterfly weed, which do not need to be wired. Be careful to distribute the various colors and textures and to vary the angles to add interest. Study the garland from a distance and add pieces to balance the over-all design if needed.

Chinese lanterns and fresh rugosa rose hips brighten a splendid garland combining fresh and dried plant material that hangs over the mantel in the library at Carter's Grove. Hydrangeas, iris pods, pine cones, globe amaranth, yarrow, and Autumn Joy sedum are also included.

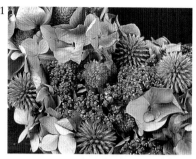

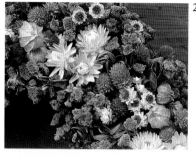

Very soft colors are blended in both wreaths. (1) Pink globe amaranth and pink yarrow on a hydrangea wreath contrast with the textures of lavender and globe thistles. (2) Pink strawflowers and globe amaranth on a base of mountain mint are accented with iris pods, ground cherry lanterns, and dark centered everlastings.

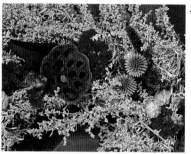

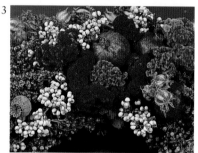

(3) Red crested celosia is striking used with the reds of pepperberries, nigella, and pomegranates. White Chinese tallow-tree berries, poppy seed heads, and dock provide contrast. (4) The celosia is less prominent in an artemisia wreath with lotus pods, globe thistles, ground cherry lanterns, knotweed, spikes of agastache nepetoides, and glycerinized leaves.

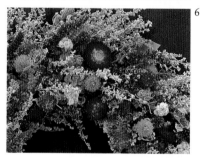

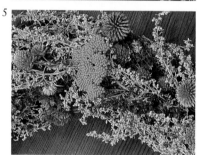

Blue salvia and yellow yarrow accent artemisia bases that also contain (5) globe thistles, purple statice, and pink globe amaranth and (6) orange and rust strawflowers, green spikes of agastache nepetoides, curry plant, anise hyssop, bay leaves, blackberry lily seed heads, and ambrosia.

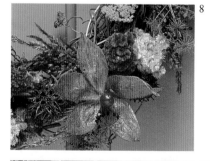

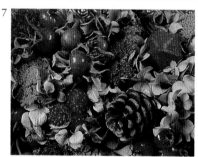

(7) Orange Chinese lanterns, rugosa rose hips, globe amaranth, Autumn Joy sedum, cones, yarrow, and iris pods are arranged on a bed of hydrangeas. (8) Flowers formed from cut Chinese lanterns are combined with pearly everlastings, sweet gum balls, yarrow, celosia, and sarsaparilla seed heads on a vine wreath.

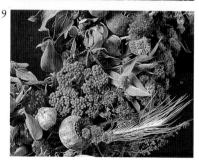

Bright yellow yarrow is used in both wreaths with (9) a base of mountain mint and ambrosia, poppy seed heads, wheat, orange globe amaranth, ground cherry lanterns, butterfly weed, and dried rosebuds, and (10) a German statice base and red celosia, clipped statice branches, galax leaves, and nigella.

Tiny wreaths fashioned from small vines or branches of herbs are decorated, using white glue, with bits of blossoms and foliage—or even a candle. These wreaths also make delightful Christmas tree ornaments. Bunches of yarrow, blue salvia, and globe amaranth hang from drawer knobs to dry.

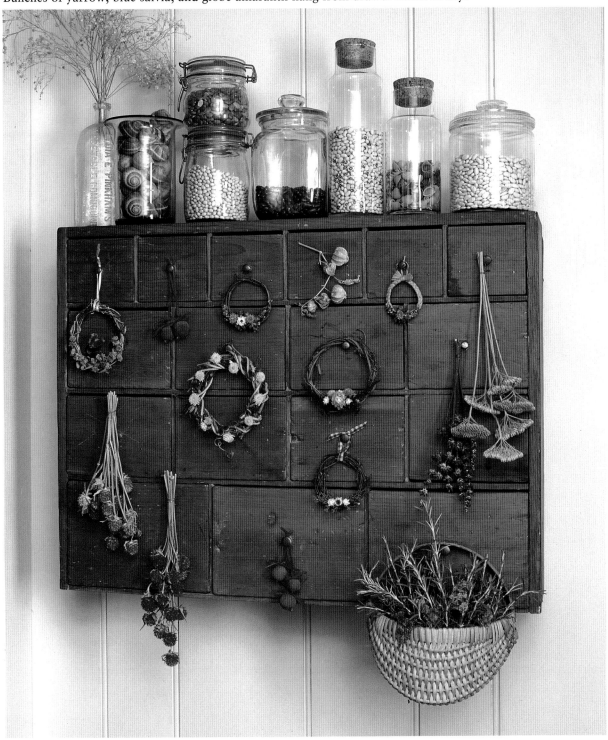

How to Make a Cone on a Nail-Studded Wooden Form

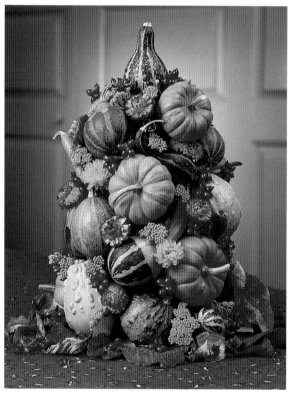

Colorful gourds and mini-pumpkins arranged in a random pattern are accented with yarrow, strawflowers, and dogwood berries.

Supplies and materials needed: nail-studded wooden form, sixpenny galvanized finishing nails (optional), hammer (optional), Spanish moss, ammonia, clear liquid floor wax (optional), heavy cardboard or cardboard cake round, scissors, plastic wrap, tape, clippers, gourds, mini-pumpkins, leaves, berries, and other dried materials.

Colonial Williamsburg's classic apple cone is synonymous with Christmas, but this form can be used throughout the year. The wooden form makes construction easy and invites you to use your imagination. When using small fruits or vegetables, you may wish to drive in additional finishing nails between the ones already on the form. It is helpful to wrap the form with Spanish moss, which will give a better base into which to tuck stems, and it will conceal the wooden form.

Select a variety of gourds and mini-pumpkins without blemishes. Wash them in soapy water to remove mildew, wipe with ammonia, and allow them to dry thoroughly. When dry, they may be dipped in clear liquid floor wax for a glossy look.

Cut a circle of heavy cardboard 1½ inches wider than the base or use a cardboard cake round. Wrap the cardboard with plastic wrap and tape the plastic wrap to the underside. Tape fall leaves around the edge of the round as shown. Place the wooden form on the round.

Impale the gourds and mini-pumpkins on the nails in a random fashion with the largest ones toward the bottom. Use a tall gourd on the top. Vary the adjacent colors and angles to add interest. Fill in the spaces with small gourds, and tuck berries, strawflowers, and pieces of yarrow into the moss.

NOTE: Single types of fruits or vegetables can be used in horizontal, vertical, alternating, or spiral bands. Mixed fruits and vegetables usually look best in a random arrangement. Any type of conditioned foliage or dried materials can be used to fill in the spaces. The form may be placed on a pedestal or flat surface.

TO MAKE A CONE OF FRUIT AND FLOW-ERS ON A NAIL-STUDDED WOODEN FORM ON A FLORAL FOAM BASE, you will also need floral foam, floral preservative, knife, plastic wrap, low dish, hair spray, paper towels, lemons, and conditioned plant materials (see page 152).

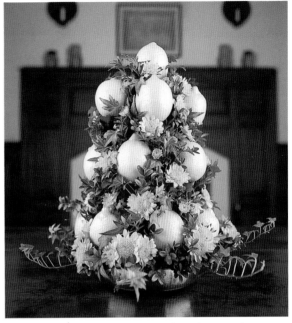

Spirals of lemons are combined with twined ivy, chrysanthemums, and sprigs of boxwood.

This interesting variation of the traditional form prolongs the life of the plant materials used on it and features chrysanthemums and lemons. Soak the foam in water to which floral preservative has been added. Cut the foam to fit into a low dish. The foam should extend 2 inches above the rim of the dish. Place a round of plastic wrap on the foam and place the wooden form wrapped in moss on it.

To remove the brand name from the lemons, spray lightly with hair spray and wipe with paper towels. Arrange the lemons in diagonal lines with the largest ones at the bottom. Fill in spaces with boxwood and chrysanthemums. Insert sprigs of boxwood and ivy into the foam. Wind the long ivy tendrils up and around the cone and extend the short pieces out over the sides. Insert chrysanthemums in the foam around the base. Use buds and flowers in various stages to add interest.

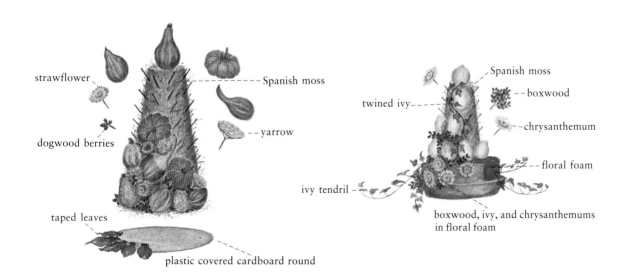

strawflower

Spanish moss

dogwood berries

yarrow

taped leaves

plastic covered cardboard round

Spanish moss

twined ivy

boxwood

chrysanthemum

floral foam

ivy tendril

boxwood, ivy, and chrysanthemums in floral foam

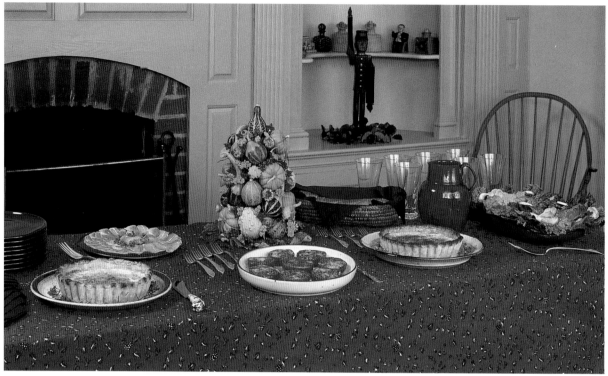

Following a busy morning, the wreaths and garlands are put aside and a luncheon of Virginia ham, grilled tomatoes and herbs, mixed salad greens with mushrooms, herb buttered bread, and delicious Cheshire cheese pie is served. The colorful gourd cone complements the table.

CHESHIRE CHEESE PIE

1½ cups light cream
2 eggs
2 egg yolks
½ teaspoon dry mustard
½ teaspoon salt
dash of cayenne
2 cups Cheshire or other Cheddar cheese, grated
9-inch unbaked pie shell

Preheat the oven to 350°F. Scald the cream and let it cool slightly. Beat the eggs, egg yolks, and seasonings together. Gradually stir in the warm cream. Sprinkle the cheese on the bottom of the unbaked pie shell and carefully spoon the custard mixture over it. Bake at 350°F. for 30 to 45 minutes or until the custard is set.

Opposite: Interesting roof angles catch the visitors' attention in this cluster of Colonial Williamsburg outbuildings. The last of Indian summer's flowers bloom along the fence.

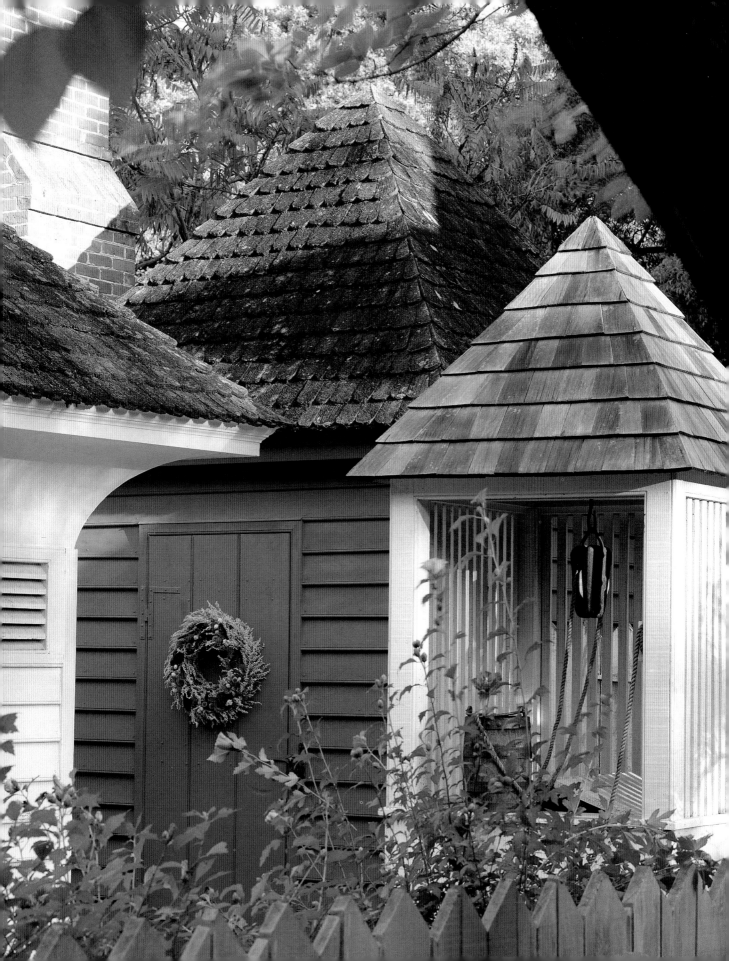

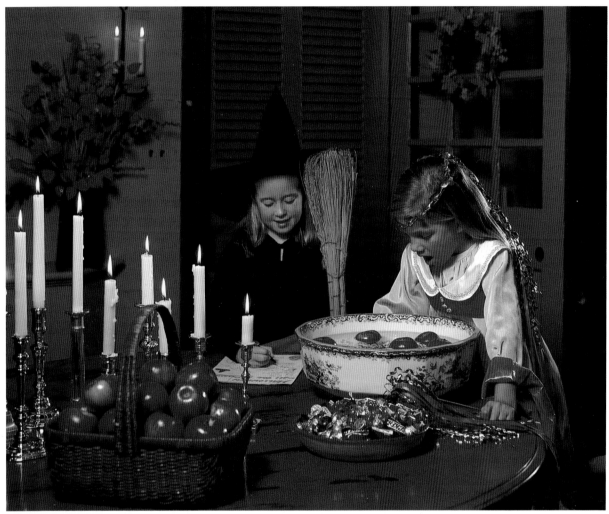

A friendly neighborhood witch signs her name on the Spook List while a fairy princess bobs for apples in the large punch bowl on Halloween night.

HALLOWEEN NIGHT
AT THE NICOLSON STORE

For over twenty years, the Nicolson Store has been open on Halloween night to neighborhood children for apple bobbing and treats and—most important of all—for signing the Spook List. Children return each year and delight in finding their names.

How to Make a Pumpkin Tureen

A large pumpkin filled with steaming pumpkin and squash soup is trimmed with fresh chrysanthemums. Fall leaves, bittersweet berries, and acorns ring the base.

Supplies and materials needed: pumpkin, knife, large metal spoon, ice pick or skewer, colorful autumn leaves, nuts, bittersweet, and chrysanthemums or other edible flowers.

Cut off the top of a large pumpkin. Scoop out the seeds and fibers with a sharp-edged metal spoon. Rinse the pumpkin with water. Make 2-inch-deep holes around the rim every 2 to 3 inches with an ice pick or skewer. Insert flowers with 3-inch stems into the holes. Arrange leaves, nuts, and bittersweet around the base. Carefully pour the piping hot soup into the pumpkin tureen from a pitcher to avoid disturbing the flowers.

PUMPKIN SOUP *10 servings*

1 tablespoon butter
1 large onion, finely chopped
2 tablespoons shallot, minced
4 to 6 cups chicken stock, divided
2 cups cooked pumpkin
2 cups cooked winter squash
2 cups milk, divided
1 teaspoon thyme leaves
3 tablespoons sherry
1 teaspoon allspice
1 teaspoon nutmeg
salt and white pepper
chopped walnuts or grated carrots

Melt the butter in a saucepan. Add the onion and shallot and sauté over medium heat until soft. Add 1 cup of the chicken stock and simmer for 5 minutes or until the onion and shallot are tender. Puree the onion, shallot, 1 cup each of the pumpkin and squash, 1 cup of milk, and ¼ cup of the chicken stock in a food processor. Return the mixture to the saucepan. Repeat with the remaining onion, shallot,

pumpkin, squash, milk, and ¼ cup of the chicken stock, and return to the saucepan with most of the remaining stock. Thin as necessary with more stock. Add the thyme and sherry and heat, stirring frequently, but do not boil. Add the allspice and nutmeg and season to taste with salt and white pepper. Garnish with chopped walnuts or grated carrots.

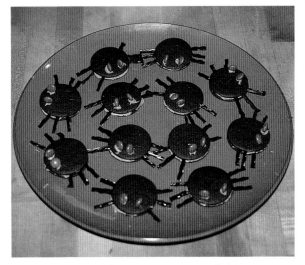

The faces on the circles of toasted bread are made by placing a stencil over the toast and shaking powdered cinnamon through the holes.

The alarming spiders creeping around this tray are bound to attract attention. They are made with two dark chocolate cookies spread with orange frosting. Six legs of finely cut strips of black licorice are arranged on the frosting and a second cookie is placed on top. Small drops of frosting hold candy eyes.

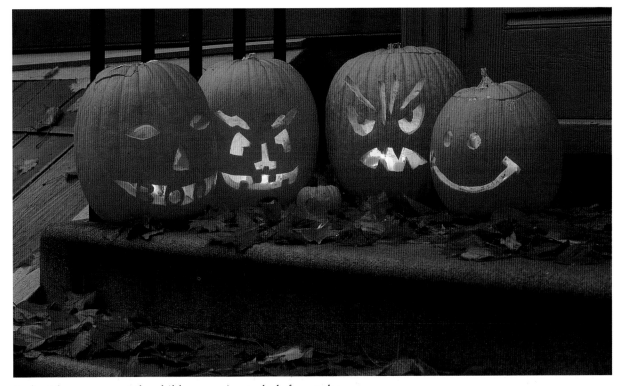

Jack-o'-lanterns greet the children coming to bob for apples.

Plant materials available in the fall introduce new color combinations and materials to use on a wire cone form (see page 55).

Left: Horizontal bands of different colored chrysanthemums are inserted through the moss and wire into the wet floral foam. The cone is placed on a pedestal.

Right: This cone is impaled on several twigs set in plaster of paris (see page 48). Vines, nuts, cones, small lichens, and berries are used in place of flowers. Frequent misting will keep the moss green and the berries bright.

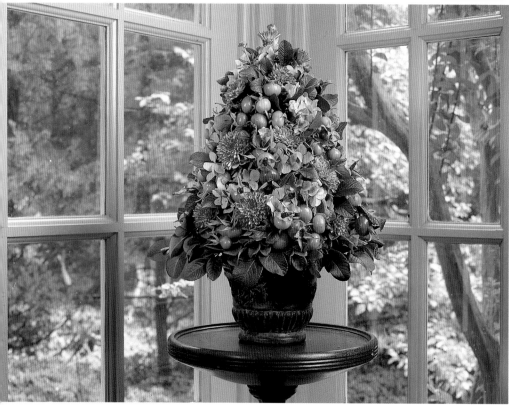

Rugosa rose hips and chrysanthemums on a base of hydrangeas and other foliage combine lovely soft colors in another cone design made on a wire form.

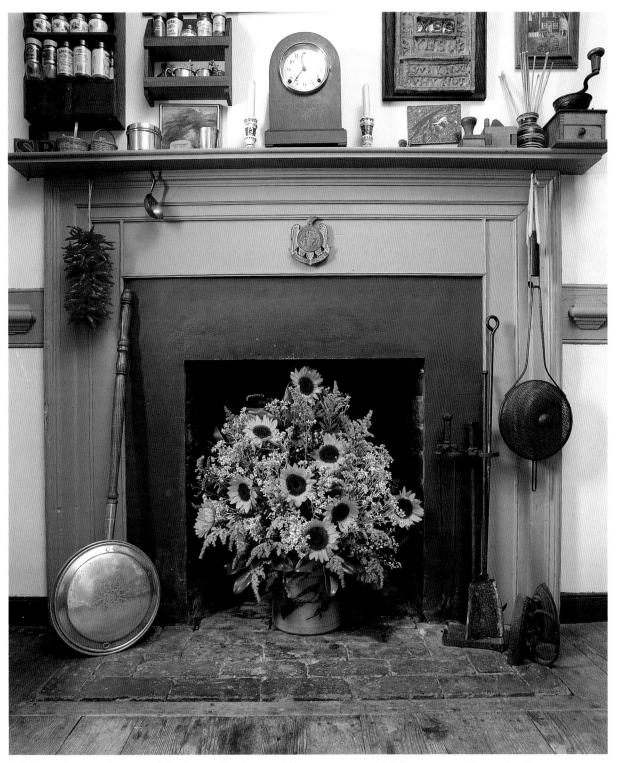

Bright yellow sunflowers add a burst of color to this arrangement of fall asters, pearly everlastings, goldenrod, and blackhaw berries.

THANKSGIVING AT THE RIVER

F amily from far and near look forward to the annual Thanksgiving reunion at their restored seventeenth-century home on the river. On this brisk November day, the celebration starts with a table laden with oysters on the half shell, roasted oysters, beaten biscuits in a dish, a basket of oyster crackers, spicy seafood sauce, and an ample jug of hot spiced punch.

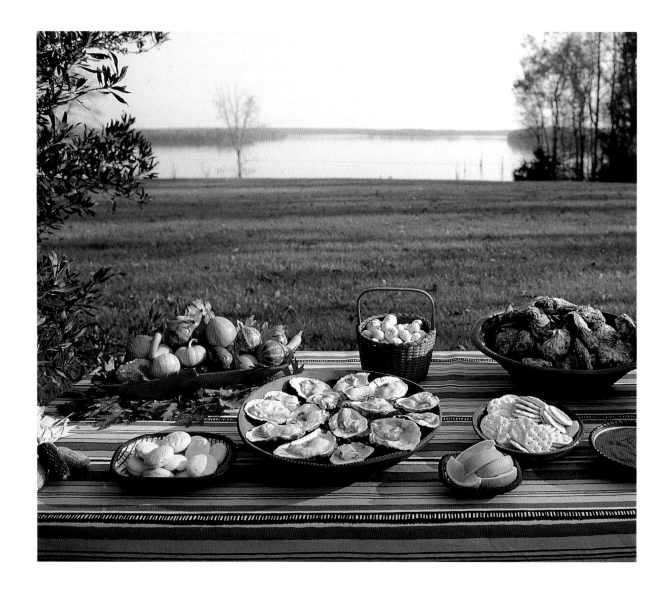

Garlands of acorns on grapevine and bittersweet swags are silhouetted above the seventeenth-century fireplace. Cheese biscuits and sherry are inviting on a table beside the fire.

ENGLISH CHEESE BISCUITS *7 dozen*

1 cup flour
¼ teaspoon salt
¼ teaspoon cayenne
½ teaspoon thyme
⅓ cup butter, softened
1½ cups Double Gloucester or Cheshire cheese, grated and divided
½ cup sesame seeds

Preheat the oven to 350°F. Grease baking sheets. Sift together the flour, salt, cayenne, and thyme. Mix in the butter and 1 cup of the cheese and form into a stiff dough. Chill for 1 hour. Roll out the dough. Using a round cutter 1 inch in diameter, cut out the biscuits. Prick the tops with a fork and sprinkle the biscuits with the sesame seeds and the rest of the cheese. Bake on the prepared baking sheets for 12 minutes or until the cheese biscuits are pale brown.

How to Make a Swag and Garland of Dried Materials

Supplies and materials needed: tape measure, 3 1-inch wire nails with heads, hammer, clippers, #20 gauge green floral wire, acorns, drill with fine bit (optional), brown floral tape, floral stickum wax, grapevine, bittersweet, and glycerinized oak leaves (see page 152).

Graceful swags and garlands are especially pleasing on a fireplace. When made of assorted evergreens, they are synonymous with Christmas; however, they can enhance any celebration. Here the vines and berries of autumn create a handsome fall decoration.

Measure the width of the mantel and mark the center. Drive in a nail slanting upward under the mantel at the center and at the 2 ends. Select 6 strands of vine approximately 10 inches longer than the distance from 1 outer nail to the center. Wire 3 strands together at 1 end. With another person holding the wired end beside the outer nail, simultaneously twist and bend the unwired end several times until it has a pleasing curve. Attach the wired end to the outer nail. Cut the unwired ends of the vine as necessary and wire them together tightly. Use the tail of the wire to secure the swag to the center nail. Repeat this process for the second swag. Be careful to make both curves alike.

To form the 2

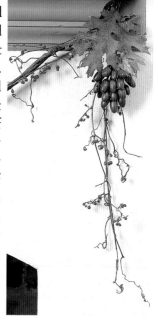

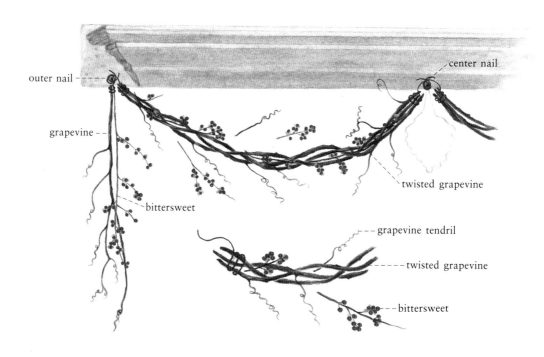

outer nail

grapevine

bittersweet

center nail

twisted grapevine

grapevine tendril

twisted grapevine

bittersweet

vertical end pieces, cut 2 pieces each of grapevine and bittersweet that have similar fullness and length. Wire the cut ends of each vertical piece together tightly and hang them from the 2 outer nails.

Cut pretty pieces of bittersweet and grapevine tendrils and insert them into the swag as shown. The twisted vine will hold these materials in place.

Collect a large number of fresh acorns. Bake them in a shallow pan at 200°F. for 2 hours to kill any insects present. Determine the vertical length of the garland for the center. The center garland shown is 10 inches long. Cut a 14-inch piece of wire. Insert the wire through the base of the first acorn, which will be the bottom of the bunch, and twist the wire to secure it. If the acorns are very dry, you may need to use a drill with a fine bit to make the hole. Wrap floral tape tightly around the base of the acorn and wrap the entire wire.

To form the bunch, wire and tape the acorns individually as shown. Acorns attached

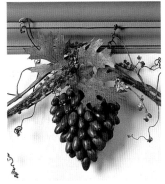

at the bottom and top of the bunch need shorter wires than those at the widest part. Attach 3 or 4 of the wired acorns at the bottom of the long center wire, keeping the finished shape of the garland in mind. Wrap these wires with floral tape where they twist around the center wire. Continue adding acorns in this manner to form a bunch 6 to 7 inches long. Make a loop in the end of the wire and hang the loop on the center nail. If necessary, more wired acorns may be added until the desired size and shape of the bunch is achieved. Repeat this process to create the 2 side garlands. Make them slightly smaller. Tuck glycerinized autumn leaves in among the vines to conceal the nails. Floral stickum wax can be used to attach the leaves to the vines.

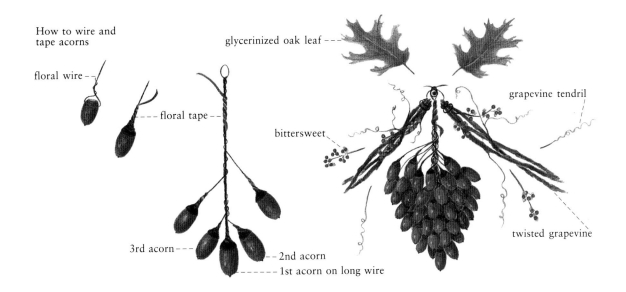

How to wire and tape acorns

floral wire

floral tape

3rd acorn

2nd acorn

1st acorn on long wire

glycerinized oak leaf

bittersweet

grapevine tendril

twisted grapevine

In the eighteenth century a symmetrical display on the dining table was extremely important. Joseph Addison remarked in 1709, "I was indeed so pleasd with the several objects which lay before me, that I did not care for displacing any of them, and was half angry with the rest of the company, that for the sake of a piece of lemon-peel, or a sugar-plumb, would spoil so pleasing a picture." Here Staf-

fordshire gods and a goddess ring antique salvers on which fresh and dried fruits, nuts, candied peels, dried flowers, and small Staffordshire rabbits have been carefully arranged according to the custom of that time. A miniature pineapple on a bed of chopped peel is placed in a goblet at the top. Small shell dishes between the figurines hold marzipan and candied peels.

A set of stacking glass salvers is the centerpiece of this striking tableau.

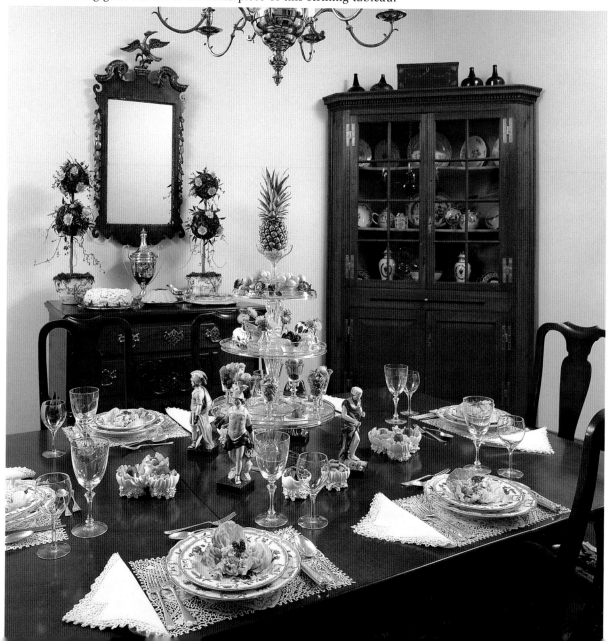

How to Make a Vine Ball Topiary

Supplies and materials needed: branch with pointed top and base embedded in plaster of paris (see page 48) approximately 30 inches tall, 8-inch vine ball, 5-inch vine ball, outer ornamental container, 2 1½-inch nails, drill with small bit the diameter of the nails, field moss, bittersweet, and conditioned plant materials (see page 152).

This pair of 30-inch-tall topiaries is in the traditional double ball form but is presented in a different way using fall vines and flowers. Various designs may be made by altering the height and size of the balls.

Force the branch through the 8-inch vine ball. Check the ball from all angles to make sure it is centered on the branch. Slide it down toward the base. Impale the 5-inch ball and

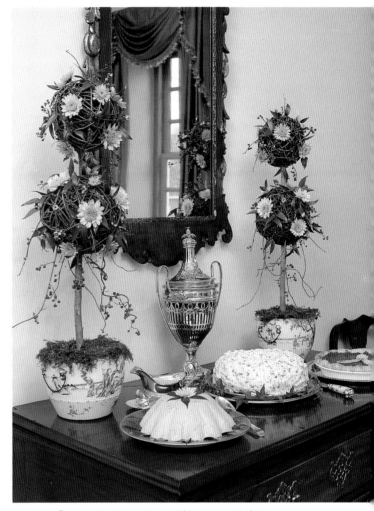

A pair of topiaries in antique Chinese porcelain containers repeat the colors used in the glass pyramid and in the Duke of Gloucester china on the table.

center it with the pointed end of the branch anchored in the top of the ball. Place the form in the ornamental container. Adjust the larger ball so that it is positioned pleasingly between the smaller ball and the ornamental container.

Once positioned, mark where the branch exits at the bottom of each ball. Drill a hole and insert the nail so that it extends out both sides of the branch to prevent the ball from slipping. When making a pair of topiaries, adjust the vine balls carefully to make sure they are correctly positioned.

Insert chrysanthemums, sprigs of bittersweet, and Alexandrian laurel into the balls. Use longer curling pieces of bittersweet in the lower ball. Cover the top of the container with moss.

PUMPKIN MOUSSE

2 tablespoons gelatin
½ cup bourbon
½ cup sugar
1 tablespoon lemon juice
1½ cups canned pumpkin
1½ teaspoons cinnamon
1 teaspoon ginger
½ teaspoon mace
2 cups whipping cream
1 tablespoon walnuts, chopped

Soften the gelatin in 1 cup of cold water. Dissolve it in the top of a double boiler over hot water. Remove from the heat. Add the bourbon, sugar, and lemon juice, mix well, and chill until slightly thickened. Combine the pumpkin, cinnamon, ginger, and mace. Whip the cream until soft peaks form. Fold the pumpkin mixture into the whipped cream. Fold the whipped cream and pumpkin mix-

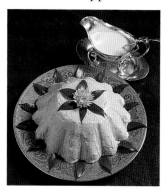

ture into the slightly thickened gelatin and turn into a 5½-cup mold that has been rinsed in cold water. Chill until firm. Unmold. Garnish with walnuts and serve with sabayon sauce.

SABAYON SAUCE

4 egg yolks
⅔ cup sugar
1 cup Marsala
1 tablespoon kirsch or rum

Whisk together the egg yolks and sugar in the top of a double boiler over hot water until the mixture is very light and fluffy. Stir in the Marsala. Continue whisking until the mixture becomes creamy and thickens. Remove the sauce from the heat and stir in the kirsch or rum. Serve hot.

PUMPKIN PIE

1 tablespoon gelatin
3 eggs, separated
½ cup granulated sugar, divided
½ cup dark brown sugar, divided
2 tablespoons black strap molasses
1¼ cups canned pumpkin
½ cup milk
½ teaspoon cinnamon
1 teaspoon ginger
⅛ teaspoon nutmeg
¼ teaspoon salt
9-inch baked pie shell

Soak the gelatin in ¼ cup of cold water. Set aside. Beat the egg yolks slightly. Add ¼ cup of granulated sugar, ¼ cup of dark brown sugar, and the molasses, pumpkin, milk, cinnamon, ginger, and nutmeg. Place the mixture in the top of a double boiler and cook over hot water until it thickens, stirring constantly. Stir in the softened gelatin. Cool. When the mixture begins to set, stir in the remaining ¼ cup of granulated sugar and ¼ cup of dark brown

sugar. Beat the egg whites until foamy. Add the salt and beat until stiff peaks form. Fold the egg whites into the pumpkin mixture and spoon it into the baked pie shell. Chill.

PUMPKIN CAKE

4 eggs
2 cups sugar
1 cup vegetable oil
2 cups sifted all-purpose flour
2 teaspoons baking soda
½ teaspoon salt
2 teaspoons cinnamon
½ teaspoon nutmeg
2 cups pumpkin

Preheat the oven to 350°F. Grease and flour a 10-inch bundt pan. Beat the eggs and mix in the sugar. Beat in the oil. Sift together the flour, baking soda, salt, cinnamon, and nutmeg. Add the dry ingredients to the egg mixture. Beat in the pumpkin. Pour the 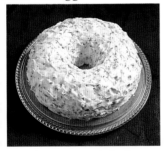 batter into the prepared pan and bake at 350°F. for 55 to 60 minutes or until the cake tests done. Cool in the pan for 15 minutes, then turn out onto a rack. When cool, frost with bourbon pecan frosting.

BOURBON PECAN FROSTING

8 ounces cream cheese, softened
½ cup butter, softened
4½ cups sifted confectioners' sugar
1 tablespoon bourbon
1 cup pecans, chopped

Cream the cheese and butter. Add the sugar a little at a time. Add the bourbon and pecans and mix until the frosting is of spreading consistency.

CANDIED PEEL

2 cups of grapefruit, lemon, or orange peels, packed
1 cup sugar
½ cup water
fine sugar

This confection was very popular in the eighteenth century. Remove the peel in ⅛- to ¼-inch-wide strips. Avoid the bitter white pith. Place the peel in a stainless steel saucepan and cover with cool water. Boil slowly for 10 minutes. Remove from the heat, let stand for 5 minutes, and drain. Repeat this process twice more. Cook the sugar in the water until it dissolves. Add the peel and cook until the syrup is almost absorbed and the peel is translucent. Shake fine sugar onto waxed paper and roll the peel in the sugar until it is well coated. Dry on a wire rack.

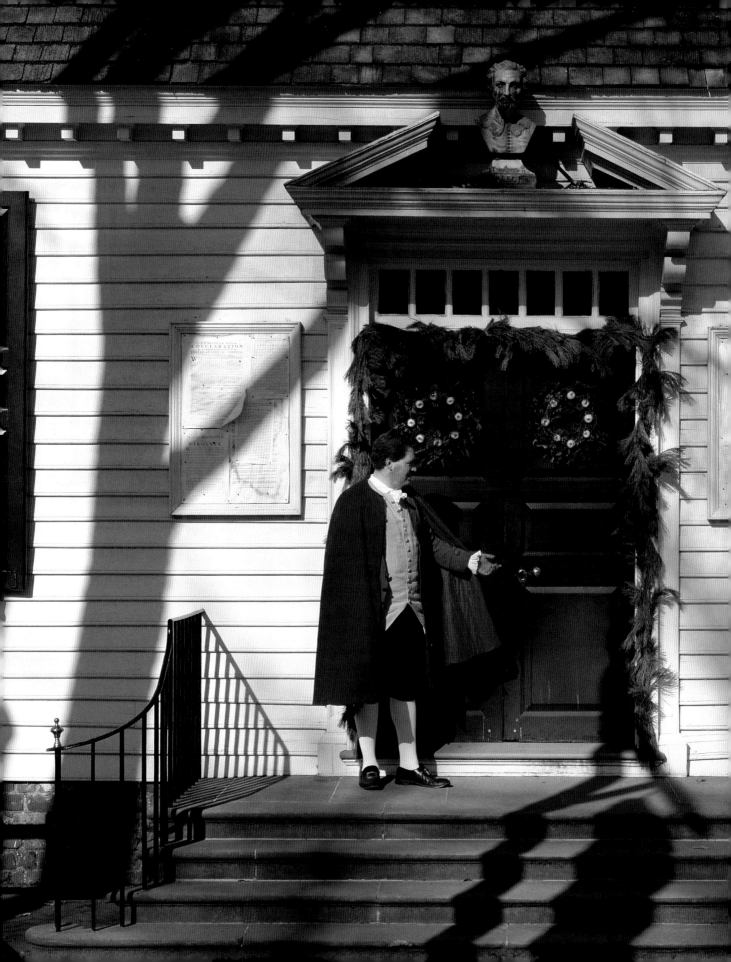

CHRISTMAS HOLIDAYS

The Christmas holidays in tidewater Virginia have always been a merry season of celebration. The hospitality of colonial Virginians during this special time of year was noted by Philip Vickers Fithian: "Nothing is now to be heard of in conversation, but the *Balls,* the *Fox-hunts,* the fine *entertainments,* and the *good fellowship,* which are to be exhibited at the approaching *Christmas.*"

From the Grand Illumination of the City early in December to the concluding events on New Year's Day, Christmas in Williamsburg is still marked by delectable meals, candlelight concerts, dances and plays popular in the eighteenth century, warm hospitality, and good fellowship. Visitors are welcomed to homes and public buildings festively decorated with natural materials.

Opposite: A congenial host welcomes visitors to the Raleigh Tavern.
Above: The Capitol glows in the light of bonfires and the fireworks on Grand Illumination Night.

GRAND ILLUMINATION BUFFET AT THE PALMER HOUSE

Early in December, Grand Illumination ushers in the Christmas holidays in Williamsburg. During the day the Historic Area is alive with activity as the buildings are decorated with wreaths and garlands in preparation for this special night. At the Palmer House, an original eighteenth-century dwelling long famous at Christmas for the bright red apples placed in the putlog holes that punctuate its walls, the residents have an annual celebration for their friends before the fireworks next door at the Capitol that conclude the festivities.

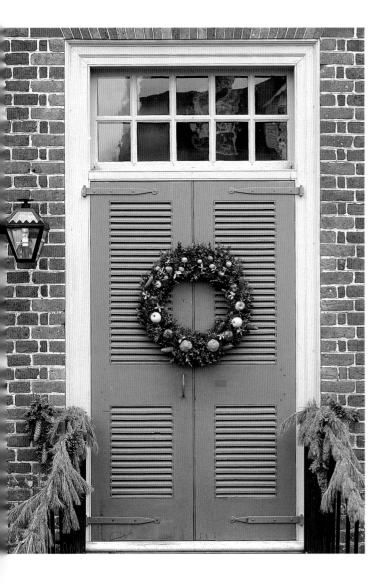

How to Make a Divided Wreath

Supplies and materials needed: green plastic foam wreath, knife, chenille wire, wire clippers, 4-inch unwired green floral picks, fruits, cones, berries, and conditioned plant materials (see page 152).

Creating a wreath for a divided door can present a problem that can be solved by cutting a plastic foam wreath form in half and decorating the 2 sections. The sections are hung side by side on the divided door to form a traditionally shaped wreath. Trim 1 inch from the ends of the cut foam sections so that, once made and assembled, the wreath will appear round. Follow the directions given for making a fruit curve (see page 92) for inserting greenery, fruits, cones, and berries into a plastic foam form.

This divided wreath contains symmetrically arranged pairs of fresh fruits, cones, and nuts that decrease in size from bottom to top. Cotton bolls and berries add interest.

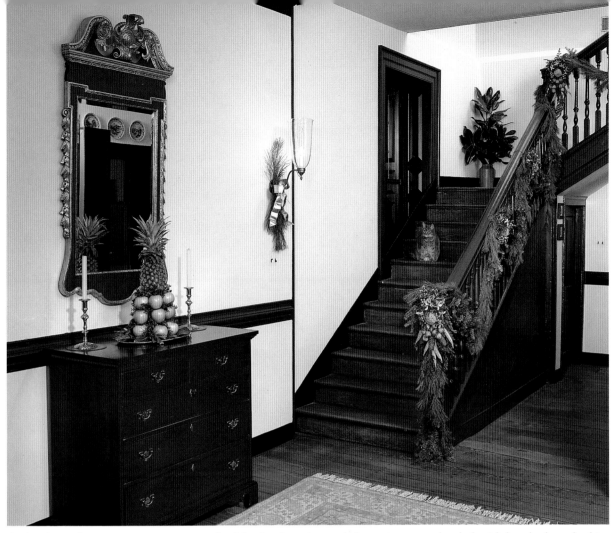

A classic apple cone, a sconce swagged with pine boughs, and the stairway garlanded with hemlock and white pine roping welcome guests. The family cat considers the preparations from its observation post on the steps.

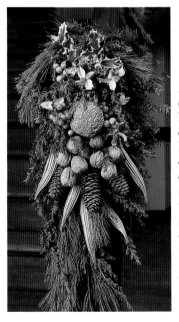

Left and right: An osage orange, Norway spruce cones, okra pods, English walnuts, chinaberries, and cotton bolls are accented with variegated holly and small white spruce cones. Both garlands use a plastic foam block as a base into which materials are inserted (see page 92).

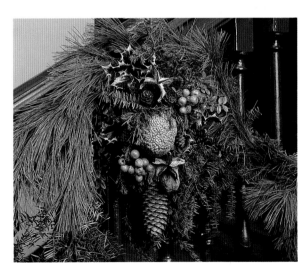

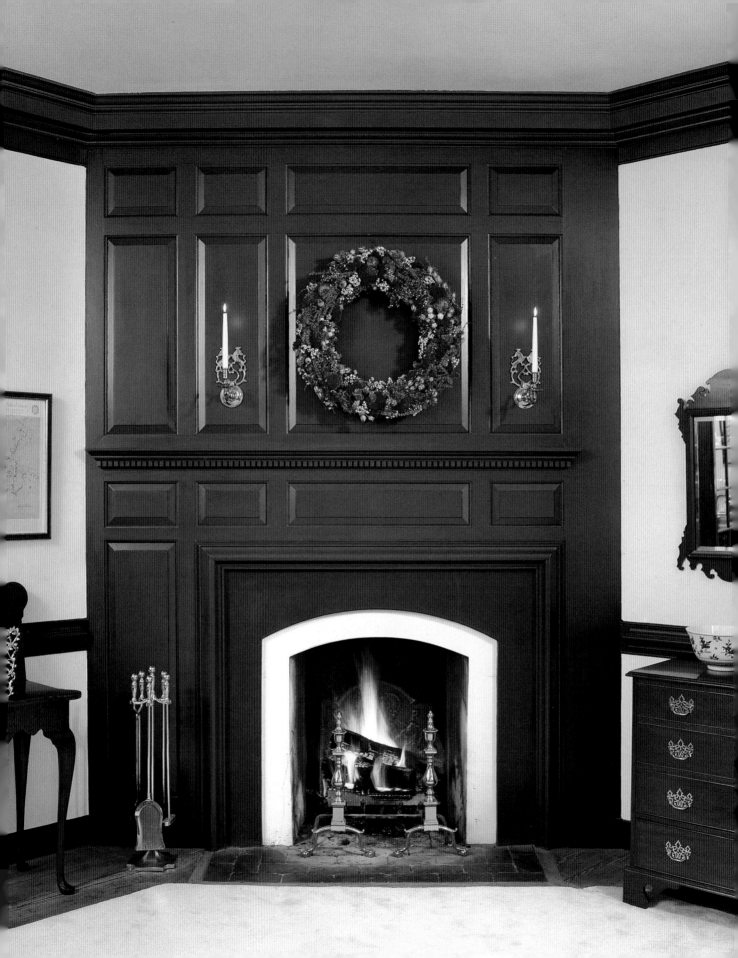

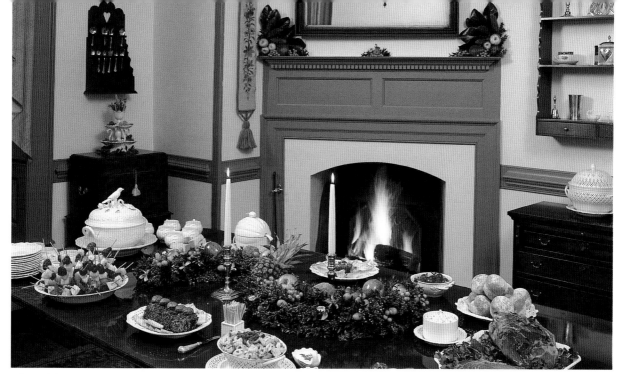

The table, laden with foods in pierced creamware dishes and a tureen of Cheddar cheese soup, is graced with another classic Williamsburg decoration—a fruit curve.

CHEDDAR CHEESE SOUP
10 to 12 servings

1 medium onion, chopped
1 rib of celery, chopped
1 cup butter
1 cup all-purpose flour
2 quarts chicken stock
1¾ cups Cheddar cheese, grated and divided
¾ cup dry white wine
2 cups half and half
salt and white
 pepper
bacon
scallions

Opposite: A handsome dried wreath of celosia, pomegranates, pepperberries, and nigella accented with white Chinese tallow-tree berries, poppy seed heads, and dock hangs over the fireplace in the living room (see page 61).

Sauté the onion and the celery in butter until soft but not brown. Stir in the flour until well blended. Add the chicken stock, stirring constantly, and bring to a boil. Add 1½ cups of the cheese and the wine, stirring to blend thoroughly, and cook over low heat until the cheese has melted and the soup has thickened to the desired consistency. Add the half and half, return to low heat, and heat until very hot but do not boil. Serve garnished with crumbled bacon, finely chopped scallions, and the remaining cheese.

Endive leaves filled with a robust tapenade alternate with curried minced chicken. Spinach and cheese tortellini are accompanied by herb and spicy tomato dips.

How to Make a Curve of Fruits and Berries

Supplies and materials needed: 18-inch green plastic foam wreath, knife, strip of heavy plastic, scissors, clippers, fern pins, 3-inch wired and unwired green floral picks, 3 4-inch unwired green floral picks, fruits, berries, cotton bolls, and conditioned plant materials (see page 152).

Hogarth curves or S-curves are attractive and dramatic table centerpieces and may be made in a variety of sizes and with many different materials. The ends may be joined flush, overlapped as shown here, or, on an especially large table, the curve may be elongated by adding a center arrangement.

Cut the wreath form in half. Cut plastic 2 inches wider than the form on each side and in the same shape. The plastic will protect the table. When inserting the boxwood background

The soft rose colors of the pepperberries and Gala apples are enhanced by lady apples, cotton bolls, osage oranges, kumquats, chinaberries, two colors of grapes, and a small pineapple.

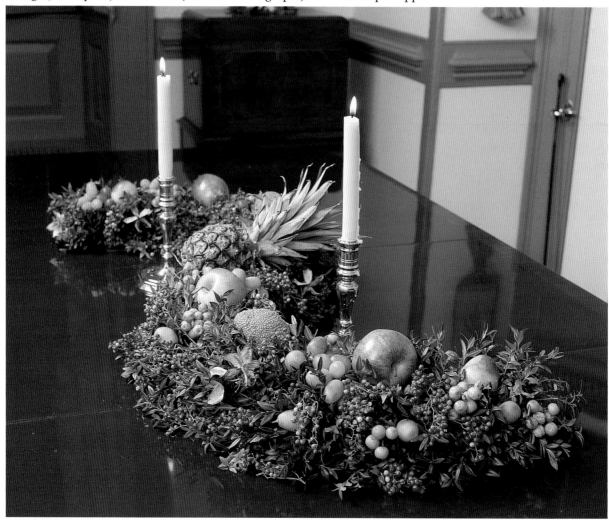

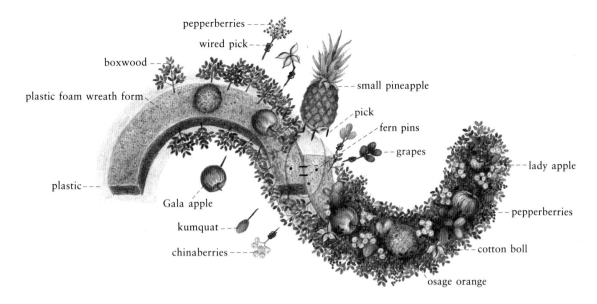

pepperberries

wired pick

boxwood

plastic foam wreath form

small pineapple

pick

fern pins

grapes

lady apple

plastic

pepperberries

Gala apple

cotton boll

kumquat

chinaberries

osage orange

material in each half it is easiest to work on a table or counter. Cut the stems of 4- to 5-inch sprigs of boxwood at an angle for easier insertion and remove the lower leaves. Insert the sprigs into the foam. Cover the form with boxwood except the center section where the ends will be joined. Place the 2 sections on the cut plastic on the table and secure with fern pins as shown.

Position the largest fruits to distribute the colors and to determine the design. Impale these fruits on 3-inch unwired picks and insert

them into the foam. Wire bunches of pepperberries, chinaberries, grapes, and cotton bolls to the 3-inch wired picks and insert them. Impale the kumquats and lady apples on 3-inch unwired picks and insert them, being careful to distribute these colors and textures throughout the fruit curve. Impale the small pineapple on 3 4-inch picks and insert it into the center section as shown. Fill in as needed with additional boxwood and sprigs of berries. Be sure that the plastic strip is concealed by the boxwood.

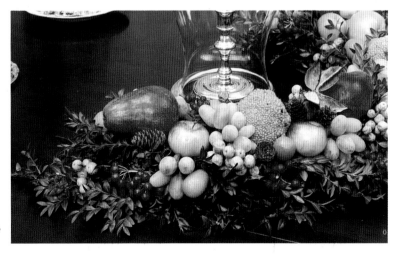

At Carter's Grove another beautiful fruit curve combines red pears, pyracantha berries, spruce cones, osage oranges, cotton bolls, kumquats, grapes, chinaberries, and lady apples.

A little "faux" feather tree of boxwood is surrounded by a reproduction German toy village. Tartan trimmed baskets hold frosted gingerbread boys and reindeer. Sheep pull toys and colonial dolls wait for their playmates.

CHILDREN'S GINGERBREAD PARTY

Every child looks forward to the holidays and the celebrations special to this time of the year. The fragrant aroma of baking gingerbread spices the air. Cookies for the children to help make and decorate—and nibble—and others to hang on the tree or in a window are made with care and delight. Another project might include creating a whimsical gingerbread house such as one of the ones shown. Children enjoy cutting out the pieces, adding the candies and other decorations, and creating the surrounding scene.

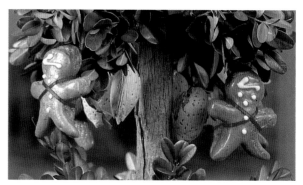

Beribboned gingerbread boys seem to cavort about the branches of boxwood. Rose hips and bunches of nandina berries add color.

GINGERBREAD COOKIES

1 cup sugar
2 teaspoons ginger
1 teaspoon nutmeg
1 teaspoon cinnamon
½ teaspoon salt
1½ teaspoons baking soda
1 cup margarine or butter, melted
½ cup evaporated milk
1 cup unsulfured molasses
¾ teaspoon vanilla extract (optional)
5 to 6 cups unbleached flour, unsifted

Combine the sugar, ginger, nutmeg, cinnamon, salt, and baking soda. Mix well. Add the margarine or butter, evaporated milk, molasses, and vanilla. Mix well. Beat in 5 cups of flour. When the dough stiffens, finish mixing by hand. The dough should be stiff enough to handle without sticking to your fingers. Add more flour if necessary. Divide the dough into 3 balls, wrap in plastic wrap, and chill for 3 hours.

Preheat the oven to 350°F. Grease baking sheets. Roll the dough out a scant ¼-inch thick on a floured surface. Cut out the cookies, transfer them to the prepared baking sheets, and bake at 350°F. for 12 to 15 minutes or until lightly browned. Cool on a rack. The cookies may be decorated with royal icing. NOTE: To make a hole for hanging the cookies on a tree or in a window, break a toothpick in half and rotate the wide end in the dough. Bake the toothpick in the cookie and rotate it again before cooling the cookies on a rack.

ROYAL ICING

6 egg whites
1 teaspoon cream of tartar
2 pounds confectioners' sugar
lemon juice (optional)

Beat the egg whites and cream of tartar in the large bowl of an electric mixer at low speed until foamy. Gradually add the confectioners' sugar and beat at high speed for 8 to 10 minutes or until the icing is very thick. Keep the bowl of icing covered with a damp towel. NOTE: For piping on the details for doors, walls, and shutters or for decorating cookies, thin the icing with a few drops of lemon juice if it seems too thick.

These gingerbread cookies are made from traditional tin cutters and from painted quilt templates. Some are pierced with red thread hangers.

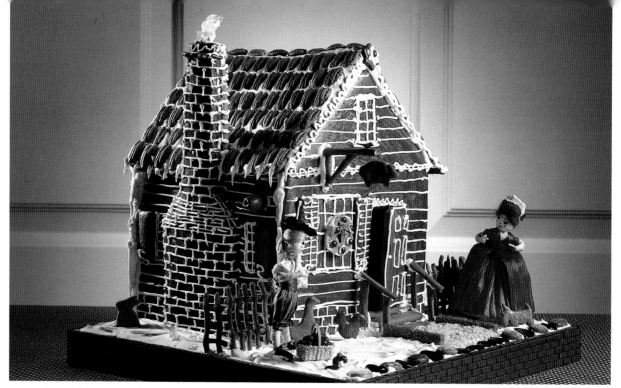

An eighteenth-century shopkeeper and her little dog greet the apple man outside this gingerbread version of the Hunter Store. Children have fun adding a chopped candied ginger walkway edged with sesame bars, a cinnamon stick railing, horehound drop and licorice drop cobblestones, a roof tiled with pecan halves, smoke made from rock candy crystals, a shop sign hanging from cinnamon stick braces, and gingerbread animals. A decorated dried apple wreath hangs on the window.

How to Make a Gingerbread House

Supplies and materials needed: poster board or graph paper, ruler, pencil, scissors, tape, 1 egg, pinch of salt, baking sheets, aluminum foil, chilled gingerbread dough (see page 95), rolling pin, flour, knife, pastry brush, fork, wide knife, plywood base, royal icing (see page 95), pastry bag, couplers, #2 and #8 round tubes, and confectioners' sugar.

Enlarge the patterns shown based on the measurements given or you may wish to change the dimensions. Transfer the patterns onto the poster board or graph paper. Cut out all the pieces and label them. Assemble and temporarily tape the patterns to be sure that you have

made all the pattern pieces and that they fit properly.

Baking: Make an egg wash by lightly beating 1 egg with 1 teaspoon of water and a pinch of salt. Preheat the oven to 350°F. Line baking sheets with aluminum foil. Roll out the gingerbread dough a scant ¼-inch thick on a floured

An elaborate gingerbread chalet in a woodland fantasy of frosting and marzipan delights guests of the Williamsburg Inn. A cheery group of revelers is coming down the path.

The Hunter Store, an eighteenth-century grocer's, is the source of many of the ingredients for this gingerbread house.

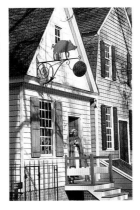

surface. Cut out the following pattern pieces: 2 ends, 2 sides, 2 chimneys, 2 roofs, 4 large shutters, 4 small shutters, 2 steps, and 1 door.

To make the chimney, brush 1 chimney piece with the egg wash and place the second piece on top of it to bond the 2. This thicker piece will take longer to bake.

Transfer the pieces to the prepared baking sheets. Prick the pieces lightly with a fork. Bake at 350°F. for 12 to 15 minutes or until golden brown. Halfway through the baking process, brush the pieces with the egg wash. During baking, check for air bubbles and prick any that form with a fork. Cool on a rack.

To make the fence, cut thin strips of dough, place them horizontally on a baking sheet, brush with egg wash to bond, and place "pickets" on top. Bake. To make a bird bottle, form a little bottle out of dough. Make a hole in the center. Bake the bottle upright. Make

animals from the dough using tiny cutters or your own patterns and bake. Watch smaller pieces carefully because they will bake more quickly.

To Assemble the Walls: Using a wide knife, frost the plywood base with ¼ inch of royal icing. Fill the pastry bag fitted with a #8 tube half full of royal icing and carefully roll down the open end. Position the back wall in the frosting at the back of the plywood base as shown. Pipe a line of icing up 1 edge of the back wall (1). Push 1 side wall into the frosted base and press it against the icing on the back wall. Be sure that the corner is square. Hold for a minute until the icing sets. Pipe a line of icing along the inside corner. Pipe another line

of icing where the bottom of the 2 walls and the base join on the inside to reinforce the joinings. Continue to follow the diagram with the other 2 sides, being careful to keep the building square (2), (3), (4). Allow the icing to set until firm.

To Decorate the Chimney, Shutters, Door, etc.: While the icing holding the walls is hardening, use the pastry bag fitted with a #2 tube to decorate the chimney, shutters, and door. On the building, pipe lines of icing for clapboards, windowpanes, a brickwork base for the foundation, and other decorations. Allow to dry.

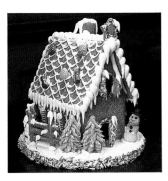

A tiny candy house with ice dripping from the eaves, marzipan trees, and a snowman await Hansel and Gretel.

A miniature basket of apples attracts a wee squirrel.

Roof: Pipe a thick line of icing along the gables and tops of the side pieces and on the roof pieces where the roof will connect with the gables and sides. Carefully position the roof pieces leaving an equal overhang on both sides. Hold until the icing sets. Pipe another generous line of icing along the ridge pole. Press pecan halves lengthwise along the ridge pole in the icing. Allow it to harden. Starting near the top edge, ice a small area of the roof and press pecan halves in rows into the icing. Continue until the roof is decorated.

Finishing: Apply icing to hold the chimney on the wall below the notched area on the left side of the roof. Press the chimney in place and hold until the icing sets. Rock candy set in icing is convincing as "smoke." Put the steps in place with icing. Put the door in place and secure it with icing "hinges." Attach the shutters with icing. Hold the fence in place with icing. Make the cinnamon stick sign holder and railing by joining cut pieces of cinnamon sticks with icing. Add a walkway of chopped ginger. Make icicles using the pastry bag fitted with the #2 tube. Push out icing onto the eave, then pull down and away to create a tip on the icicle. Add a perch for the bird bottle held by a small bit of icing. Allow to dry. Use a dried apple ring with candy decorations held by icing for a wreath. Sifted confectioners' sugar gives the appearance of snow.

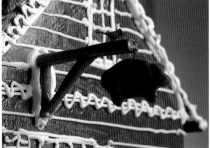

This shop sign provides a good vantage point for a bright red cardinal.

A gingerbread bird bottle is protected from the frosting icicles.

A dried apple ring wreath decorates the shop window.

bird bottle

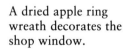

sign holder

shop sign

steps and railing

wreath

fence

Front

5⅛"

9"

¾"

3½"

4¼"

4¼"

1¾"

1½"

5½"

4¼"

Side

Indicates chimney placement

5½"

1"

1½"

2½"

7"

Door

3¾"

1½"

Steps

½"

1"

2"

7¾"

Roof

5¾"

1½"

2¾"

3½"

Remove notch on left side

Chimney

5"

1⅛"

1½"

3½"

9¾"

3"

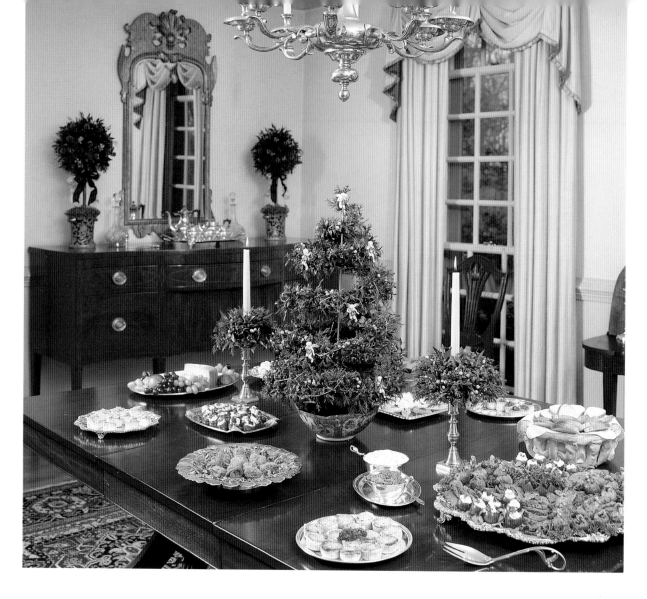

A Christmas Engagement Party

Christmas is a popular time to celebrate an engagement with a party featuring special decorations to honor the happy couple. On a table laden with tempting foods, tiny reproductions of eighteenth-century Neapolitan cherubs holding minute moss-covered hearts decorate the spiral centerpiece. After the party they are given to the bride and groom for the couple's first Christmas tree. A pair of candlesticks are adapted to hold assorted greens. In the background "faux" topiaries flank a handsome gilt mirror.

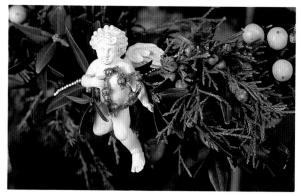

A tiny wire heart covered with moss (see page 11) and gilded berries is held by this cherub.

From the left: Curried crabmeat with dill in heart-shaped pastry shells, rare filet of beef with walnut stuffed brussels sprouts, cherry tomatoes stuffed with herb cheese, ratatouille in pastry rounds surrounded by grilled scallops, marinated lamb wrapped around cubes of eggplant, and tiny herb quiches entice the guests.

How to Make a Spiral Tree

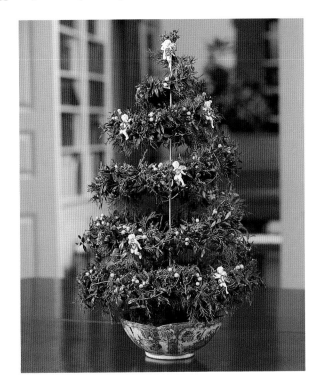

A spiral topiary form set in plaster of paris (see page 48) and placed in an oriental porcelain bowl is covered with cedar and American boxwood that is wired in the fashion described on page 103 with newly added bunches covering the cut ends of the previous bunches. Blue cedar and ivory nandina berries are tucked in and a chain of small gold beads is twisted among the greenery. Little cherubs are placed about the form.

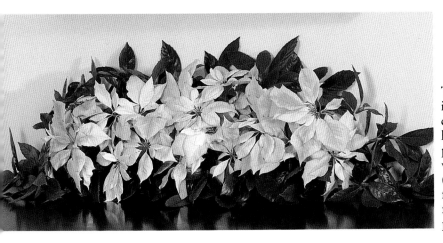

This arrangement of ivory poinsettias is dramatic and easily made. Fill a chicken feeder with floral foam that has been soaked in water and floral preservative. Cut poinsettia blooms with short stems and sear in a flame (see page 152). Insert them into the feeder to make a narrow arrangement for the back of a sideboard. This allows plenty of space for serving.

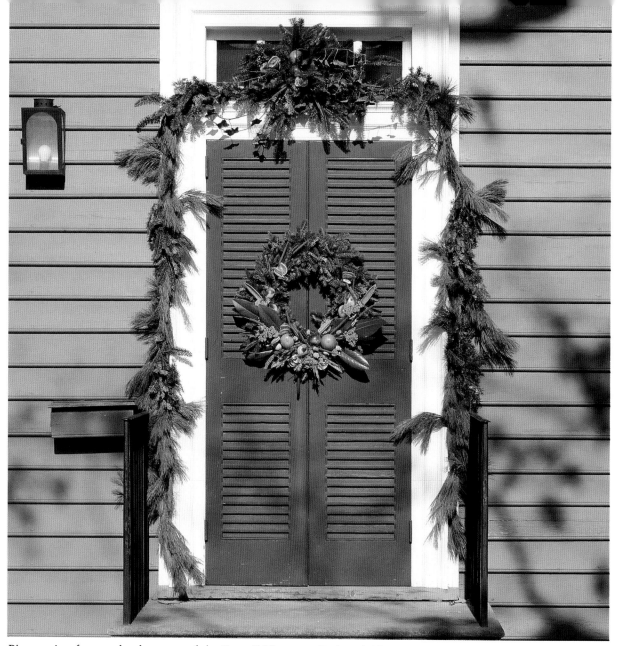

Pine roping frames the doorway of the Russell House on Duke of Gloucester Street. Centered over the doorway is a colorful collection of fruits and dried materials. These plant materials are repeated in the striking wreath on the door.

A GARLANDS AND GREENS TOUR OF THE HISTORIC AREA

Tours of Colonial Williamsburg's homes and public buildings decorated for Christmas are always popular with visitors who see a variety of plant materials, many native, and the different construction details of the wreaths, swags, garlands, and plaques displayed on doors, windows, and gates throughout the Historic Area.

How to Make and Decorate a Balsam Wreath

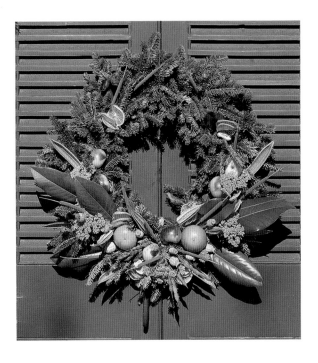

Supplies and materials needed: flat 2-wire wreath form, #24 gauge spool wire, #18 gauge green floral wire, 4-inch wired floral picks, wire cutters, clippers, fruits, nuts, pods, and conditioned plant materials (see page 152).

Many evergreens can be used to make a wreath but balsam is especially popular because it conditions well.

Cut 6- to 8-inch pieces of balsam. Attach the end of the spool wire to the wire form. Leave the wire attached to the spool. Hold a bunch of balsam on the form and wrap the spool wire around the cut ends and the form several times. Place another bunch so that it covers the wired ends of the previous bunch and attach as described above. Continue to wire the bunches to the form until it is completely covered. The last bunch should be wired underneath the first bunch. Cut the spool wire and wrap the end securely around the form. Attach a heavy wire loop to the back.

Position the fruits and other large elements to determine the design. Push pieces of #18 gauge wire through the oranges and lady apples. Bend the wires down, insert them through the wreath, and twist on the back to secure. Add pods, leaves, and dried fruit slices wired to 4-inch picks. Tuck yarrow, poppy seed heads, and cattails, which do not need to be wired, into the wreath at different heights and angles to give depth and add interest.

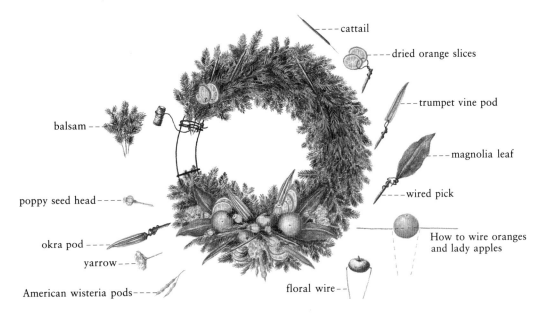

cattail

dried orange slices

trumpet vine pod

magnolia leaf

wired pick

balsam

poppy seed head

How to wire oranges and lady apples

okra pod

yarrow

American wisteria pods

floral wire

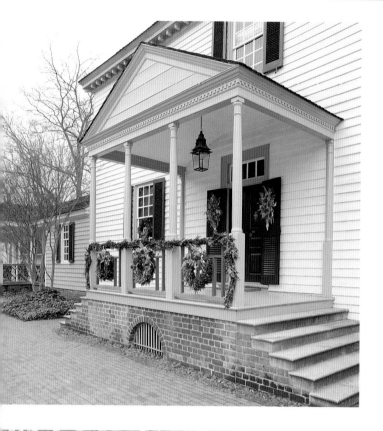

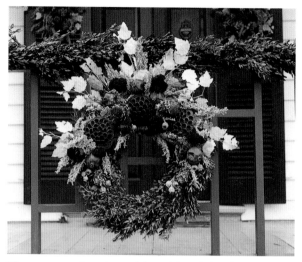

Plaques are placed on either side of the door under the portico of the eighteenth-century Robert Carter House on Palace green. The three boxwood wreaths hanging on the Chippendale railing feature unusual arrangements of lotus pods, pomegranates, celosia, yarrow, pressed white poplar leaves, poppy pods, thistles, and sprigs of artemisia.

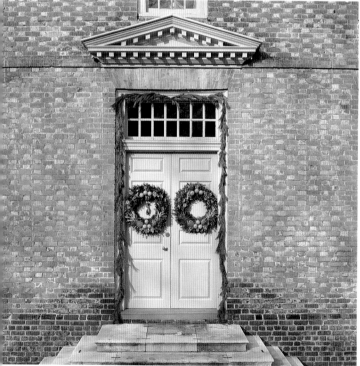

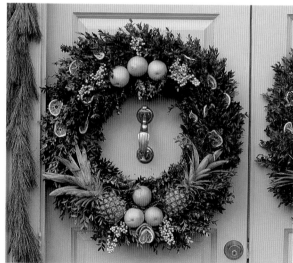

The wreaths on the entrance of the President's House at the College of William and Mary include oranges symbolizing King William's ties to the House of Orange. They are used with small pineapples, long the symbol of hospitality in Virginia. Dried orange slices and white nandina berries complement these materials.

Each row, left to right:
Brightly colored lady apples and nandina berries and subtly shaded nandina foliage are grouped at the base of this boxwood wreath. Nandina berries and camellia leaves accent the top.

At the William Waters House loblolly cones and white nandina berries are placed above a pineapple encircled with lemons, apples, red berries, and sprigs of bayberries.

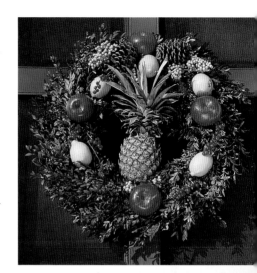

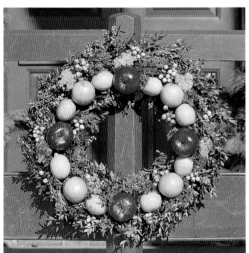

On the Prentis Store railing lemons, oranges, and apples form a colorful circle on the boxwood wreath to which cedar cones, chinaberries, bayberry sprigs, and yarrow have been added.

A balsam wreath is decorated with cut loblolly cones, small black pine cones, cotton bolls, and masses of bright holly berries.

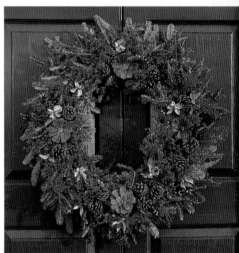

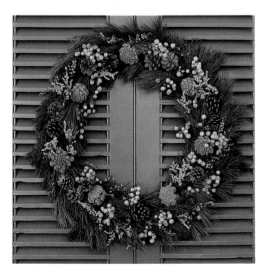

Piñon cones, chinaberries, black pine cones, bayberry sprigs, and German statice are combined on a white pine wreath.

A grapevine wreath is trimmed with gingerbread boys tied with red yarn. The raffia bow holds a holly sprig.

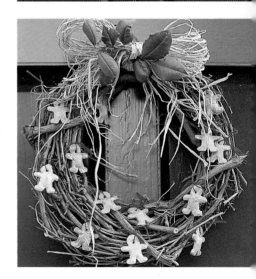

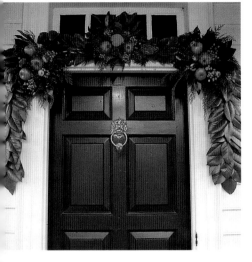

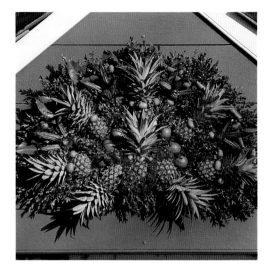

Each row, left to right:
A handsome overdoor decoration at Bassett Hall combines overlapping rows of magnolia leaves with three clusters containing Granny Smith and lady apples, pomegranates, chinaberries, black pine cones, and an osage orange in the center.

This fan on the Blue Bell features pineapples. Kumquats, cranberries, celosia, limes, deodar cones, and okra pods enhance the design.

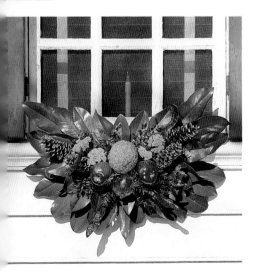

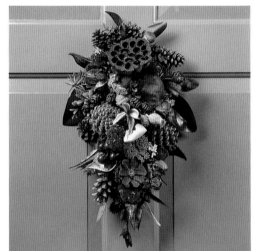

Plaques on either side of the door of the James Anderson House combine lemons, magnolia fruits, and yarrow on a background of magnolia leaves, boxwood, variegated aucuba, cedar with berries, white pine, and ivy tendrils.

A dried garland includes a lotus pod, dried pomegranates, nuts, cones, pods, glycerinized leaves, a folded corn husk, celosia, boxwood, and bits of yarrow.

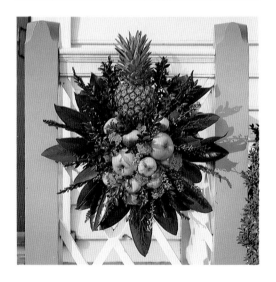

A colorful plaque beneath a window at the Prentis House contains an osage orange, a fresh pomegranate bordered by two apples, white pine cones, honey locust pods, and yarrow on magnolia leaves.

On the railing at the Coke-Garrett House a round plaque features lady apples, Granny Smith apples, and yarrow. A pineapple top and dried fertile fronds of sensitive ferns add an unusual touch.

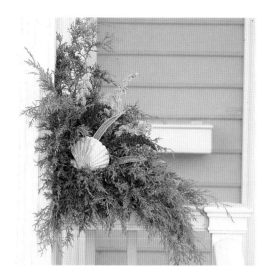

Each row, left to right:
Graceful branches of cedar, a scallop shell, a trumpet vine pod, sumac, cedar berries, and rabbit tobacco, all native to tidewater Virginia, form an unusual decoration on the corner of this railing at the Charlton House.

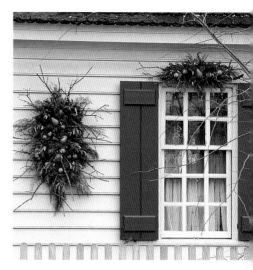

At the Tayloe Kitchen narrow plaques are mounted above each window with a plaque between the windows. Red pears, limes, red berries, honey locust pods, sweet gum branches, and other foliage are used.

Bayberry, Alexandrian laurel, and magnolia leaves form a background for bright yellow yarrow heads, blue cedar berries, red rose hips, and dried fertile fronds of sensitive ferns in a basket.

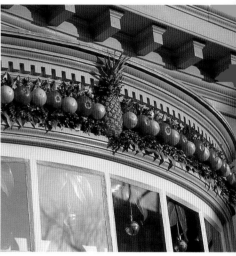

A colorful band of alternating oranges and apples below the dentil molding of the curved window at the Sign of the Rhinoceros features a pineapple.

A well house in front of the Elkanah Deane Kitchen is decorated with boxwood roping and a bucket filled with cedar, nandina foliage and berries, and sprigs of German statice.

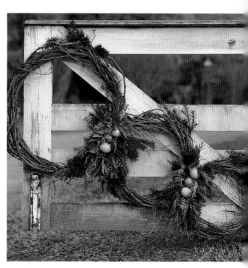

Vine wreaths in three sizes decorated with yew, variegated aucuba, lemons, limes, gypsophila, and red berries festoon this gate.

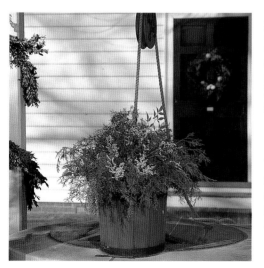

In the entry hall of the President's House large portraits of King William III and Queen Mary II remind visitors of the English origins of this venerable college. A stately arrangement of large white Dutch tulips, cream poinsettia blooms, orange alstroemeria, pine cones, and evergreens is placed below the portraits.

RECEPTION AT THE PRESIDENT'S HOUSE, COLLEGE OF WILLIAM AND MARY

The College of William and Mary, one of America's oldest institutions of higher learning, received its charter in 1693 from King William III and Queen Mary II. For over three hundred years, the college has greatly influenced the intellectual life of Virginia and the nation, and an extraordinary number of distinguished Virginians have studied or taught there. Thomas Jefferson, James Monroe, and John Marshall were among its outstanding alumni in the eighteenth century.

Built in 1732, the President's House is the oldest college presidential residence in America. Its first occupant was William and Mary's first president, the Reverend James Blair, who had persuaded the king and queen to charter the college. The presidents of the college and their families have always received faculty, distinguished scholars and visitors, students, alumni, and friends in this handsome Georgian residence during the holiday season and throughout the year.

Using greens from the college grounds, hanging garlands of balsam (see page 33) are enlivened with dried oranges, orange slices and peels, yarrow, white pine cones, and sprigs of bittersweet berries. Longleaf holly, variegated aucuba, and camellia foliage and buds contribute a vibrant, shiny quality. A soft gold bow is added.

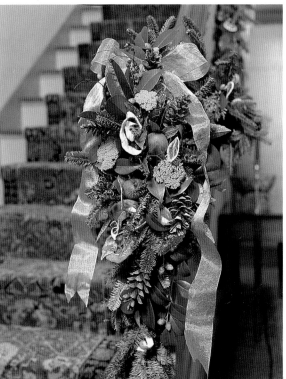

Embellished roping is gathered at midpoint with a simple garland of plant materials echoing those used in the garland on the newel post and landing. Eighteenth-century English prints of birds and flora by the naturalist Mark Catesby hang in the stairway.

Wired dried orange slices, camellia foliage, and sprigs of incense cedar are attached to the roping by carefully lifting the foliage ends and wiring the additional materials to the twine. This allows the balsam to cover the wired ends of the newly added materials.

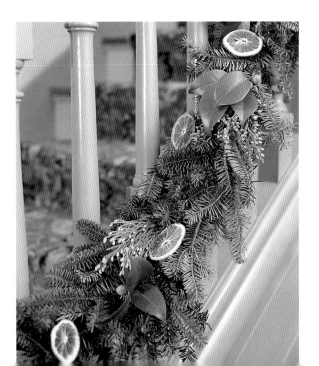

How to Make a Garland of Natural Materials in the Style of Grinling Gibbons

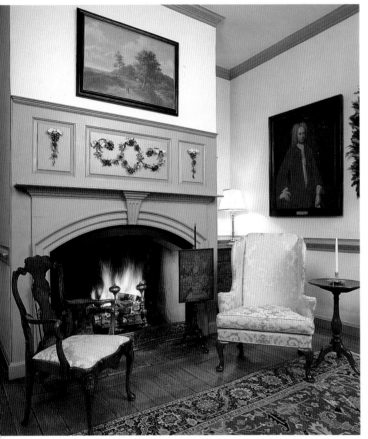

The garland, which fits within the panels above the fireplace, is based on the carving shown on the opposite page.

Supplies and materials needed: pencil, ruler, poster board, clothesline wire, wire cutters, needle nose pliers, brown floral tape, clippers, #28 gauge spool wire, #20 gauge green floral wire, chenille wire, drill with small bit (optional), white hobby glue, 1-inch wire nails, hammer, clear fishing line, scissors, wired rib-bon, fresh long straight pieces of Russian olive, and dried materials such as the nuts, cones, dried lemon slices, dried ginkgo leaves, and oak leaves shown.

Symmetrical garlands of dried materials may be made in a wide variety of designs. The design shown was inspired by the finely detailed wood and marble carvings of plant materials by the English artisan Grinling Gibbons (1648-1721). The size and design shown here were determined by the dimensions of the panels. The center panel measures 34 inches by 15 inches; the 2 side panels are each 9 inches by 15 inches. The design consists of 5 parts: 2 vertical garlands each 10 inches long and 2 curved side pieces joined to an oval form that is 8 inches across.

When designing this type of garland, draw the panels to scale, then draw precise patterns of the 5 elements of the garland on the poster board. Select the dried materials you will use and note their exact location on the pattern. This will ensure that the decorated garland will fit within the panels when the plant materials are added. Working on the pattern will make the bent wire pieces correspond exactly to each of the pattern's elements. Bend the clothesline wire to form the center oval. Inter-

A marble relief by Grinling Gibbons in James II's chapel at Whitehall was the inspiration for the overmantel decoration.

lock the 2 ends securely at the top. Bend the wire to form 2 identical curved side pieces. Make a small loop at the inner end of each side piece. This loop will be used to connect the side pieces to the center oval. Cut 2 9-inch pieces of heavy wire for the straight side pieces and make a small loop for hanging at the top of each piece. Wrap each piece with tape.

Position a long piece of Russian olive with leaves and thorns removed on each side of the 5 wrapped wire forms. Secure the Russian olive to the wire at intervals with short pieces of spool wire. Keep the Russian olive and the pieces of wire flat; do not allow them to cross. The spool wire can be removed after all the decorative elements have been attached.

Wire the dried materials with 6-inch pieces of #20 gauge floral wire. You may need to use a drill with a fine bit to make holes in acorns.

Fill the holes on the underside of deodar cones with glue, insert 6-inch pieces of chenille wire, and allow them to dry. Wrap all wires with brown tape. Yarrow, ginkgo leaves, and grapevine tendrils do not need to be wired. Wrap yarrow stems with brown tape.

Attach the wired materials by twisting their wires individually to the form. Group the materials in small clusters as shown, leaving some areas of the form visible. Trim excess wire. Cover the joining points with brown tape. Glue on pieces of yarrow and ginkgo leaves to add color and to conceal the joining points. Note how the yarrow and ginkgo leaf conceal the area where the acorns and pine cone scale were attached to the bottom of the center oval. Glue on grapevine tendrils to add interest and delicacy. Connect the side pieces to the center oval with spool wire. Wrap the joinings with brown tape. Cover the joinings with dried materials as shown in the photograph.

Drive 3 tiny nails into the edges of the paneling. Use the clear fishing line to hang the garland from the nails. View the garland from a distance to be sure that the elements are symmetrical. Tie the ribbon into soft bows and attach them with spool wire.

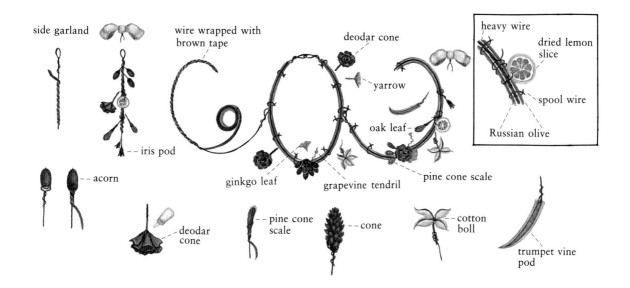

How to Make an Arch of Fresh Greens and Cones

Supplies and materials needed: ¼-inch plywood frame 4 inches wide made in 2 sections to fit the archway, eye hooks, finishing nails, staple gun and staples, clippers, #24 gauge spool wire, cones, and conditioned plant materials (see page 152).

This form can be covered with greens and cones for a dramatic statement as shown here.

Make the form in 2 parts and carefully pre-fit them to the arch. Working on a flat surface and starting at the bottom, staple short pieces of spruce, cypress, and fir onto the frame facing downward. Each successive bunch will cover the cut ends of the preceding bunch and extend over the edges of the form. Be careful to cover the ends of the form at the keystone with the evergreens. Wire the Norway spruce cones (see page 111) around their bases with long pieces of spool wire. Wrap the tails of wire around the frame. This enables the cones to be adjusted after the archway is in place. Hang the forms from eye hooks in the frame.

An impressive garland surrounds the archway between the two parlors. A large boxwood kissing ball (see page 131) adds to the festive decorations.

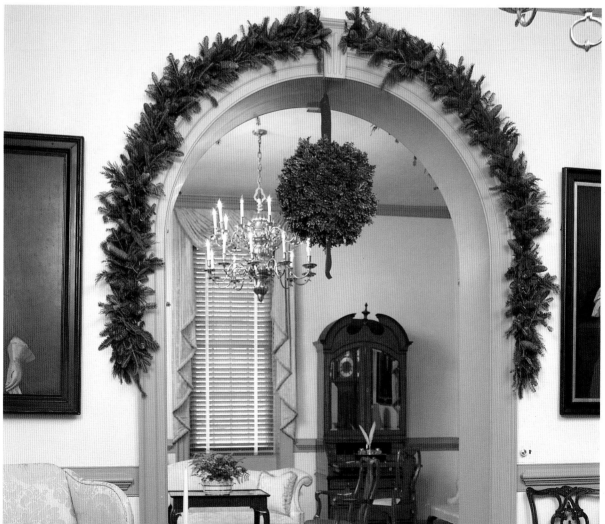

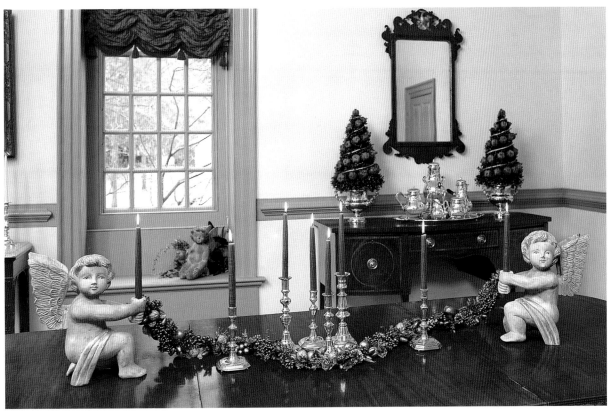

Hand-carved angels hold candles and the ends of a garland that curves along the center of the table. The Chinese photinia berries, candles, and pomegranates echo the soft red of the Venetian shade in the window.

A large cone rests on a silver wine cooler. The base is a large floral foam-filled wire cone (see page 55). The boxwood was inserted into the wet foam at an angle and secured with fern pins to make a flat surface. Pomegranates on floral picks are arranged in spirals divided by gold cording held in place with pieces of bent floral wire.

A garland made by wiring gilded nuts, cones, and pods onto a cord curves around brass candlesticks. The fresh berries and boxwood sprigs add color and interest.

TREE TRIMMING PARTY

During the Christmas holidays, a gathering of family and friends is always welcome, especially when they can help trim the tree and enjoy an informal supper afterwards. The tradition of bringing a tree indoors and decorating it was introduced to Williamsburg in 1842

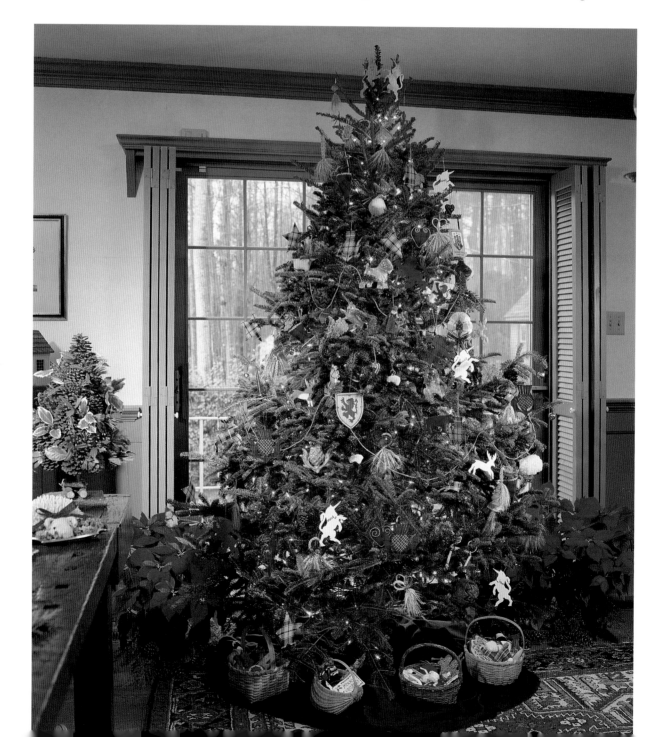

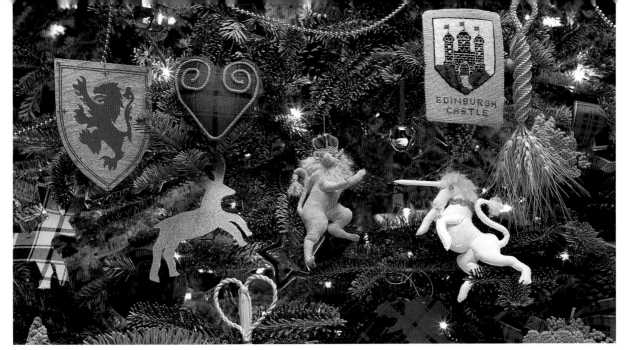

Three-dimensional Ultrasuede crowned lion and unicorn ornaments inspired by the British coat of arms, a petit point tavern sign, yarrow tied with tartan ribbon, stuffed and bonded tartan ornaments, painted wooden ornaments, and woven corn dollies hang on the tree.

by Charles Minnegerode, a German immigrant teaching at the College of William and Mary, who shared a treasured memory of his youth when he presented a small tree to the children of his friend Professor Nathaniel Beverley Tucker.

Tiny cornucopias filled with dried fruits, nuts, and cookies decorated the first trees, but as the idea became more popular, colorful glass balls, pressed metal figures, and many other more exotic trimmings were introduced from Germany.

This tree reflects Williamsburg's many ties with England and Scotland in colonial times. Decorations include fabric, dough, and wooden versions of the lion and unicorn from the coat of arms at the Governor's Palace. Corn dollies or wheat weavings, an ancient European craft, and a variety of tartan ornaments inspired by the apparel in the portrait of Lord Dunmore, the last royal governor of Virginia, such as thistles, cornucopias, and bunches of yarrow tied with tartan ribbons, are also used. Needlepoint and painted wooden and dough ornaments complete the theme.

Corn dollies in designs characteristic of different regions of England and Wales are used on this tree. A tradition since pagan times, they are made with the last sheaf of wheat from the harvest and returned to the fields the next spring to ensure a bountiful crop.

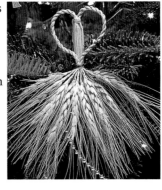

Pictured are the royal coat of arms and *John Murray, 4th earl of Dunmore,* by Sir Joshua Reynolds (courtesy Scottish National Portrait Gallery).

When enlarged this pattern can be used for bonded fabric or salt dough ornaments or even for a wooden cutout decoration similar to the stag pictured below and on page 115.

How to Make Bonded Fabric Ornaments

An inexpensive and easy way to make ornaments is to use a fusible web to bond two fabrics together following the manufacturer's instructions. The patterns for the lion, unicorn, cornucopia, and thistle shown here were made by tracing the patterns onto the bonded fabric and then cutting out the designs. Gold threads were added to the unicorn's horn and to the thistle. The patterns given here may be enlarged with a copier or graph paper.

This thistle design is interpreted on the left in a baked dough ornament and in one made with a bonded fabric. Gold embroidery threads on the fabric thistle catch the light.

A colorful collection of ornaments includes a paisley Santa, bunches of yarrow tied with tartan ribbons, shiny sleigh bells that catch the light hung from red ribbons, clothespin dolls of a kilted drum major and his tartan-clad lady carrying a basket of white heather, corn dollies, a salt dough lion, a tavern sign of the Red Lion, a golden stag, and a lion and unicorn.

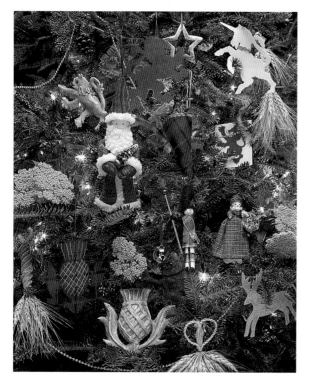

This 5-inch-long cornucopia is made from a quarter of a circle with a 10-inch diameter. Fuse stiff interfacing to the back of the fabric according to the manufacturer's instructions, cut out the pattern, and sew the two sides together on the dotted lines with the right sides together. Turn the right sides out. Glue or sew gold braid around the top. Yarrow, white heather, and red berries fill the cone.

How to Make Salt Dough Ornaments

SALT DOUGH

2 to 3 cups unbleached flour, unsifted
1 cup salt
1 tablespoon vegetable oil
1 cup water
egg white, beaten
aluminum foil
toothpicks
waxed paper
spray varnish

Combine 2 cups of flour and the salt in a large bowl, make a well in the center, and add the oil and water. Mix the dough by hand until it is

pliable, adding more flour if necessary. Sprinkle flour on a pastry board and knead the dough until it is smooth.

Roll out ⅓ of the dough until it is about ¼-inch thick. Cut into ornaments using the patterns provided here and place the pieces on a baking sheet covered with aluminum foil. To add details such as the ones on the thistle or lion, cut narrow strips of dough, moisten the area where you want to add the detail with water or brush with egg white, add the pieces, and gently press together. Brush the whole surface with egg white. To make a hole for hanging, see page 95. Bake at 325°F. for about 30 minutes or until dry and golden. When the pieces are dry and cool, place them on waxed paper and spray with several light coats of varnish, one side at a time, to prevent insect problems.

TO MAKE A DOUGH BASKET, double this recipe. Weave long strips over an inverted bowl covered with aluminum foil placed on a baking sheet. Trim the edges. Brush with egg white where the strips overlap. Bake at 325°F. for 1 hour or until the basket is a light toast color. Make a rim by twisting 2 ¼-inch-wide strips of dough together and bending them around the edge of the basket. Brush the edges of the cooked basket with egg white, then press the twisted edging gently onto the basket. Brush the top with egg white. Bake the basket on the baking sheet at 325°F. for 20 to 30 minutes or until it is a light toast color.

How to Make Three-Dimensional Lion and Unicorn Christmas Ornaments

Supplies and materials needed: graph paper (optional), paper, pencil, ⅛ yard each tawny gold and off-white Facile Ultrasuede, scissors, thread, fine sewing needle, embroidery scissors, stuffing, index card, 2 strands matching gold and off-white needlepoint yarn, #18 gauge wire, wire cutters, amber and blue beads, 5-inch piece of wired gold cord, tape (optional), metallic gold thread, scrap of purple Facile Ultrasuede or felt, 6-inch piece of ¼-inch-wide woven gold braid, white hobby glue, and short white golf tee.

This project is for those experienced hand-sewers who like a challenge! Approximately 5 inches tall, these whimsical creatures will make a special addition to your tree. The patterns may be enlarged using a copy machine or graph paper.

LION: Make paper patterns and label them as shown. Reverse the patterns and trace them carefully onto the wrong side of the fabric. Cut the number of pieces indicated. *Sew all pieces with wrong sides together.* Whipstitch Leg B to Body A along the outside of the leg from dot ① to dot ②. Stuff firmly. Whipstitch Leg D to Body C along the outside of the leg from dot ③ to dot ④. Stuff firmly. Whipstitch Body A to Body C starting at dot ⑤. Whipstitch up and around the head, down the back, and up 1 side of the tail to dot ⑥.

Make a pom-pom for the tail by cutting a strip of index card ⅝ x 3 inches. Cut a 6-inch strand of gold yarn and wrap 1 ply of the yarn around the card 4 times. Tie another ply of the yarn through the top of the loops, tie a knot, and wrap the ends around the top of the loops under the knot to form the pom-pom. Cut the loops at the other end. Trim evenly.

Working on the paper pattern for Body A, curve a piece of wire to conform to the shape of the tail with ½ inch extending into the body. Place the curved wire into the open side of the tail. Anchor the tied end of the pom-pom inside the tip of the tail. Start whipstitching the tail together. Add a tiny amount of stuffing at the tip and continue sewing, stopping every ¼ inch to add a bit of stuffing. Sew the 2 sections together securely at the base of the tail and continue to dot ⑦. Whipstitch the rump of Body C to Leg B from dot ⑦ to dot ④ on Body C. Fasten Body A to Body C securely at dot ①. Stuff the head firmly and partially stuff the body. Whipstitch Chest E to Body A from dot ⑤ to dot ①. Whipstitch Chest E to Body C from dot ⑤ to dot ③. Stuff firmly and close, tucking the upper part of Leg D under Chest E as needed.

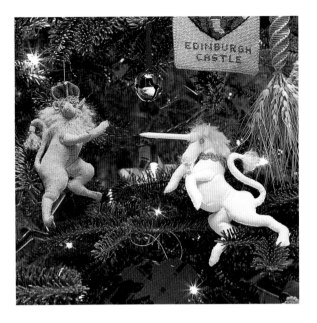

Mane: Using 1 ply of the yarn, make ⅛-inch backstitches across the back of the neck as indicated on the pattern, making a series of ½-inch-long loops. Make approximately 6 more rows of loops ⅛ inch apart to cover the back of the head as indicated. Stitch a row around the face as indicated. Cut each of the loops in half. Open and separate the yarn with the point of the needle to make it resemble fur. Trim as needed.

Snout: Whipstitch the 2 pieces of Snout G between the dots as indicated, leaving the

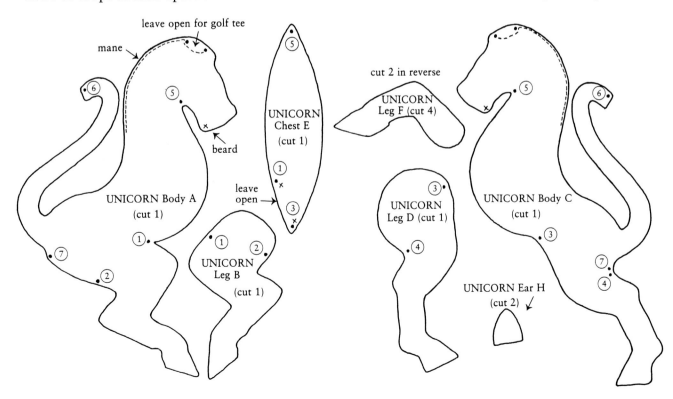

leave open for golf tee

mane

beard

UNICORN Body A (cut 1)

UNICORN Chest E (cut 1)

leave open

UNICORN Leg B (cut 1)

cut 2 in reverse

UNICORN Leg F (cut 4)

UNICORN Leg D (cut 1)

UNICORN Body C (cut 1)

UNICORN Ear H (cut 2)

larger back portion open. Stuff. Whipstitch the flaps to the face on Body A.

Front legs: Whipstitch the front Legs F together, stuffing firmly as you work. Sew to the body with the left leg pointing upward and the right leg pointing forward as shown in the picture.

Eyes: Sew 2 amber beads on the upper part of the snout.

Ears: Fold each Ear H in half vertically and whipstitch each bottom edge together. Attach near the eyes with the openings facing the front.

Crown: Wrap the ends of the wired gold cord with tape or thread to prevent fraying. Referring to the photograph, bend the cord to form a rounded loop about $1/2$-inch high x $3/4$-inch wide with a depression in the center. Bend the cord at a right angle to the loop and curve it out and back slightly. Bend the cord at a right angle to form another loop that crosses the middle of the first loop. Bend the cord again at the base to make another curve to meet the end of the first loop. Trim the excess wire; tape or wrap the cut end to prevent fraying. Tack the "crown" onto the head. Tie the crossing with metallic thread. Make tiny gathering stitches around the edge of Crown I and pull tight to form a cap. Insert Crown I into the center of the "crown" and position it with the tip of the needle. Cut a piece of braid to fit around the base of the crown. Coat the ends of the braid with white hobby glue. Wrap the braid around the base of the crown and tack the overlapping edges with metallic thread.

Hanger: Sew a hanger into the top of the head.

UNICORN: Referring to the above directions, join Leg B to Body A, Leg D to Body C, and Body A to Body C, leaving the area between the dots on the top of the head open. Insert the golf tee between the dots on the top of the head. Sew and stuff the tail as above. Whipstitch the rump of Body A across Leg D. Join Leg B to Leg D, ending at dot ③. Stitch Chest E to Body C from dot ⑤ to dot ③. Stitch Chest E to Body A from dot ⑤ to dot ①. Stuff firmly and close. Sew and stuff the front Legs F. Place the right leg pointing upward and the left leg pointing forward. Using 1 ply of the yarn, stitch the mane as indicated. Stitch the beard onto the chin. Separate the strands to make the yarn hairlike. Add the blue beads for the eyes; add the ears. Add the gold braid for the collar. Sew a hanger to the head.

SHERRY CHEESE HEDGEHOG

12 ounces cream cheese
4 cups extra sharp Cheddar cheese, grated
$1/4$ cup sherry
1 teaspoon curry powder
$1/2$ teaspoon salt
$1/2$ teaspoon cayenne
$1 1/2$ cups slivered almonds, toasted
currants
nutmeg

Combine the cheeses, sherry, curry powder, salt, and cayenne in a food processor. Chill for several hours. Form a mound for the body with $3/4$ of the mixture. Insert slivered almonds into the chilled cheese mixture for the spines. Model the face and ears from the remaining mixture. Use currants for the eyes. Color the face and ears with a shake of nutmeg. Chill. NOTE: Do not add the almonds too far ahead or they will get soggy.

A hedgehog to bring good luck nestles in a bed of parsley and winter kale with red pepper crescents. His currant eyes and toasted almond spines lend a feeling of reality. Sprigs of holly and white pine and nandina and holly berries brighten the small pine cone tree.

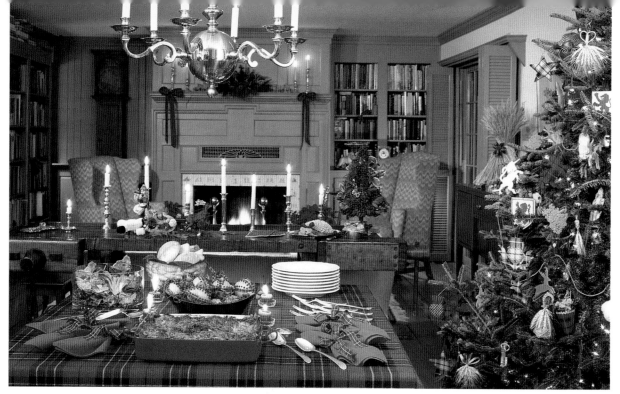

An old toleware bread tray filled with bright lemons, King's Arms Tavern china, shell pattern silver, red napkins tied with tartan ribbon, rolls in a basket made from dough (see page 117), a crisp salad of fresh mixed greens, mushrooms, and walnuts, and a piping hot southern version of lasagna are assembled on a tartan cloth. A cheerful fire burns in the background.

LASAGNA WITH VIRGINIA HAM AND ZUCCHINI

8 servings

1 cup onions, finely chopped
4 cloves garlic, minced
4 tablespoons peanut oil, divided
2 cans (28 ounces each) crushed Italian plum tomatoes
1 can (6 ounces) tomato paste
2 teaspoons basil
2 teaspoons thyme
1 tablespoon oregano
½ cup parsley, chopped
2 tablespoons sun-dried tomatoes packed in olive oil, chopped
1 teaspoon pepper
8 ounces lasagna noodles
2 medium zucchini, grated
1½ pounds mushrooms, thinly sliced
2 tablespoons lemon juice
¼ pound Virginia ham, thinly sliced
8 ounces goat cheese

8 ounces mozzarella cheese, grated
1½ cups Parmesan cheese, grated

Soften the onions and garlic in 2 tablespoons of peanut oil over medium heat. Stir in the tomatoes, tomato paste, basil, thyme, oregano, parsley, sun-dried tomatoes, and pepper. Bring the sauce to a boil, reduce the heat, and sim-

mer, uncovered, for 30 minutes, stirring occasionally. Meanwhile, cook the noodles according to the package directions. Preheat the oven to 350°F. Sauté the zucchini in 1 tablespoon of peanut oil and reserve. Sauté the mushrooms in the remaining tablespoon of oil and the lemon juice and reserve. Cover the bottom of a 13-inch x 9-inch x 2-inch baking pan with 1 cup of sauce. Alternate layers of ⅓ of the noodles and remaining sauce, ½ of the ham, mushrooms, and goat cheese, and ⅓ of the mozzarella and Parmesan. Repeat, adding all the zucchini after the second layer of sauce. End with a layer of noodles and sauce and top with the remaining mozzarella and Parmesan. Bake at 350°F. for 40 to 50 minutes until lightly browned and bubbling. Allow to stand for 20 minutes before serving.

Lemon pomanders (see page 126) tied with tartan bows carry out the Scottish theme. Rosemary, white pine sprigs, yarrow, and nandina berries are tucked in for added color.

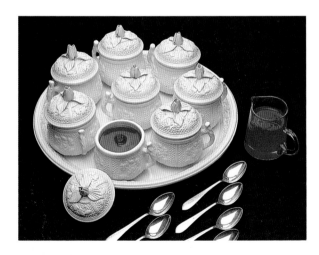

FROZEN CRANBERRY MOUSSE
8 servings

1½ cups cranberries
½ cup water
⅔ cup sugar, divided
rind from ½ orange, grated
2 eggs
½ teaspoon vanilla
pinch of salt
1 cup whipping cream
cranberry liqueur

Cook the cranberries in the water with ⅓ cup of the sugar and the orange peel for 5 minutes or until the berries begin to burst. Drain the cranberries and puree them in a food processor, then press the mixture through a sieve. Beat the eggs until light and fluffy. Gradually beat in the rest of the sugar. Combine the eggs with the strained cranberry mixture, vanilla, and salt. Whip the cream until stiff. Fold the cranberry mixture into the cream. Freeze until firm. Remove from the freezer a few minutes before serving. Pour 1 teaspoon of cranberry liqueur over each serving.

CHRISTMAS MORNING BREAKFAST

In the kitchen of the eighteenth-century Grissell Hay Lodging House, which faces Market Square, a holiday breakfast is laid out on a table near the fire. A kitchen wreath is flanked by two bay leaf trees with cinnamon stick trunks. The fragrances of fresh herbs, orange pomanders, hot coffee, and newly baked muffins greet the family on Christmas morning.

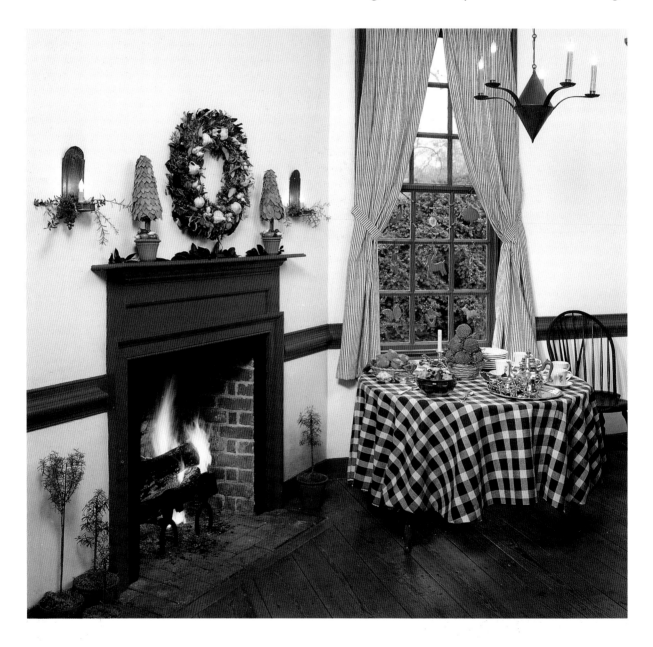

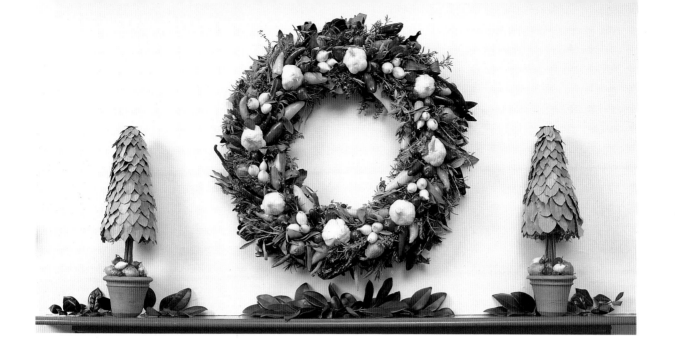

How to Decorate a Straw Wreath

Supplies and materials needed: straw wreath, chenille wire, 3-inch unwired green floral picks, fern pins, toothpicks, peppers, garlic heads, pearl onions, shallots, and conditioned plant materials (see page 152).

Undecorated straw wreaths are widely available. Here fresh herbs form the base for a large and colorful kitchen wreath. Although this form can be used to make a dried wreath, fresh materials are easier to use.

Wrap a chenille wire around the form and twist the ends into a loop. This hanger marks the top of the wreath. Fasten bunches of sage, rosemary, lavender, thyme, and bay leaves to the straw base with the fern pins as shown, overlapping the bunches to cover the cut ends. Cover the surface completely.

Position the garlic heads and any other dominant shapes or colors around the wreath to determine the number needed and the overall design. Impale the garlic on floral picks and insert them into the form. Impale the pearl onions on individual toothpicks and insert them into the form in groups of 3. Attach the flat dried red peppers with fern pins. Impale the shallots and other peppers on toothpicks and insert. Be careful to distribute colors and shapes to create an interesting design.

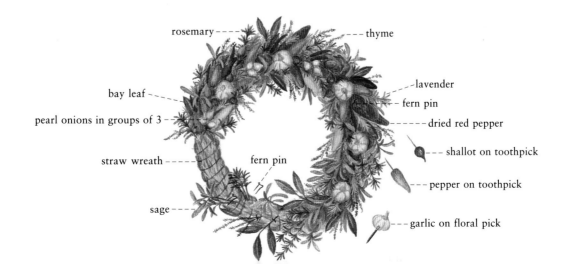

rosemary --- thyme
bay leaf --- lavender
--- fern pin
pearl onions in groups of 3 --- dried red pepper
--- shallot on toothpick
straw wreath --- fern pin
--- pepper on toothpick
sage --- garlic on floral pick

125

How to Make Pomanders

Supplies and materials needed: unblemished firm oranges, lemons, limes, or kumquats, bamboo skewers, whole cloves, ground cinnamon, allspice, nutmeg, and orrisroot.

Pungent fruit pomanders create an inviting aroma and also make welcome Christmas gifts.

TO MAKE TRADITIONAL POMANDERS like those shown on the opposite page, wash the fruit and dry it thoroughly. Starting at one end, make holes ⅛- to ¼-inch apart in the fruit with a skewer. Insert the stem end of whole cloves. Cover the entire surface of the fruit. Roll the fruit in equal parts of cinnamon, allspice, nutmeg, and orrisroot until it is completely covered. Allow it to dry. The pomander will shrink and harden as it dries. When dry, it can be placed in a bowl or wrapped in fabric and ribbons to use as a sachet. The pomander will last indefinitely.

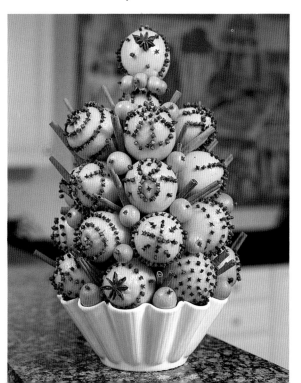

TO MAKE POMANDERS WITH DESIGNS like the ones below, draw a design on the surface of the washed and dried fruit. Make holes ⅛- to ¼-inch apart on the design. Wipe the fruit to remove the lines. Insert the cloves into the punctures. Pomanders made in this manner stay fragrant and colorful for several days.

PEAR MUFFINS *18 servings*

½ cup butter
1 cup sugar
2 eggs
2 cups all-purpose flour
2 teaspoons baking powder
½ teaspoon baking soda
½ teaspoon salt
⅔ cup buttermilk
1 teaspoon vanilla
1 cup ripe pears, chopped
½ cup walnuts, chopped
½ teaspoon cinnamon
⅛ teaspoon nutmeg
rind of 1 lemon, grated

Preheat the oven to 375°F. Grease muffin tins that are 2½ inches in diameter. Cream the butter and sugar until light and fluffy. Add the eggs, 1 at a time, beating well after each addition. Sift the flour, baking powder, baking soda, and salt together. Add the flour mixture alternately with the buttermilk and vanilla, mixing just until blended. Do not overmix. In a bowl combine the pears with the walnuts, cinnamon, nutmeg, and lemon rind. Gently fold into the batter. Spoon into the

A striking lemon cone (see page 68) is studded with cloves and star anise. Cinnamon sticks and clove-decorated tiny ornamental oranges and kumquats are tucked between the lemons.

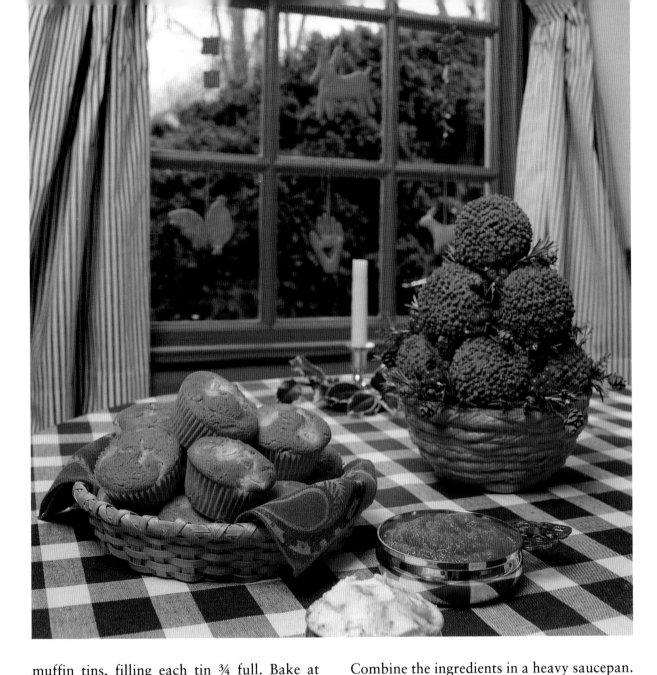

muffin tins, filling each tin ¾ full. Bake at 375°F. for 25 minutes or until nicely browned. Serve warm with apple butter.

APPLE BUTTER *1 cup*

2 cups unsweetened applesauce
⅓ cup sugar
1 teaspoon cinnamon
¼ teaspoon allspice
⅛ teaspoon ginger
⅛ teaspoon cloves

Combine the ingredients in a heavy saucepan. Bring to a boil, lower the heat, and cook, stirring frequently, 45 minutes to 1 hour, or until the mixture has thickened.

Above: Piping hot pear muffins are served with spicy apple butter and sweet cinnamon butter. A coiled dough basket (see page 117) is piled high with fragrant pomanders. Sprigs of hemlock greens and cones, rosemary, and red pyracantha berries are tucked in for color. Gingerbread cookies (see page 95) hang in the window.

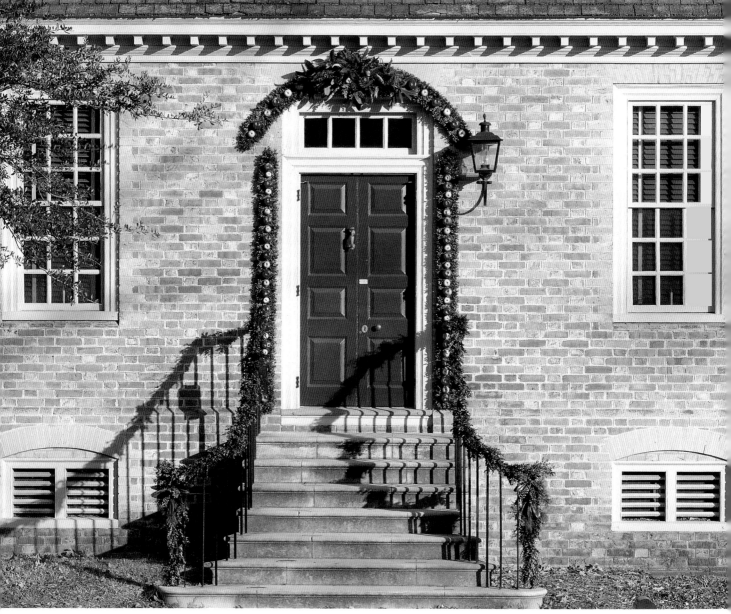

A striking design frames the doorway at the Red Lion. Narrow plywood strips to which boxwood sprigs have been stapled have upward-slanting nails that hold red delicious apples alternating with lady apples. A similar but curved form mounted above the door includes a cluster of greens, cones, pods, apples, and rose hips.

CHRISTMAS DAY IN WILLIAMSBURG

Christmas in Williamsburg is full of activity, with a number of memorable events scheduled for guests including caroling, other musical programs, and special decorations tours. Many Williamsburg families and their friends enjoy time-honored Christmas day activities and entertainments in homes that have been decorated inside and out with traditional and imaginative creations. The following pages contain ideas for decorating throughout the house. We encourage you to try some of them with family members.

How to Make a Newel Post Decoration

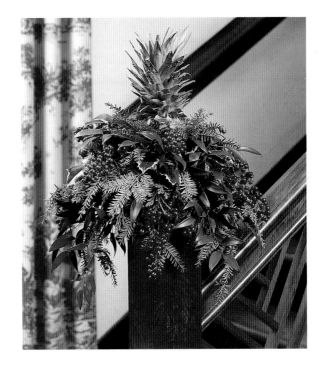

Supplies and materials needed: domed plastic floral foam holder (3¼ inches tall x 3⅜ inches in diameter), floral preservative, chenille wire, 4-inch green floral pick, sharp knife, clippers, small pineapple, berries, and conditioned plant materials (see page 152).

A domed holder is a useful accessory. It can be positioned horizontally or vertically or perhaps used in a wire topiary form (see page 151). This example uses a pineapple top, sprigs of variegated holly, Alexandrian laurel, hemlock, and pyracantha and nandina berries to form a graceful decoration.

Soak the holder in water to which floral preservative has been added. Dry the bottom of the holder thoroughly and place it on top of the newel post. Join the ends of 2 or more chenille wires to form 1 wire that is long enough to anchor the holder securely under the molding of the newel post as shown.

Remove the lower foliage on 6- to 8-inch pieces of hemlock, Alexandrian laurel, and variegated holly and insert the foliage into the floral foam. Arrange the greenery evenly around the form, distributing the different materials in an interesting manner. Cut the top from a small pineapple, impale the top on the floral pick, and insert it into the form as shown. Add sprigs of berries for color.

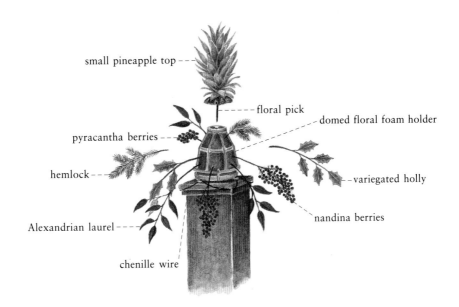

small pineapple top

floral pick

domed floral foam holder

pyracantha berries

hemlock

variegated holly

nandina berries

Alexandrian laurel

chenille wire

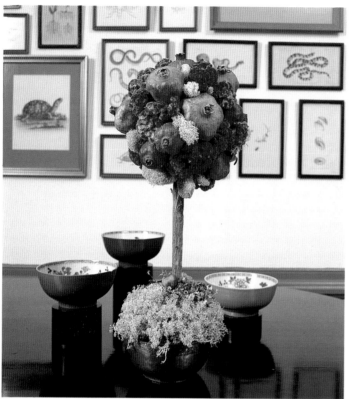

Upper left: A plastic foam ball impaled on a branch set in plaster of paris (see page 48) is covered with celosia, dried pomegranates, and reindeer moss. Lichens, reindeer moss, and a tiny pomegranate measuring 1 inch across decorate the base.

Lower left: Rows of lady apples in graduated sizes ascend a wooden cone topped with a miniature pineapple (see page 68). Red globe amaranth and rose hips are added as accents.

Lower center: Spirals of lemons, plums, and Seckel pears encircle a wooden cone (see page 68). Variegated ivy and boxwood are tucked in around the fruit, and variegated aucuba leaves are placed around the base.

Lower right: A small cone on a wire form (see page 55) is covered with miniature Kingsville boxwood and spirals of pyracantha berries. Hemlock and alder cones, acorns, and white strawflowers add interest. The cone is impaled on a group of twigs set in plaster of paris (see page 48).

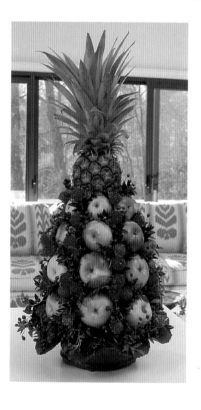

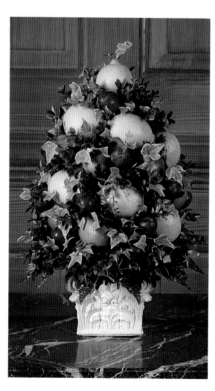

A kissing ball of variegated pittosporum, white carnations, and red roses hangs from a brass chandelier at Carter's Grove.

How to Make a Kissing Ball

Supplies and materials needed: ½ block floral foam, floral preservative, garden netting or chicken wire, scissors, twine, wire cutters, #18 gauge green floral wire, ribbon, spool wire, clippers, tray, and conditioned plant materials (see page 152).

Kissing balls are always popular at Christmas, especially in Williamsburg. This example features lovely variegated pittosporum. Boxwood, ivy, and herbs are three of many other plant materials that may be used.

Soak the floral foam in water to which floral preservative has been added. Wrap the wet floral foam with garden netting or chicken wire. Tie the gathered netting securely at the top and bottom with twine as shown. If chicken wire is used, cut the wire, bend it around the foam, and secure it with floral wire. Push a 10-inch piece of #18 gauge floral wire through the center of the foam. Make a large J-shaped hook at the bottom end. Secure ribbon streamers to the J-hook with a piece of spool wire. Pull the wire back up through the foam so that the hook catches in the tied ends of the netting or wire and becomes embedded in the foam. Make a loop for hanging at the top of the wire. Hang the kissing ball at a convenient working height and work over a tray to catch the drips as the plant materials are inserted.

Remove the lower foliage on 4-inch pieces of pittosporum. Insert the pittosporum into the foam to cover the form in a solid and nicely rounded manner. Add roses and carnations with stems cut short, distributing the flowers around the form. View the kissing ball from all sides and make any adjustments necessary. Attach a wired ribbon bow to the loop at the top of the ball.

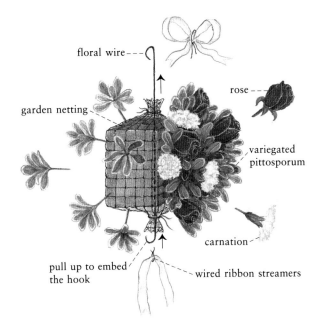

floral wire

garden netting

rose

variegated pittosporum

carnation

pull up to embed the hook

wired ribbon streamers

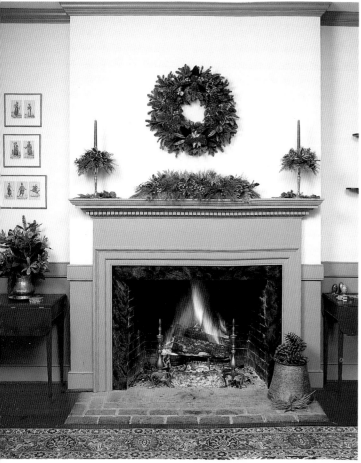

Longleaf holly leaves, okra pods, celosia, cotton bolls, and nandina berries accent the wreath.

This form will dress up a table or mantel with greens and berries or fresh flowers. The foam insert can be replaced easily and the form may be used without a candle to create a tall cascade.

Soak the foam in water to which floral preservative has been added. Put the adapter into the candlestick and insert the candle holder as shown. Remove the lower foliage on 5-inch pieces of the greens and insert them into the foam. Be sure to conceal the adapter. Add sprigs of variegated holly and berries for accents. Add the candle. Keep the foam wet to extend the life of the plant materials.

Shown above and opposite are four ways to decorate a mantel. Here, pods, cones, chinaberries, a variety of foliage sprigs, and red celosia and nandina berries form a ring around a large balsam wreath. Similar materials are arranged in a chicken feeder filled with floral foam. A pair of brass candlesticks are adapted to hold a cascade of greens and berries.

How to Make a Candlestick Cascade

Supplies and materials needed: plastic candlestick adapter with floral foam insert, floral preservative, plastic candle holder insert, candlestick, candle, and conditioned plant materials (see page 152).

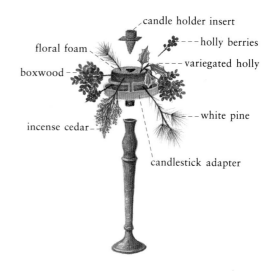

candle holder insert

floral foam

holly berries

boxwood

variegated holly

incense cedar

white pine

candlestick adapter

White pine, arborvitae, balsam, chamaecyparis, and variegated holly are arranged in a chicken feeder filled with floral foam. Three loblolly cones are wired to picks which are inserted into the foam, and small black pine cones are secured at the front. White heather and nandina and holly berries add contrast. Straw deer flank the arrangement.

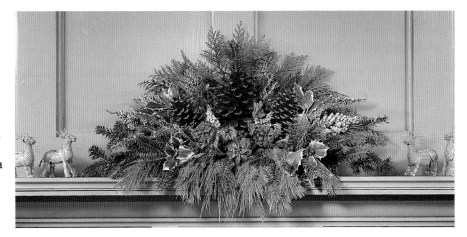

Triangular arrangements of magnolia leaves, spruce cones, lady apples, chinaberries, boxwood, and a shiny red pear are secured on picks in blocks of plastic foam. A Gala apple is ringed with chinaberries and framed with boxwood sprigs in the center of the mantel.

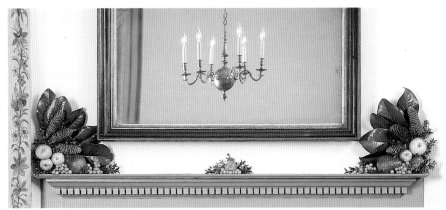

The large pineapple in the center is set off by the small ornamental pineapples, shiny longleaf holly leaves, and red nandina foliage and berries on either side. Pineapple-shaped ivy topiaries (see page 5) are placed at the corners of the mantel.

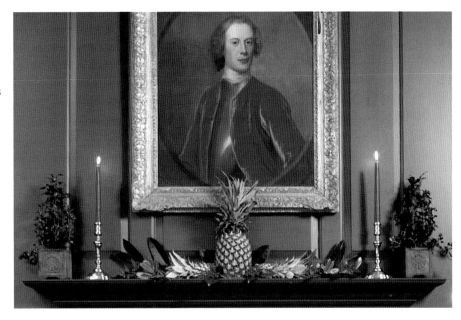

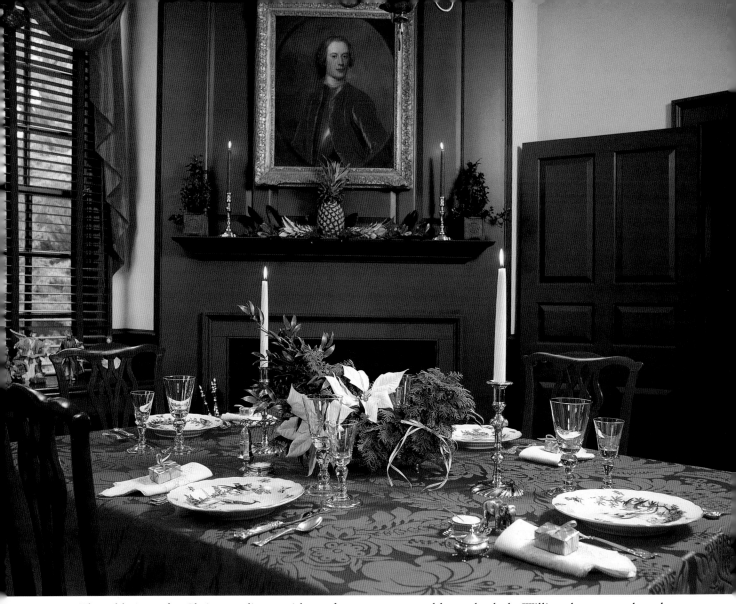

The table is set for Christmas dinner with a soft pomegranate red brocade cloth, Williamsburg crystal, and Chelsea Bird plates. The fanciful floral bird echoes the central motif on the china and the large floral shapes in the tablecloth. Small gold favor boxes lend a festive air.

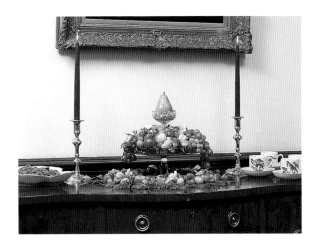

In an adaptation of one of the most popular eighteenth-century centerpieces (see page 82), a goblet holding a beautiful pear on a bed of chopped candied ginger is placed on a modern glass cake stand and surrounded by an arrangement including grapes, Seckel pears, small oranges, kumquats, and lady apples. Freesia blooms, Alexandrian laurel, and ivy are tucked in. Fruits, berries, marzipan, and blossoms on a bed of chamaecyparis form a wreath around the stand.

How to Make a Floral Foam Bird

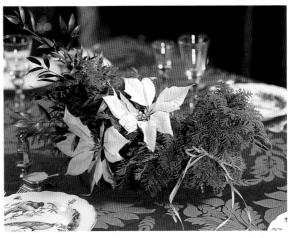

A pheasant made of feathery chamaecyparis foliage, Alexandrian laurel, and large cream and pink-tinged poinsettias is a flamboyant centerpiece on this Christmas table.

Supplies and materials needed: 2 blocks of floral foam, 6-inch unwired green floral picks, sharp knife, floral preservative, shallow tray or plate, ribbon, berries, and conditioned plant materials (see page 152).

A variety of birds, animals, and other shapes can be made by using the techniques shown here. They will stay fresh if the floral foam is kept watered.

Position the blocks of floral foam as shown and draw the outline of a bird on them with a floral pick. Carefully cut away the unwanted floral foam with a sharp knife. Taper the head area. Soak the pieces of floral foam in water to which floral preservative has been added.

Arrange the wet floral foam on a shallow plate or tray. Insert floral picks to secure the 2 parts as shown. Remove the lower foliage on

3-inch pieces of chamaecyparis (false cypress) and insert the pieces into the floral foam to cover the form. Be careful to give a tapered look to the head. Insert 2 Alexandrian laurel leaves for the beak and a small bunch of nandina berries for the eyes as shown. Insert long arching pieces of Alexandrian laurel and longer pieces of chamaecyparis for the tail as shown. Insert the stems of poinsettia blooms (see page 152) into the floral foam. Tie a bow around the neck. Keep the bird well watered.

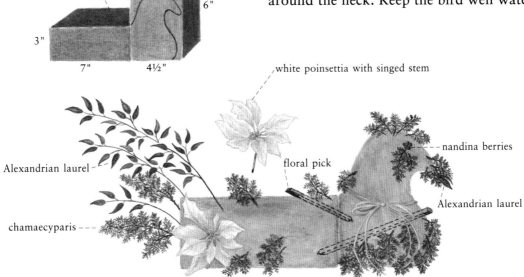

How to Make Spice Ball Ornaments

A tiny Noah's ark, a gingerbread horse, a chain of light and dark raisins, and a cinnamon heart are sure to delight young and old.

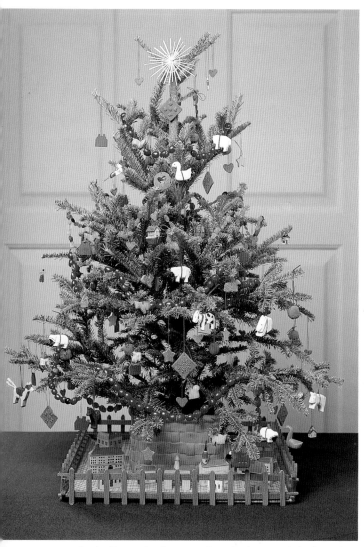

A small tree is decorated with chains of dark and light raisins and cranberries, miniature toys and animals, beeswax animals originally used to coat sewing thread, gingerbread cookies, and spice balls and medallions made from an old recipe. A wooden toy village is arranged around the base behind an old fence.

Supplies and materials needed: 1 can (3 pounds) unsweetened applesauce, 4 tablespoons arrowroot, 2 cans (3¾ ounces each) cinnamon, 1 can (1⅛ ounces) cloves, 1 can (1⅛ ounces) nutmeg, ⅛-inch red ribbon, small crochet hook, whole cloves, and scissors.

Round spice balls or cutouts can be made easily from this fragrant dough by children and adults alike.

Drain the applesauce at room temperature in a strainer over a dish for 2 days or until it is very thick and has stopped dripping. Spoon it into a mixing bowl and add the arrowroot and spices. Mix well. To make a spice ball, roll a piece of dough into a walnut-sized ball. Fold an 8-inch piece of the ribbon in half. Push a crochet hook through the center of the ball. Catch the loop of the ribbon and pull it back through the hole. Insert a whole clove in the loop before pulling the ribbon tight. The clove will keep the ribbon from pulling out of the ball. Knot the cut ends of the ribbon to make the hanger. Tie a bow at the top of the ball.

The dough can also be rolled out and cut into shapes with small cookie cutters. Designs can be made by pricking the dough with toothpicks or by pressing small metal stencils into it. Make a hanger hole with a toothpick, air dry the shapes on a rack, and hang them with red ribbon or string.

A tree with widely spaced branches displays a large number of treasures. Old toys saved through the years *(upper left)*, needlework ornaments reflecting an owner's hobby *(lower left)*, cherished gifts from friends, and objects made into unexpected decorations create a tree that invites examination. A Scottish terrier rests beside the companions of her family's childhoods.

Birds of all feathers, whose presence was recorded by the colonial naturalists Mark Catesby and John Lawson and who still inhabit Williamsburg's gardens and woods, are found on this tree with their favorite berries, cones, fruits, and nuts. The cardinal, Virginia's state bird, hangs in the center.

How to Make a Cardinal

Supplies and materials needed: graph paper (optional), pencil, ⅛ yard red Facile Ultrasuede, scrap of black Facile Ultrasuede, scissors, needle, thread, stuffing, and 2 black beads.

These birds can be made in any size. The one shown is 4 inches from the tip of the beak to the tip of the tail.

Enlarge the pattern on a copier or graph paper. Cut the pieces as indicated on the pattern. With the wrong sides together and leaving the tail end open, whipstitch the body pieces together. Stuff. You may need to stuff smaller birds as you sew them. With the wrong sides together and leaving the narrow end open, whipstitch the tail pieces together. Do not stuff the tail. Flatten the open end of the tail. Holding the tail perpendicular to the body, whipstitch the tail to the body. With the wrong sides together, whipstitch the wings above the dots. Open the unsewn ends of the wings and place them on either side of the bird. Whipstitch the wings to the body. Fold the black mask with the wrong sides together and join the ends. Place the mask around the beak with the seam side under the beak and secure it to the body. Add the beads for the eyes. Make a yarn or thread ornament hanger.

How to Make Embroidered Fabric Hearts and Circles

Supplies and materials needed: contrasting colors of closely woven fabric, felt, or Ultrasuede, scissors, needle, perle cotton or buttonhole thread, sewing thread, and stuffing.

The directions below are for making circles and hearts reminiscent of nineteenth-century penny rugs, but the same technique can be used to make hearts based on traditional Hmong hearts, ancient symbols of love and long life.

Cut 2 circles or hearts of the same size. Cut smaller circles or hearts of contrasting colors and attach them to the larger pieces with embroidery stitches. With the wrong sides together, stitch the edges of the 2 larger pieces together with a decorative embroidery stitch such as the buttonhole stitch. Leave an opening through which to insert the stuffing. Stuff. Close and add a thread hanger.

The small Hmong red and green heart was made with reverse appliqués, trapunto,

and embroidery. The design has been adapted on the larger red heart with an appliquéd white double spiral. The gold cord on the tartan heart was couched on the right side, then the two pieces were sewn with the right sides together, turned, and stuffed. The opening was sewn shut and a thread hanger added.

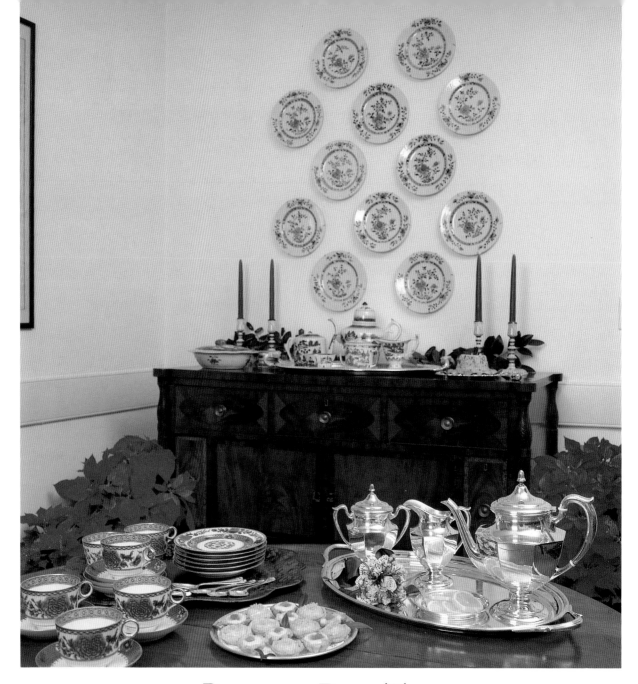

BOXING DAY TEA

Blue and white porcelain has long been cherished and used in America. In this dining room are examples from three centuries. Plates from the Nanking cargo, salvaged intact a few years ago from a Dutch ship that sank in the South China Sea in 1752, are mounted on the wall. The Canton tea set on the sideboard was made in China in the nineteenth century. Attractive teawares like these were imported to this country in great quantities. The table is set for tea on Boxing Day, the English holiday which was observed in colonial Virginia, and features Williamsburg's Imperial Blue porcelain, adapted from eighteenth-century Chinese pieces in Colonial Williamsburg's collection.

A rich nutcake, made from an old Virginia family recipe, is surrounded by kumquats, ornamental oranges, and Burford holly leaves.

VIRGINIA HOLIDAY NUTCAKE

2 pounds golden raisins
¼ pound glacé red cherries, cut up
¼ pound glacé green pineapple slices, cut up
1¾ cups sherry, divided
2 cups butter, softened
3 cups sugar
12 eggs, separated
juice of 1 lemon
1 tablespoon vanilla
6 cups all-purpose flour
5¼ cups almonds, chopped
6 cups walnuts, chopped
⅔ cup black walnuts, chopped

Soak the raisins, cherries, and pineapple in ¾ cup of the sherry overnight in a covered container. Preheat the oven to 300°F. Grease well and lightly flour 1 10-inch, 2 8-inch, and 1 5-inch tube pans. Cream the butter and sugar. Add the egg yolks 1 at a time. Combine the remaining sherry, lemon juice, and vanilla. Add the flour and the sherry mixture alternately, beginning and ending with the flour. Beat the egg whites until they form soft peaks. Add the nuts, fruit, and egg whites alternately, stirring until well blended. Transfer the batter into the prepared pans and bake at 300°F. Bake the smallest cake for ¾ to 1 hour, the 2 medium cakes 1¼ to 1½ hours, and the large cake for 2 to 2½ hours, or until each tests done.

Irish lemon curd tarts garnished with lemon zest and sweet vanilla cream custard tarts with an apricot glaze look inviting.

IRISH LEMON CURD TARTS *2 dozen*

2 eggs
2 egg yolks
½ cup sugar
rind of 4 lemons, grated
⅔ cup lemon juice
1 cup butter, melted
24 small baked tart shells

Beat the eggs, egg yolks, and sugar. Beat in the grated lemon rind, lemon juice, and butter, and pour the mixture into the top of a double boiler. Cook the mixture, stirring constantly, over hot water until it has thickened. Cool, cover, and refrigerate. Fill the baked tart shells with the chilled mixture.

On the tea tray is a special favor for the guest of honor: a delicate tussie-mussie tied with a dark blue bow. Rosemary foliage accents the yellow flowers and the rose at the center.

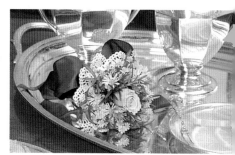

AN INFORMAL HOLIDAY SUPPER AT THE RUSSELL HOUSE

With many formal occasions planned during the holidays, it is always a treat to be invited to a relaxing informal supper. At the Russell House, guests gather around the fire for a bowl of chili before going out into the icy December night to enjoy the bonfires, candlelit homes, and special activities along Duke of Gloucester Street.

A cheerful Father Christmas surveys a steaming bowl of chili surrounded by chopped red and yellow peppers, minced scallions, grated sharp Cheddar cheese, sour cream, and piping hot corn bread.

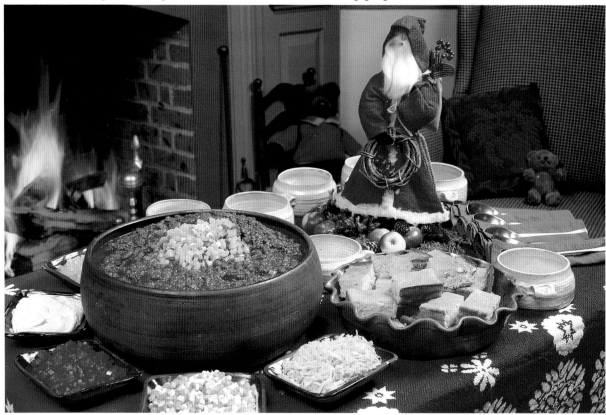

TIDEWATER CHILI *18 to 20 servings*

4 large onions, chopped
4 cloves garlic, minced
$^{1}/_{3}$ cup peanut oil
3 cans (28 ounces each) Italian plum tomatoes
2 cans (29 ounces each) tomato puree

2 teaspoons oregano
1 teaspoon crushed red pepper or to taste
1 tablespoon salt
1$^{1}/_{2}$ tablespoons basil
$^{1}/_{3}$ cup chili powder
2 tablespoons cumin
2 pounds Surry County, Virginia, smoked

sausage or Italian smoked sausage
5 pounds lean chuck
4 cans (15 ounces each) red kidney beans, drained

Sauté the onion and garlic in the peanut oil over medium heat. Stir in the tomatoes, tomato puree, and herbs and spices and simmer while cooking the meats. Cut the sausage into ½-inch pieces and brown. Drain and add to the mixture. Brown the chuck in small batches; drain and add to the mixture. Simmer for 1 hour. Add the beans.

CRANBERRY CHEESECAKE

4 tablespoons butter
1⅓ cups graham cracker crumbs, divided
1 cup plus 6 tablespoons sugar, divided
1 teaspoon cinnamon
3 packages (8 ounces each) cream cheese
2 tablespoons lemon juice
4 eggs
½ cup light cream
1 cup sour cream
½ cup cranberries
¼ cup water

Preheat the oven to 350°F. Grease a 10-inch round cake pan. Combine the butter, 1 cup of cracker crumbs, and 4 tablespoons of sugar to make the dough for the crust and press it on the bottom of the prepared pan. Push down with a smaller pan to pack firmly. Sprinkle with cinnamon. Mix the cream cheese, 1 cup of sugar, and the lemon juice until smooth. Add the eggs 1 at a time. Add the light cream and the sour cream. Cook the cranberries with the remaining sugar and the water for 5 minutes or until the berries begin to burst. Cool, add to the cream cheese mixture, and pour the mixture over the crust. Place the cake pan in a

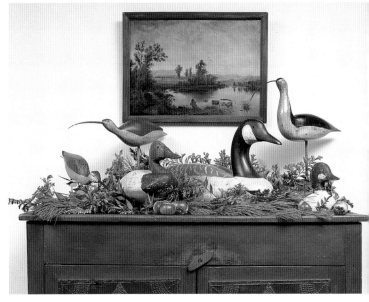

A collection of decoys made in nearby Gloucester County and on Virginia's Eastern Shore attest to the skills still practiced by Virginia artisans. They nestle among lady apples, nandina berries, and greens on the top of a nineteenth-century pie safe.

larger pan filled with enough water to come ⅔ of the way up the sides of the cake pan. Bake at 350°F. for 45 minutes or until the cheesecake is lightly browned and tests done. Cool and then freeze. Before serving, place the pan briefly on a hot burner, then unmold the cheesecake. Put the remaining crumbs on the sides and serve with cranberry sauce.

CRANBERRY SAUCE

2 cups cranberries
⅓ cup light brown sugar
2 teaspoons lemon juice
⅓ cup orange juice
rind of 1 orange, grated
1 tablespoon cranberry liqueur

Combine all of the ingredients and cook for 5 minutes or until the berries begin to burst. Chill.

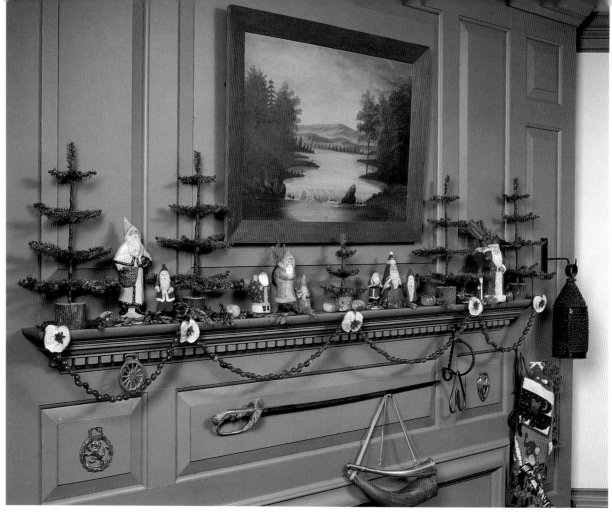

A collection of Father Christmas figures and feather trees are gathered along a paneled mantel beneath a mid-nineteenth-century landscape painting. Loops of cranberry chains and tiny lady apples add a touch of color.

Sweet gum branches are anchored into plaster of paris (see page 48) to form a small tree which emerges from a mossy bank surrounded by a low fence. Dried lady apple and kumquat slices, spice balls and hearts (see page 136), star anise, rose hips, and gingerbread cookies seem to tantalize the sheep gathered below. Modern versions of these sheep rest at the corner of the fence.

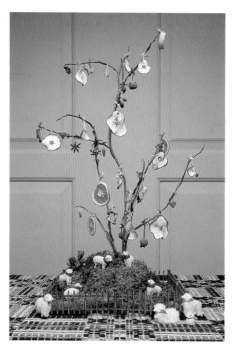

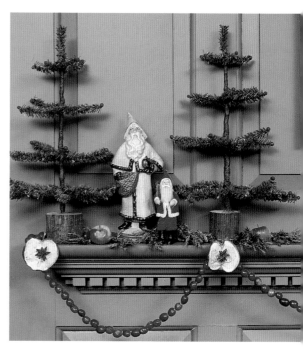

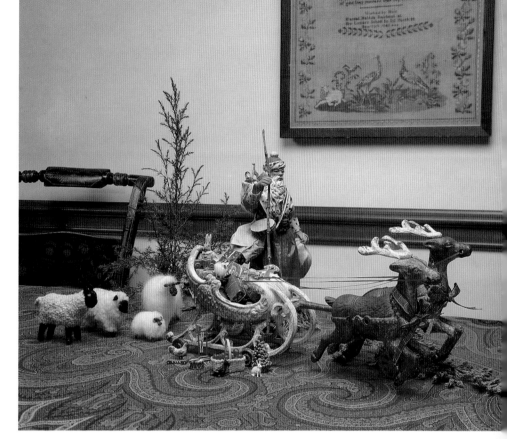

A nineteenth-century paisley shawl provides the background for two winter scenes created with family treasures and toys. *Upper*: Father Christmas stands beside an iron sleigh piled high with toys and packages and trailed by a flock of sheep. Reindeer are festively harnessed with tartan ribbon. *Lower:* A reproduction wooden village is arranged around a mirror lake bordered by a felt shoreline. Tiny lead figures skate across the ice. A delicate wreath of cedar accented with its own blue berries and red pyracantha berries encircles the scene.

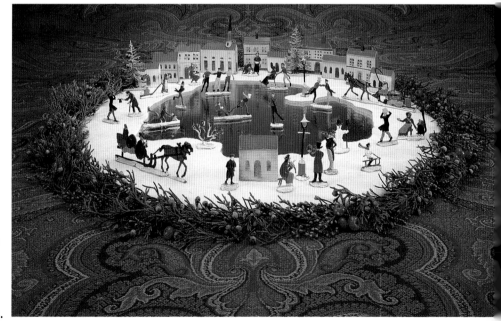

Opposite: An adaptation of the feather trees so popular in the nineteenth century is made from pruned artificial trees with nandina berries wired onto the ends of their branches. Star anise are secured to the centers of the dried apple slices that hold the cranberry chain in place.

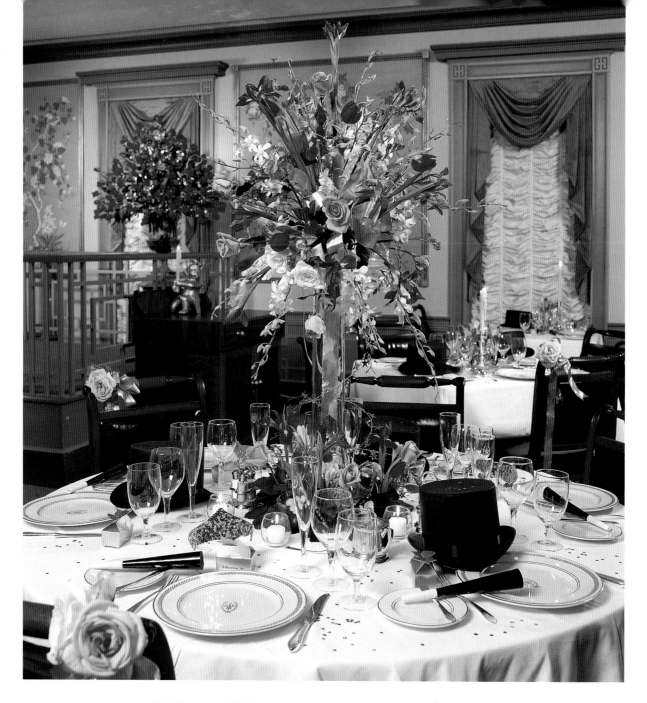

NEW YEAR'S EVE AT THE WILLIAMSBURG INN

New Year's Eve in the Regency Room of the Williamsburg Inn promises an evening of fine cuisine and entertainment in elegant surroundings. A tall crystal vase with a beautiful cascade of flowers is placed on a mirror in the center of the table and ringed with a wreath of colorful blooms springing up through galax leaves. Souvenir top hats for the gentlemen, coronets for the ladies, and special party favors are in place for the revelers.

New Year's Day
Open House

Virginians have long been tied to the water for abundant seafood, commerce, and pleasure. Friends gather in this contemporary home overlooking a tidal creek to welcome the New Year. Pots of white poinsettias from Christmas and narcissus and daffodil blossoms from forced bulbs forming a spring garden wreath herald the end of winter and the coming of spring. The wreath was inspired by the more formal ring of flowers opposite.

Okra gumbo made with oysters, tomatoes, and Virginia ham, parslied rice, highly seasoned traditional black-eyed peas, and a lemon pound cake encircled with marzipan lemons will satisfy the hungriest guest.

CARTER'S GROVE OKRA GUMBO WITH VIRGINIA HAM *10 to 12 servings*

2 quarts oysters and their liquor
6 tablespoons butter
¼ cup oil
½ cup flour
2 cups onion, chopped
1 red bell pepper, chopped
1 green bell pepper, chopped
1 cup scallion tops, thinly sliced
2 cloves garlic, finely minced
3 cups cold water
4½ cups Virginia ham, diced
3 teaspoons parsley, minced
1 pound okra, chopped
3 cans (28 ounces each) plum tomatoes and
 their juice
1 teaspoon salt
¾ teaspoon cracked black pepper
3 bay leaves
1 teaspoon thyme

1 teaspoon oregano
¼ teaspoon mace
¼ teaspoon cayenne or to taste

Drain the oysters and save the liquor. While the oysters are draining, melt the butter in a large pot over low heat. Add the oil. Cook over low heat for 2 minutes. Gradually add the flour and cook over low heat, stirring constantly, until the mixture thickens and is a medium brown color. Stir in the onion, peppers, scallion tops, and garlic. Add ¼ cup of the water and the ham. Mix thoroughly and continue to cook over low heat, stirring constantly, for 10 minutes. Add the parsley, oyster liquor, okra, tomatoes and their juice, and all of the seasonings. Gradually add the remaining water and bring the gumbo to a boil. Lower the heat and simmer for 1 hour, stirring frequently. Add the oysters and cook for 5 minutes more or until their edges begin to curl. Serve in deep bowls over rice.

SOUTHERN BLACK-EYED PEAS

10 to 12 servings

6 large links of Surry County, Virginia, smoked sausage, chopped
1 large onion
3 cloves of garlic, minced
2 packages (10 ounces each) frozen black-eyed peas
4 cups water
2 teaspoons fresh or 1 teaspoon dried rosemary, crushed
1½ teaspoons salt
¼ teaspoon pepper

Sauté the sausage in a large pot until lightly browned; drain. Add the onion and garlic and cook until softened. Add the peas, water, and seasonings. Heat to boiling, stirring frequently. Cover and simmer approximately 45 minutes or until the peas are tender. Add more water if the mixture becomes too dry.

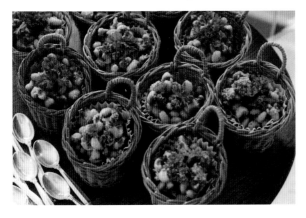

LEMON POUND CAKE

1 cup milk
5 eggs
1 teaspoon vanilla
1 teaspoon lemon extract
3 cups cake flour

½ teaspoon salt
½ teaspoon baking powder
3 cups sugar
2 tablespoons grated lemon rind
1 cup unsalted butter
⅓ cup shortening

Allow all of the ingredients to come to room temperature. Grease and flour a 10-inch tube pan. Line the bottom of the pan with waxed paper, then grease and flour the waxed paper. Combine the milk, eggs, vanilla, and lemon extract in a medium bowl. Set aside. Sift the flour, salt, and baking powder. Combine the flour mixture with the sugar in the large bowl of a mixer, add the lemon rind, and mix on low speed for 30 seconds. Add the butter, shortening, and half of the egg mixture. Mix on low speed until the dry ingredients are absorbed, then beat on medium speed for 1 minute. Add ½ of the remaining egg mixture and beat for 20 seconds. Add the rest of the egg mixture and beat an additional 20 seconds. Spoon the batter into the prepared pan and place it in a cold oven. Bake at 350°F. for 75 minutes or until the cake tests done. Cool in the pan 10 minutes, then finish cooling on a cake rack.

How to Make a Spring Garden Wreath

Supplies and materials needed: 10-inch diameter x 2-inch wide nail-studded wooden wreath form made in 2 halves, floral foam, knife, floral preservative, small tubes such as lipstick tube caps, plastic sandwich bags, fern pins, clippers, round plate or tray, two small potted primroses, and conditioned plant materials (see page 152).

January is a good time to enjoy forced bulbs, both in pots and as cut flowers. This example uses cut narcissus and miniature Tête-à-tête daffodil blooms in tubes, 2 potted plants in plastic bags, and foliage in floral foam. The halves of the form may also be arranged to make an S-curve.

Cut 6 blocks of floral foam to fit the form; taper the sides of the pieces. Soak the blocks in water to which floral preservative has been added. Impale the blocks on the nails. Place the small tubes between the blocks as shown and fill with water. Remove some of the dirt from the primroses and place each in a plastic sandwich bag. Put the primroses on opposite sides of the form in the areas without floral foam.

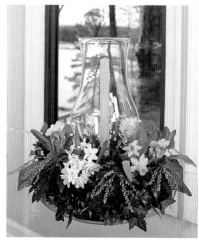

Insert long tendrils of ivy into the foam and encircle the inside, outside, and top of the form. Secure with fern pins. Remove the lower foliage from 2-inch pieces of boxwood and insert them into the foam to cover the form. Insert 4- to 5-inch sprigs of pieris japonica panicles and foliage. Place narcissus and daffodil blooms with 4- to 5-inch stems and foliage in the tubes. Place the wreath on a plate or tray to protect the table. Keep the tubes filled with water, the floral foam wet, and the primroses damp in their bags.

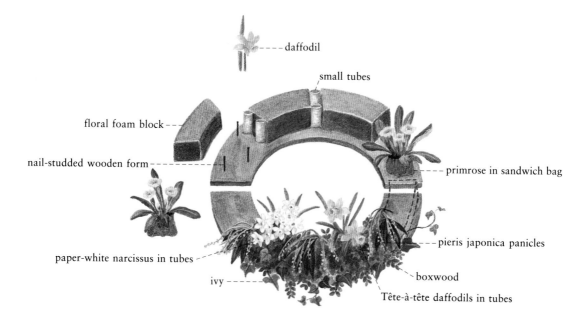

daffodil

small tubes

floral foam block

nail-studded wooden form

primrose in sandwich bag

pieris japonica panicles

paper-white narcissus in tubes

ivy

boxwood

Tête-à-tête daffodils in tubes

A large topiary covered with California ivy decorated with the blossoms from Christmas poinsettias and forced narcissus bulbs is outlined against a winter sunset. A domed holder (see page 129) was wired into the top section of the topiary, then filled with plant materials. Boxwood and Alexandrian laurel were inserted directly into the soil at the base. The blooms at the base were placed in floral tubes inserted into the soil.

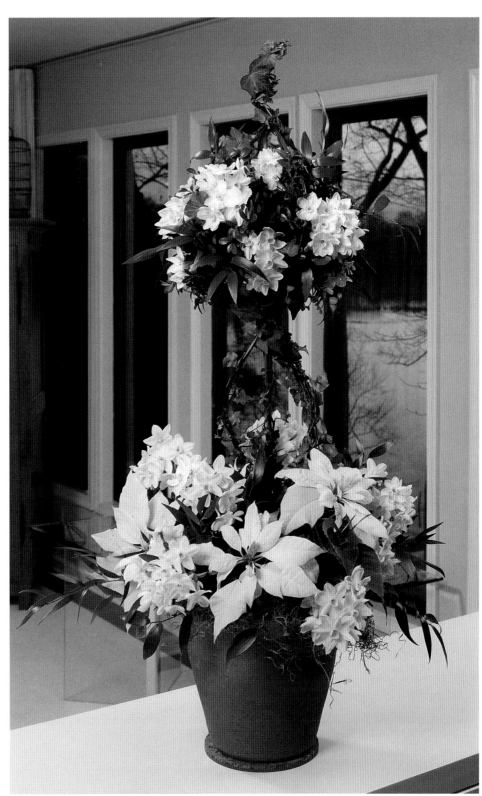

Conditioning and Use of Plant Materials

General Information and Suggestions

If you carefully condition the greens and flowers you use, your efforts will be well rewarded. Properly conditioned plant materials remain fresh much longer.

Before cutting or purchasing plant materials, be aware of protected species in your area. Do not use these materials even if they are available from a local vendor. For example, the amount of the slow-growing princess pine needed to make one wreath can represent a substantial loss in its original habitat.

Always use clean containers. Household bleach will kill most bacteria and other organisms. Rinse the bleached containers well.

When cutting, carry pails of water for the cut materials. Do not crowd the plant materials.

If your exterior decorations will be in full sun, select your materials accordingly. Cones, pods, and nuts will fare far better than fruit on a wreath that faces the sun for much of the day. Balsam or spruce will not dry out and turn brown as quickly as white pine. If you live in an area where the temperatures are frequently below freezing, remember that most fruits are damaged and will change color when frozen.

In Williamsburg, squirrels and birds also enjoy our fruit wreaths!

Conditioning Foliage

Evergreens with woody stems (holly, magnolia, pines, boxwood, firs, and cedar): When you return from cutting, recut the stems at an angle, slit up from the cut end about 2 inches with sharp clippers or a knife, and scrape off the lower bark to increase the plant's water intake.

Submerge your materials, if possible, in warm water in a sink, large pail, or even a bathtub. The next day, cut the pieces to the desired length with the stems cut at an angle, remove all of the foliage below the waterline, and stand the freshly cut stems upright in clean water mixed with floral preservative until ready to use. Spray with an antidesiccant to reduce moisture loss. After conditioning overnight, boxwood may be dried, dipped in liquid floor wax, and dried on newspapers. This effectively extends its life.

Evergreens with nonwoody stems (ivy, Alexandrian laurel, aucuba, and cleyera): When you return from cutting, recut the stems at an angle, remove all of the foliage below the waterline, and stand the materials upright in water mixed with floral preservative. Leave overnight. After conditioning overnight, ivy may be dried, dipped in liquid floor wax, and dried on newspapers.

Conditioning Flowers

General: After collecting or buying flowers, cut the stems at an angle and immediately put them into a clean container of warm water mixed with floral preservative at least one-half the length of the stems. If possible, choose flowers not yet fully opened. Remove all foliage below the waterline. Condition overnight or for at least 4 hours away from heat, sunlight, and drafts. Use hot water for wilting flowers and warm water for those with very soft stems. Mist the flowers frequently. A few flowers require special care:

Tulips—Recut the stems, remove the lower leaves, and roll 3 or 4 stems at a time in newspaper to keep the stems straight. Stand upright in a deep container of warm water overnight.

Daffodils, hyacinths, and narcissi—These flowers exude a slimy sap which can be damaging to other flowers, but they can be used safely

with other flowers after conditioning. Condition separately from other flowers by standing upright in shallow water overnight or for at least 4 hours.

Poinsettias, euphorbia, and other stems with milky, yellow, or colorless sap—Cut each stem and immediately singe it in a candle flame for 10 to 15 seconds. Poinsettias treated this way usually will last for 12 hours out of water, or they can be singed and put into water.

Leaves Preserved in Glycerine

Preserving leaves with glycerine is very simple, and the resulting colors add an interesting element to your decorations. The glycerine solution may be reused many times.

Method: Mix 1 part glycerine and 3 parts hot water. Select branches with well-shaped leaves free of insect damage or irregular hues. Prune if necessary and wash the foliage. Cut the stems on an angle and slit them with a knife. The stems should be less than 12 inches long for best results. Stand the stems in a jar of the glycerine solution deep enough to cover the bottom 3 to 4 inches of the stems. Check frequently to maintain the level of solution, adding more as necessary. Keep in a warm place with low light. Good air circulation is important. The leaves will change color as the solution is absorbed. Remove the materials from the solution when the leaves are all one color. The process will vary from 2 to 3 weeks. Early summer after the new growth has matured is the best time to preserve leaves in glycerine. The branches may be used as is, or large leaves may be used individually. The preserved materials may be stored and reused another year.

Leaves most successfully treated: magnolia (see page 66), oak (see pages 79, 80, and 81), laurel, rhododendron, other broad-leaved evergreens, cedar sprigs (including berries), and beech. Experiment with different materials.

To Force Bulbs

Daffodils, tulips, crocus, and grape hyacinth bulbs may all be forced, but allow about 4 months for a root system to develop and the flowers to be produced. In the fall plant the bulbs in a pot of soil with the tips of the bulbs just visible on the surface. Water and place in a cool, dark area such as a garage. Do not let the pots dry out. After about 2 months, gradually bring the pots into the light and keep damp. The bulbs usually take an additional 6 weeks to flower. Paper-white narcissus bulbs can be grown easily in a shallow pot filled with pebbles. They are also striking planted in a tall glass cylinder which supports the stems as they grow. Start paper-white narcissus bulbs in a cool, dark area and introduce them gradually to light and warmer temperature when buds appear. Do not overwater.

Collecting Dried Materials

Collect pods, nuts, cones, and other interesting dried materials throughout the year and store them with insect preventative. You will eventually have plenty of materials on hand when you wish to make a wreath for your door, a garland for your mantel, or a dried cone for your table. Bake acorns and other nuts found in the wild at 200°F. for 2 hours to destroy any insects living within them.

Supplies

It is a good idea to have on hand a supply of various gauges of floral and spool wire, fern pins, wired and unwired wooden floral picks, floral tapes and adhesives, sharp clippers, wreath forms, clothesline wire, wire cutters, instant floral foam (do not reuse), and a variety of sizes of chicken feeders, plastic liners, floral foam cages, and other holders. With these supplies, you will be ready to tackle most projects once your plant materials have been prepared.

Acknowledgments

It would have been a daunting task to have designed the variety of decorations and planned the seasonal entertaining ideas presented here without the help of many people and I gratefully acknowledge and thank them:

To Betty Babb for creating wonderful drawings to illustrate how to make many of the ideas and for her imaginative interpretations of traditional forms. Both add immensely to the book.

To Tom Green for his patience, humor, and creativeness during long photo sessions, Dave Doody, who also lent his talents to the photography, and their able assistants Teresa Gregory and Dawn Estrin.

To Helen Mageras for enhancing these ideas with handsomely designed pages, Donna Sheppard and Suzanne Coffman for their skillful editing, Brenda DePaula for typesetting, Priscilla Waltner for always cheerful and dependable support, Joe Rountree for his help with the concept and testing recipes, and Louis Luedtke for clearly drawn patterns.

To Clark Taggart, Libbey Oliver, Roy Williams, Stephen Cabaniss and their staffs, Betty Babb, Peg Smith, Jewel Lynn Delaune, Gale Roberts, Jody Petersen, Chris Williamson, Sybil Eberdt, Beverley Hundley, Emily Carpenter, and Anne Willis for special arrangements, and the residents of the Historic Area who create decorations for visitors to enjoy each Christmas.

To all who helped with photographic arrangements, especially Carol Harrison whose efficiency knows no bounds, Valerie Hardy for her idea to photograph the President's House, and also Ruth Rabalais and staff, Joyce Laughlin and staff, Susan Winther, Orene Coffman, and staff, Jeff Rountree, and models Gavin Sands, Mary Conlee, Beery and Tyler Adams, and Scott Freeman.

To Jan Gilliam and John Austin for helping with eighteenth-century table designs.

To Suzy Woodall, Gordon Chappell, Carolin Shoosmith, Wesley Greene and the landscape crew, Bob Scott, Laura Viancour, Terry Yemm, Susan Dippre, Martha Armstrong, Betty Babb, Donald Haynie, Peg Smith, Jewel Lynn Delaune, and Grace H. Kirkwood for help with locating, identifying, and sharing of plant materials or preparing sites for photography.

To Chefs Marcel Walter and Judy Pearce for their confectionery skills, Chefs Hans Schadler, Steven Grant, and Wyoma Smith for a portion of the food shown, and Leith Warlick, Valerie Hardy, Helen Mageras, Mildred Layne, and Betty Babb for sharing recipes.

To Brian Lambert, Calvin Heikkila, and their staffs, Rhonda Russell, Brenda Canada, and Cindy Meyers for their good suggestions and loan of reproductions.

To Carolyn Weekley for the scratched eggs, Betty Babb for the heart wreaths and painted eggs, Carol Harrison for woven hearts, Valerie Hardy for Jack-o'-lanterns, and Sally Riley for the three-dimensional lion and unicorn patterns.

To Steve Elliott, Beverly Coleman, Rita Joyner, Marina Ashton, and Gail Burger for their support.

To Mary Norment and the staff of the Audiovisual Library for locating photographs.

To those residents of the Historic Area and other friends who so graciously allowed us to photograph in their lovely homes including Scottie and John Austin, Sally White Barnes, Gail and Hank Burger, Beverly Coleman, Sybil and Jess Eberdt, Nancy Gotwald Harris, Karen and Tom Jamison, Barbara Leach, Tessa and Al Louer, Lynn Schenck, Jackie and Frank Smith, Anne and Tim Sullivan, Carolyn Weekley, Gwen and Wayne Williams, Chris and Woods Williamson, and Gillie and Tom Wood.

And lastly to Joe, Jeff, and Chris for their cheerful support and interest.

Index

Numbers in bold indicate pages with how-to instructions or recipes